Vanguard Productions Proudly Presents
The Comic-Book Horror of Pat Boyette

THE NIGHTSTAND CHILLERS

On nights when a bloody
moon flies high,
you can hear the wail
as dark things cry,
there's a chill in your spine
as is known to the dead,
and it comes from that book
on the stand by your bed.

PAT BOYETTE'S a TEXAN of a TIME WHEN a MAN'S WORD WAS HIS BOND and a FIRM HANDSHAKE CLOSED a DEAL — as CONTRACT. FAMED PICARESQUE SAN ANTONIO WAS FAMED PICARESQUE RADIO/TV/MOTION PICTURE WRITER-PRODUCER-DIRECTOR PAT'S HOMEBASE WHEN WE MET THERE SHORT of 30 YRS AGO — a MAN OF MANY TALENTS, PRO' ABILITIES, of BEARING, HIS BASSO STENTORIA'N VOICE and DICTION PUT ME IN MIND of the GREAT SENATOR EVERETT DIRKSEN — AUTHORITATIVE — WITH SIMILAR WRY IRONIC WIT and HUNDREDS of TALES TO TELL — THO' PAT PUT LOTS of THEM TO PAPER, PRODUCING HIS OWN SELF-WRIT STORIES and ART to TELL THEM. AND ON the LONGHORN, TO REGALE MY LATE WIFE, GUYLA, and I, by the HOUR; BETWEEN US, PAT and I MUST HAVE PAID for TWO of MA BELL'S MANY SATELLITES AT LEAST, WITH OUR BILL-PAYMENTS OVER the YEARS, SINCE PAT WAS a RELUCTANT PENPAL, DESPITE the ECONOMIC BENEFITS of CHITCHAT VIA USPS — BUT WE DID CUTBACK, a LOT — and LIMPED THRU MY LONG CHITS and HIS TOO-SHORT ONES of REPLY.

PAT SPARKED HIS OWN PROJECTS for PRINT that DESERVED SUCCESS — ORIGINAL NOVEL IDEAS — ON SUBJECTS TIMELESS and FOREVER INTRIGUING and MYSTERIOUS — EGYPTOLOGY BUT ONE TOPIC WE PINGPONGED at LENGTH — ONLY NOW ENJOYING a RENEWAL of SCHOLARLY INVESTIGATIONS —

HIS DECADES OF COMIC BOOK WORK FOR CHARLTON, DC, AND WARREN, WAS QUITE A MIX OF SUBJECTS, TYPES, AND STYLES, FROM ILLUSTRATIVE TO THE SEMI-BIGFOOT CARTOONY ITEMS ABOUT HANNA-BARBERA TV ANIMATION PROPERTIES — ALL BLOODY WELL DONE, TOO! FINE FOLIO PROJECTS, ABOUT PROPHESIES, PROJECTIONS — IN A 'PAST IS PRO-LOGUE' VEIN. PAT EXCELLED AT MANY FORMS OF LETTERING — GOOD CHUNKY BLOCK TITLE LOGO-DESIGNER, OF THE EMPIRE STYLE — HE SENT SAMPLES OF HIS EXPERIMENTAL TESTS OF ALL MEDIA, OILS, W/C, TRANSPARENT TO OPAQUE, ala TEMPERA, AND ACRYLICS — KEEPING BUSY, ALERT, CURIOUS. PUTTING ME TO SHAME, VIA HIS 'TESTS' 'PLAYTIME' PAINTING — I, TOO-RARELY, DID ENOUGH, THO' I WAS A DEDICATED OPAQUE (TEMPERA) SCUMBLER! the GOUACHE MEDIUM MY FAVORITE.

LOSING MY WIFE TO CANCER in '85 WAS A CRISIS I NEVER QUITE GOT OVER. PAT SAW ME THRU the FIRST FEW YEARS WITH ME BOUNCING OFF WALLS ALONE HERE — DID HIS BEST TO STABILIZE MY RUDDERLESS OL' TUG — WHICH I MUCH-APPRECIATED — THO' I DID SHUT-DOWN SYSTEMS, RE MY WORK, ME-COULDN'T WRITE WORTH A DAMN, BUT COULD, THANK GOD, STILL DOODLE, IF NEED be, IN PRINT — IF SIMPLE.

PAT AND I LOST TOUCH — FOR SOME LONG TIME — AS I DID WITH FAMILY and OTHER FRIENDS, TOO, ALONG the WAY — WE CONNECTED AGAIN WHEN HE LOST HIS DEAR WIFE, BETTE — A TRAGIC LOSS for HIM — OF COURSE.

SHORT NOTES / LETTERS and PHONE CHATS RENEWED OUR LINES OF COMMUNICATION — HE HAS HAD HEALTH WOES SINCE — SURGERIES — HIS DAUGHTER and FAMILY AT HIS SIDE THRU IT ALL — in FT. WORTH — I PRAY HE'S WELL — BETTER — NOW — IN HIS RECUPERATION, IN COMFORT..

I COMMEND DAVID SPURLOCK for COMPILING THIS COLLECTION OF PAT'S WORK, FOR ALL TO SEE and APPRECIATE the VALUE OF TWIXT TWO COVERS, A LONG-OVERDUE ESSAYING OF PAT'S VARIGATED TALENTS as PICTUREMAKER / STORYTELLER — HOPING IT EX-CITES GREAT INTEREST and A SERIOUS STUDY by WANNABES, YOUNG TURKS / TYROS and OLD PROS —

I TIP MY HAT to HIM NOW —

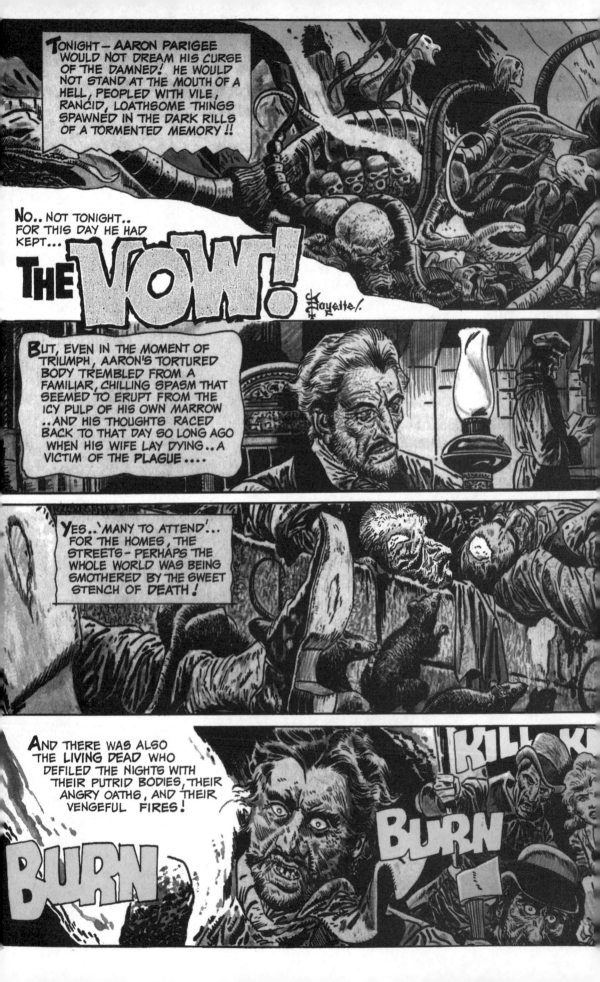

TONIGHT—AARON PARIGEE WOULD NOT DREAM HIS *CURSE OF THE DAMNED!* HE WOULD NOT STAND AT THE MOUTH OF A HELL, PEOPLED WITH VILE, RANCID, LOATHSOME THINGS SPAWNED IN THE DARK RILLS OF A TORMENTED MEMORY!!

NO.. NOT TONIGHT.. FOR THIS DAY HE HAD KEPT...

THE VOW!

Loyette!

BUT, EVEN IN THE MOMENT OF TRIUMPH, AARON'S TORTURED BODY TREMBLED FROM A FAMILIAR, CHILLING SPASM THAT SEEMED TO ERUPT FROM THE ICY PULP OF HIS OWN MARROW ..AND HIS THOUGHTS RACED BACK TO THAT DAY SO LONG AGO WHEN HIS WIFE LAY DYING..A VICTIM OF THE PLAGUE....

YES..'MANY TO ATTEND'... FOR THE HOMES, THE STREETS—PERHAPS THE WHOLE WORLD WAS BEING SMOTHERED BY THE SWEET STENCH OF DEATH!

AND THERE WAS ALSO THE *LIVING DEAD* WHO DEFILED THE NIGHTS WITH THEIR PUTRID BODIES, THEIR ANGRY OATHS, AND THEIR VENGEFUL FIRES!

KILL K

BURN

BURN

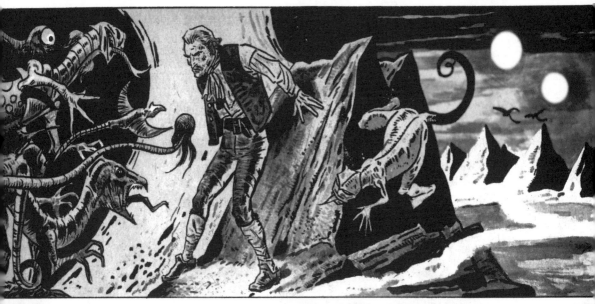

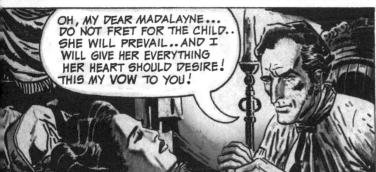

OH, MY DEAR MADALAYNE... DO NOT FRET FOR THE CHILD.. SHE WILL PREVAIL...AND I WILL GIVE HER EVERYTHING HER HEART SHOULD DESIRE! THIS MY VOW TO YOU!

SIRE..YOUR WIFE IS DEAD..AND I MUST LEAVE... THERE ARE MANY TO ATTEND...

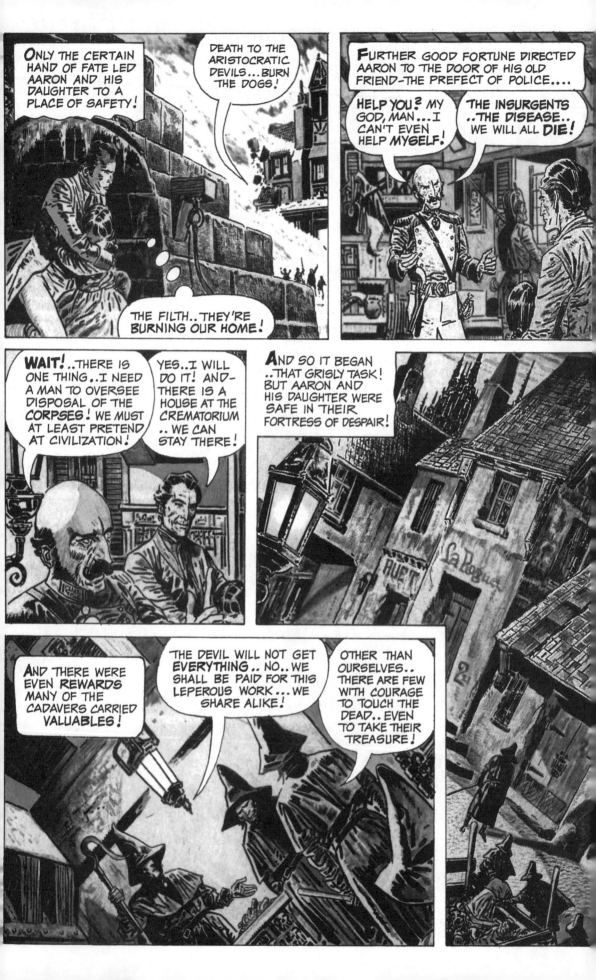

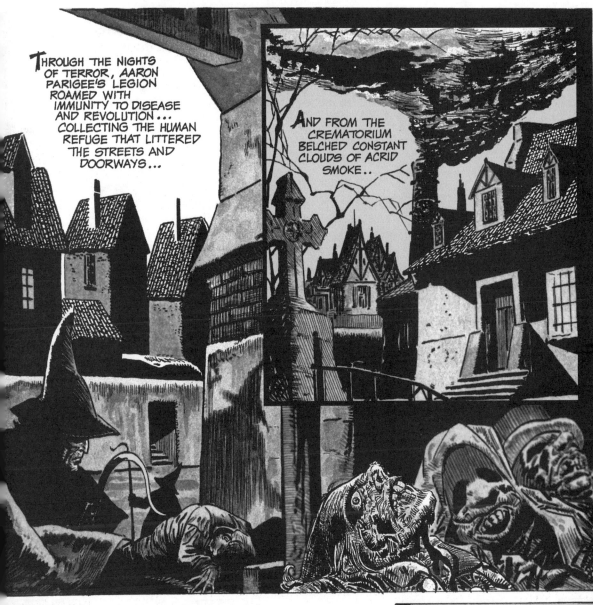

THROUGH THE NIGHTS OF TERROR, AARON PARIGEE'S LEGION ROAMED WITH IMMUNITY TO DISEASE AND REVOLUTION... COLLECTING THE HUMAN REFUSE THAT LITTERED THE STREETS AND DOORWAYS...

AND FROM THE CREMATORIUM BELCHED CONSTANT CLOUDS OF ACRID SMOKE...

AARON SET ABOUT HIS WORK WITH A FURY THAT MADE HIM OBLIVIOUS TO HIS SURROUNDINGS — EVEN TO THE WIDE LITTLE EYES - TRANSFIXED ON THE MORBID ACTIVITY...

HIS LITTLE DAUGHTER CASSANDRA WAS AARON'S ONLY JOY.. AND HER WARMTH SEEMED TO SOFTEN THE DEEP TRENCHES OF STRAIN THAT SLASHED HIS FACE...

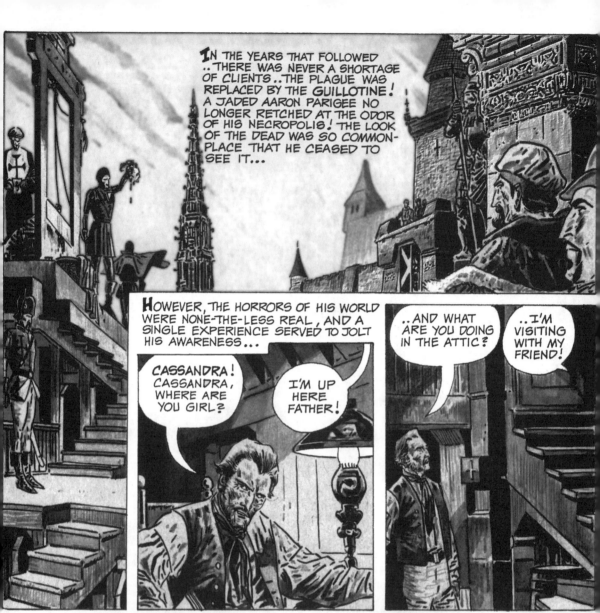

IN THE YEARS THAT FOLLOWED .. THERE WAS NEVER A SHORTAGE OF CLIENTS .. THE PLAGUE WAS REPLACED BY THE GUILLOTINE! A JADED AARON PARIGEE NO LONGER RETCHED AT THE ODOR OF HIS NECROPOLIS! THE LOOK OF THE DEAD WAS SO COMMONPLACE THAT HE CEASED TO SEE IT...

HOWEVER, THE HORRORS OF HIS WORLD WERE NONE-THE-LESS REAL, AND A SINGLE EXPERIENCE SERVED TO JOLT HIS AWARENESS...

CASSANDRA! CASSANDRA, WHERE ARE YOU GIRL?

I'M UP HERE FATHER!

.. AND WHAT ARE YOU DOING IN THE ATTIC?

.. I'M VISITING WITH MY FRIEND!

FRIEND? YOU HAVE NO...

.. FRIEND!

THIS IS MIMI!

NAUSEA AND GUILT STABBED AT AARON'S SOUL AS HE RETREATED FROM THE REPULSIVE SCENE...

I'VE FAILED MY DAUGHTER IN A MOST HORRIBLE WAY ...I VOWED TO BRING HER HAPPINESS..BUT..BUT... I'VE GOT TO MAKE IT UP TO HER!

IN DESPERATION, AARON SHOWERED CASSANDRA WITH GIFTS, BUT LIKE MOST FATHERS, HE FAILED TO NOTICE THAT SHE COULD NO LONGER BE INTERESTED IN CHILDISH BAUBLES..FOR RECENTLY THERE WAS A DIFFERENT LIGHT IN HER EYES...

LISTEN..A MUSIC BOX!

YES... THANK YOU!

THEN..ONE NIGHT, QUITE BY ACCIDENT..HE GLIMPSED A FAMILIAR FIGURE AS IT SWEPT ACROSS THE COURTYARD!

CASSANDRA.... WHERE...

AND SO AARON RECEIVED STILL ANOTHER SURPRISE..HIS BRAIN EXPLODED..HIS SENSES REELED..

..BUT NOW HE COULD ACT IN A MOST POSITIVE WAY AGAINST THIS NEW MENACE TO HIS DAUGHTER!

ENOUGH..YOU MINCING DANDY!

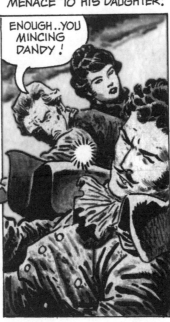

IF YOU TOUCH MY CHILD AGAIN..I'LL FEED YOU TO MY FIRES! I KNOW YOUR FACE..I KNOW WHERE TO FIND YOU!

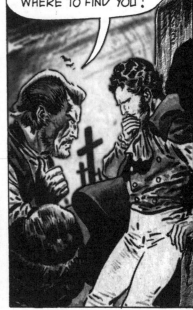

CASSANDRA LAPSED INTO DEEP DESPAIR..AND IN SORROW SHE BEGAN TO WASTE AWAY...

I'M SORRY, AARON ..SHE'S LOST HER WILL TO LIVE! PERHAPS IT'S THIS DISMAL PLACE...

NO.... PHYSICIAN! IT IS SOMETHING I HAVE DONE!

CASSANDRA ..YOU MUST UNDERSTAND...THAT MAN CANNOT BE A 'RIGHT LOVE' FOR YOU! I KNOW HIM TO BE ANDRE BRIGANCE... AND HE IS A RUMORED PARAMOUR OF THE EMPRESS ..AND IF THE EMPEROR KNEW OF THAT SHABBY LITTLE AFFAIR..HE'D..

I AM HIS TRUE LOVE! I WANT HIM WITH ME! IF IT CANNOT BE ... THEN I SHALL DIE!

NO... PLEASE! I WILL DO SOMETHING!

SO.. IT WAS NO ACCIDENT THAT AN UNSIGNED LETTER APPEARED IN THE EMPEROR'S QUARTERS...

THOSE IN AUTHORITY SAID THE NOTE OF INDICTMENT THREW THE EMPEROR INTO A FROTHING RAGE..

AAG

..AND ALTHOUGH BRIGANCE MAY HAVE BEEN A GREAT LOVER..HE WAS A PITIFULLY POOR LIAR...

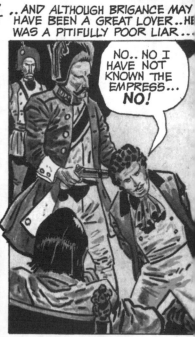

NO.. NO I HAVE NOT KNOWN THE EMPRESS... NO!

NOW..WE COME TO THIS NIGHT AND AARON PARIGEE'S COMFORT IN HAVING BROUGHT JOY TO HIS DAUGHTER'S ACHING HEART..

THE COMPETENT UNION OF A SCARLET LETTER, CUPID, AND LA BELLE GUILLOTINE HAD DELIVERED THE GROOM..AND EVEN NOW A LOVING CASSANDRA IS BUSY...

...SEWING HIS HEAD BACK ON!

END

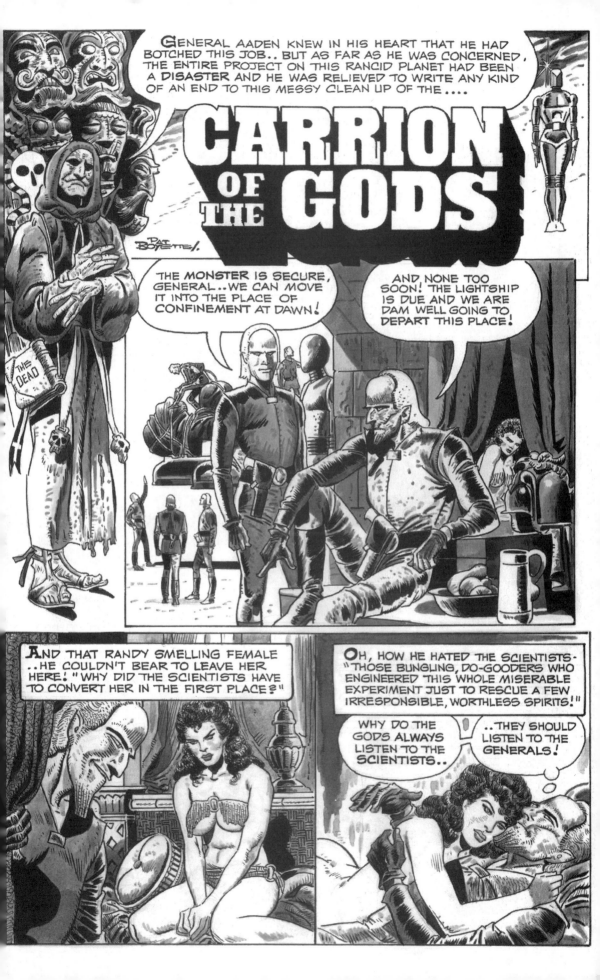

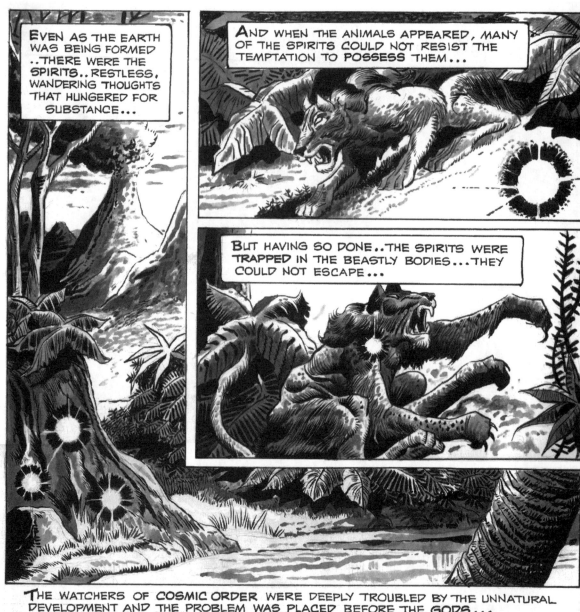

EVEN AS THE EARTH WAS BEING FORMED ..THERE WERE THE SPIRITS..RESTLESS, WANDERING THOUGHTS THAT HUNGERED FOR SUBSTANCE...

AND WHEN THE ANIMALS APPEARED, MANY OF THE SPIRITS COULD NOT RESIST THE TEMPTATION TO POSSESS THEM...

BUT HAVING SO DONE..THE SPIRITS WERE TRAPPED IN THE BEASTLY BODIES...THEY COULD NOT ESCAPE...

THE WATCHERS OF COSMIC ORDER WERE DEEPLY TROUBLED BY THE UNNATURAL DEVELOPMENT AND THE PROBLEM WAS PLACED BEFORE THE GODS...

THEN IT SHALL BE DONE! I SHALL CREATE A PERFECT BODY TO HOUSE DESERVING SPIRITS!

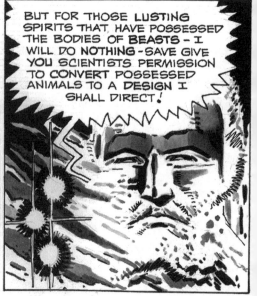

BUT FOR THOSE LUSTING SPIRITS THAT HAVE POSSESSED THE BODIES OF BEASTS - I WILL DO NOTHING - SAVE GIVE YOU SCIENTISTS PERMISSION TO CONVERT POSSESSED ANIMALS TO A DESIGN I SHALL DIRECT!

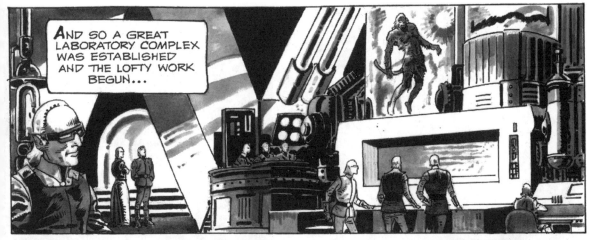

AND SO A GREAT LABORATORY COMPLEX WAS ESTABLISHED AND THE LOFTY WORK BEGUN...

BUT THE SCIENTISTS WERE NOT GODS AND EARLY ERRORS PRODUCED MANY GROTESQUE MUTATIONS...

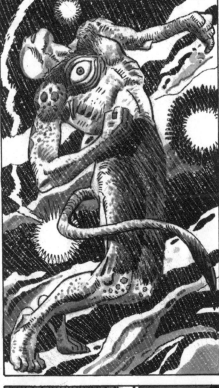

HE'S LOOSE!

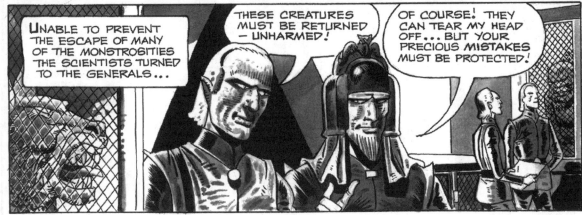

UNABLE TO PREVENT THE ESCAPE OF MANY OF THE MONSTROSITIES THE SCIENTISTS TURNED TO THE GENERALS...

THESE CREATURES MUST BE RETURNED — UNHARMED!

OF COURSE! THEY CAN TEAR MY HEAD OFF... BUT YOUR PRECIOUS MISTAKES MUST BE PROTECTED!

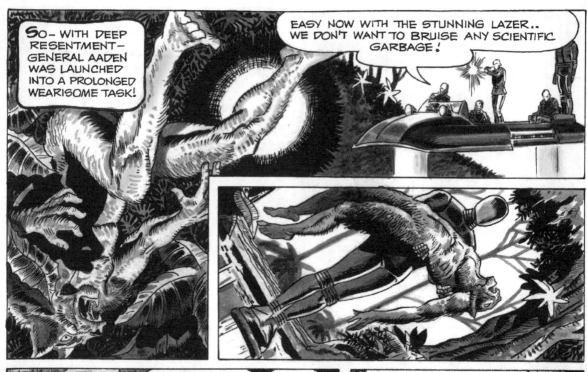

SO – WITH DEEP RESENTMENT – GENERAL AADEN WAS LAUNCHED INTO A PROLONGED WEARISOME TASK!

EASY NOW WITH THE STUNNING LAZER.. WE DON'T WANT TO BRUISE ANY SCIENTIFIC GARBAGE!

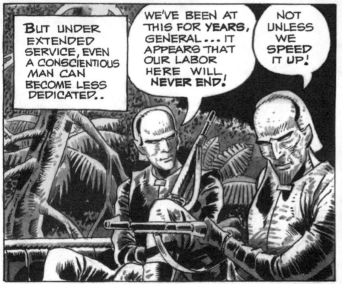

BUT UNDER EXTENDED SERVICE, EVEN A CONSCIENTIOUS MAN CAN BECOME LESS DEDICATED..

WE'VE BEEN AT THIS FOR YEARS, GENERAL ... IT APPEARS THAT OUR LABOR HERE WILL NEVER END!

NOT UNLESS WE SPEED IT UP!

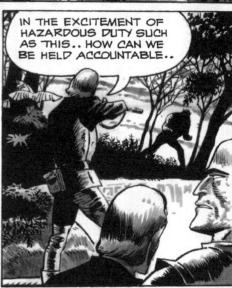

IN THE EXCITEMENT OF HAZARDOUS DUTY SUCH AS THIS.. HOW CAN WE BE HELD ACCOUNTABLE..

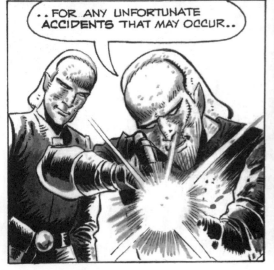

.. FOR ANY UNFORTUNATE ACCIDENTS THAT MAY OCCUR..

.. FROM TIME TO TIME..

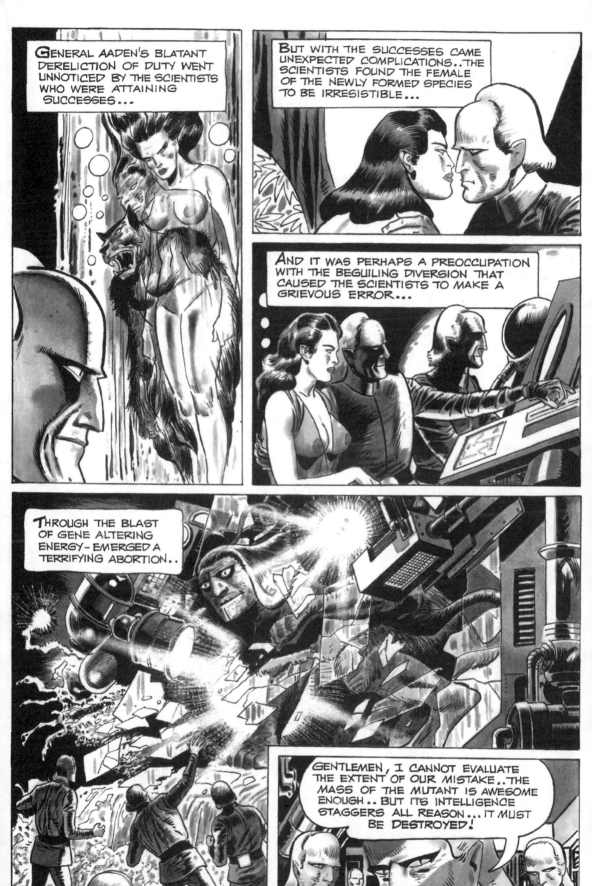

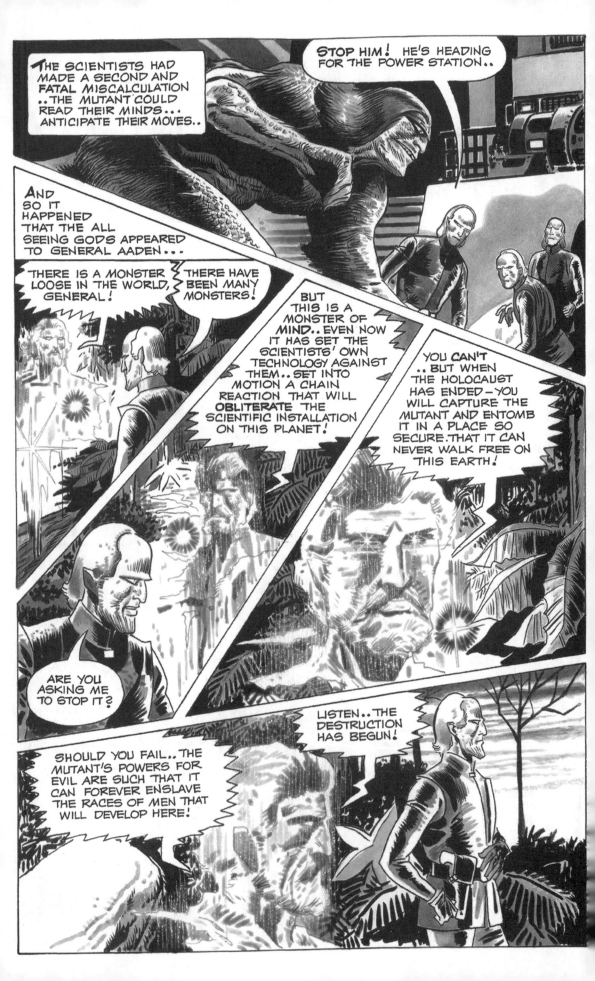

THE SKY TURNED A GLOWING CRIMSON.. AND GEN. AADEN COULD WELL IMAGINE THE DEVASTATION THAT WAS NOW TAKING PLACE...

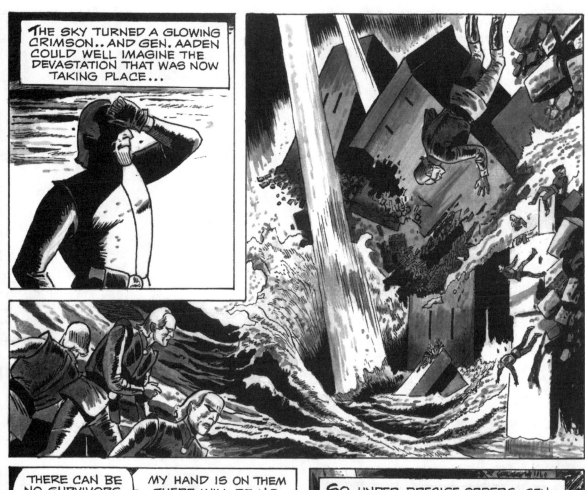

THERE CAN BE NO SURVIVORS OF WHAT IS HAPPENING!

MY HAND IS ON THEM ..THERE WILL BE NO DEATHS! IT IS MY WILL TO PROMOTE LIFE HERE... NOT TO TERMINATE IT... A MATTER YOU AND I MUST DISCUSS AT GREAT LENGTH!

SO, UNDER PRECISE ORDERS, GEN. AADEN SET OUT TO FIND AND ENTOMB THE MONSTER....

AND AMONG THE FLOTSOM OF THE SCIENTISTS' INGLORIOUS END.. THE GENERAL FOUND AN INTEREST TO BLUNT THE BOREDOM OF HIS REMAINING YEARS OF SERVICE!

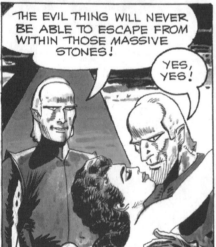

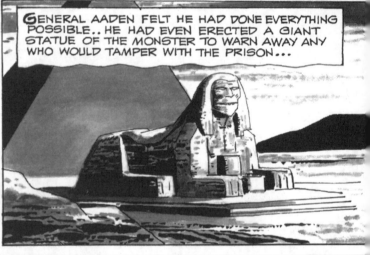

OUTLINE OF A MYSTERY MAN
By STERANKO

The comics' field ripples with talented creators, but few with the natural range and consistency, facility and style of Pat Boyette. Unlike many gifted artists and writers entrenched in narrow, repetitive, one-dimensional lives, Boyette embraced the

ment and size of his figures which embellish plot action; the mannerism and body english of his characters as a form of dramatic expression; the psychological spotting of blacks; the dementia-laden tilt panels; even the unintrusive positioning of copy blocks to

above: Creepy #33, 1970
below: Eerie #28, 1970

faceted challenge of multiple media careers and explored them all with bull's-eye success. Radio, TV, and film were fully-rendered canvasses before he moved on to address the rigors of the four-color drawing board.

When he approached comics, it was implicit that he brought a wealth of experience, sophistication, and maturity of craft to his product. Boyette's early interest in comic strips is echoed in his understanding and use of page architecture. Like Foster. Caniff, and Hogarth, to name a few, his pages are frequently masterpieces of baroque composition, textural patterns, and unified imagery–but never at the expense of comprehension. And like theirs, his page structure is remarkably personal in design, often so strikingly idiosyncratic that the work need no signature to identify it.

The element linking all his efforts, however, is his intrinsic sense of drama, collectively assimilating Boyette the actor, writer, and director. Look at what he chooses to show in his panels–and what he chooses to hide. A quick study of any Boyette story reveals that his images consistently detail more information than his balloons and captions. Check out the place-

allow the graphics maximum impact.

Boyette's historic works–including many of the stories in this volume–resonate with atmosphere and authority uncommon to the comics' form.. Their richness of narrative, charm, irony, comedy, tragedy, mystery, and farce mine the often-unexplored territory between words and pictures to express the full vitality, integrity and power of comic art.

Pat Boyette is one of my heroes and a special friend for almost as long as I've been deadlining my way through the form. The inspiration he's been is a secret ingredient in my inkwell for decades.

Jim Steranko is one of the greatest innovators in comics. He has also worked on film projects with George Lucas, Steven Spielberg, Oliver Stone, and collaborated with Francis Ford Coppola.

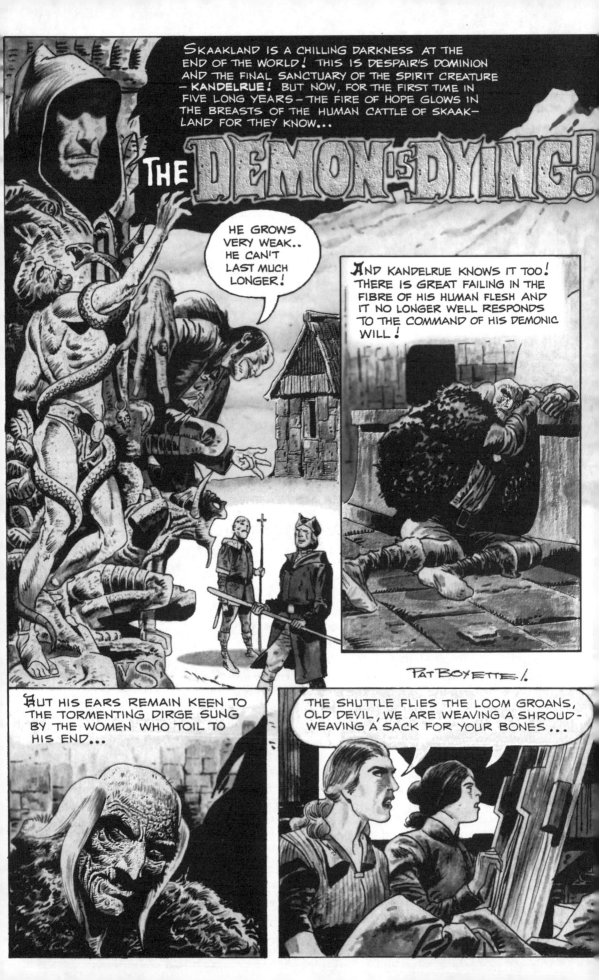

PEPE.. ANSWER ME! I KNOW YOU'RE HERE!

I AM HERE, SIRE!

THEN HELP ME TO MY FEET....

NO, SIRE!

NO, SIRE! SO.. YOU LITTLE FREAK.. YOU'VE JOINED THEM!

AND WHAT WAS YOUR PRICE?

MY LIFE, SIRE! IF I TELL THEM WHEN YOU CAN NO LONGER MOVE.. THEY WILL LET ME LIVE!

HA! THE DEATH WATCH HAS BEGUN! THE WAITING FOR A DEATH THAT WILL NOT COME!

MY SPIRIT IS ETERNAL.. AT THE MOMENT OF WHAT YOU CALL MY DEATH... I SHALL POSSESS ANOTHER BODY, AND I WILL SINGLE YOU OUT FOR A SPECIAL PLEASURE... YOU AND THAT BISHOP KANE!

THERE IS NO SIGN FROM THE CASTLE, BISHOP!

AH, BUT IT WILL COME! KANDELRUE WILL BE DELIVERED INTO OUR HANDS!

OUR HOUR OF DELIVERANCE DRAWS NEAR! THIS DAY WE WILL WRITE THE FINAL CHAPTER IN OUR LEDGER OF ANGUISH THAT BEGAN SO LONG AGO....

"OUR BELOVED SKAAKLAND IS A DIVINE GIFT..A WARM AND FERTILE VALLEY IN A FROZEN WASTE! BUT FOR TOO LONG WE HAVE BEEN THE VICTIMS OF A PLAGUE OF DEPRAVITY THAT FOLLOWED THE ANGRY ARMIES WHO CAME TO DEFILE THE PURE SNOW WITH THEIR GRIZZLY GORE!"

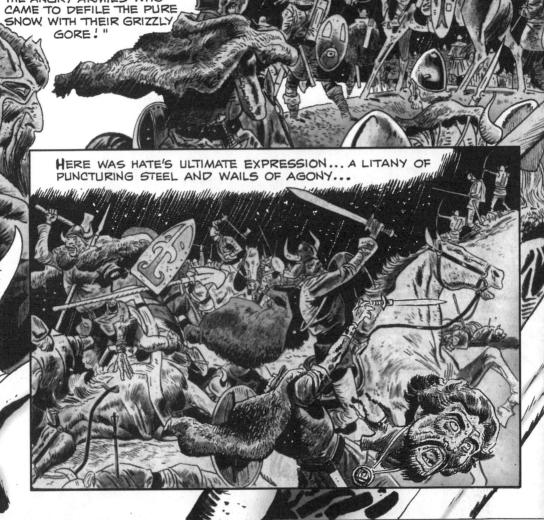

HERE WAS HATE'S ULTIMATE EXPRESSION... A LITANY OF PUNCTURING STEEL AND WAILS OF AGONY...

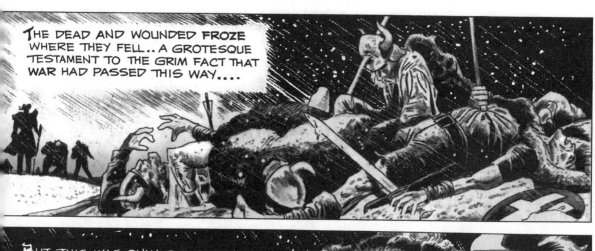

THE DEAD AND WOUNDED FROZE WHERE THEY FELL.. A GROTESQUE TESTAMENT TO THE GRIM FACT THAT WAR HAD PASSED THIS WAY....

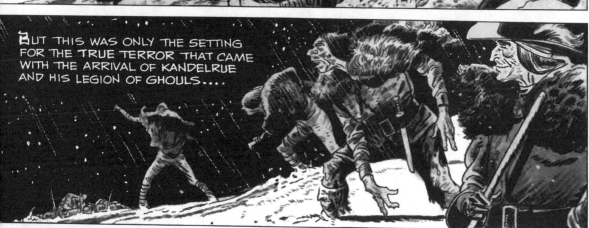

BUT THIS WAS ONLY THE SETTING FOR THE TRUE TERROR THAT CAME WITH THE ARRIVAL OF KANDELRUE AND HIS LEGION OF GHOULS....

NO LAND CAN BE SO COLD AS WHEN THE SPAWNS OF DARKNESS SET ABOUT TO SATISFY THEIR VILE NEEDS..

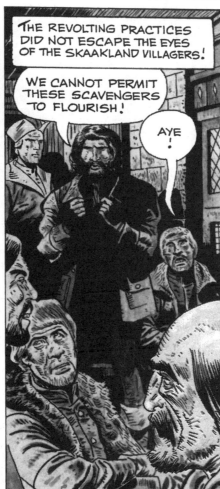

THE REVOLTING PRACTICES DID NOT ESCAPE THE EYES OF THE SKAAKLAND VILLAGERS!

WE CANNOT PERMIT THESE SCAVENGERS TO FLOURISH!

AYE!

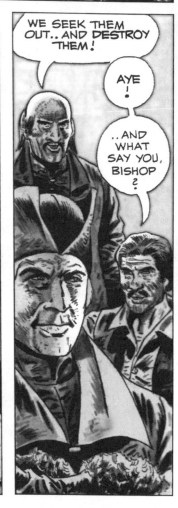

WE SEEK THEM OUT.. AND DESTROY THEM!

AYE!

..AND WHAT SAY YOU, BISHOP?

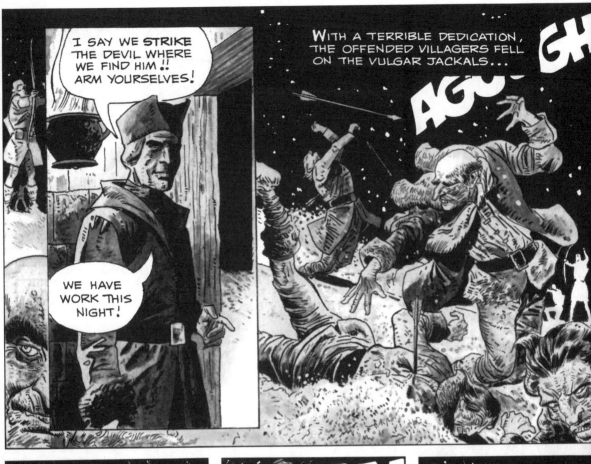

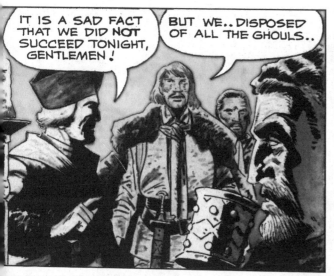

IT IS A SAD FACT THAT WE DID **NOT** SUCCEED TONIGHT, GENTLEMEN!

BUT WE.. DISPOSED OF ALL THE GHOULS..

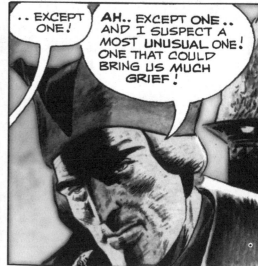

.. EXCEPT ONE!

AH.. EXCEPT ONE.. AND I SUSPECT A MOST **UNUSUAL** ONE! ONE THAT COULD BRING US MUCH GRIEF!

AND IT CAME SOONER THAN THE GOOD BISHOP HAD IMAGINED! THE DAUGHTER OF COBBLER HIMES WAS THE FIRST VICTIM...

FATHER HELP ME!

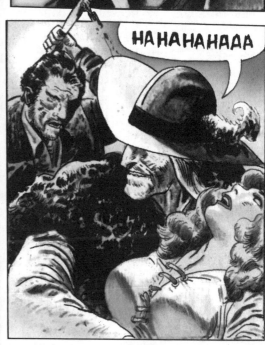

HAHAHAHAAA

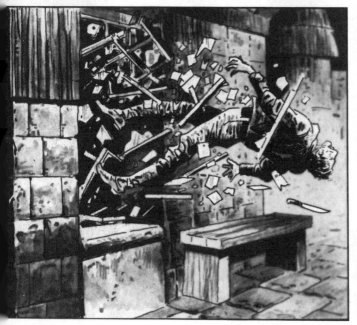

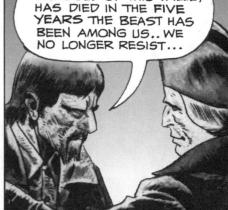

SO THE LONG NIGHT HAD SET IN.. A DEMON WAS IN RESIDENCE IN SKAAKLAND.. AND HE COULD NOT BE KILLED...

I TELL YOU BISHOP.. THE SOUL OF THIS VALLEY HAS DIED IN THE FIVE YEARS THE BEAST HAS BEEN AMONG US.. WE NO LONGER RESIST...

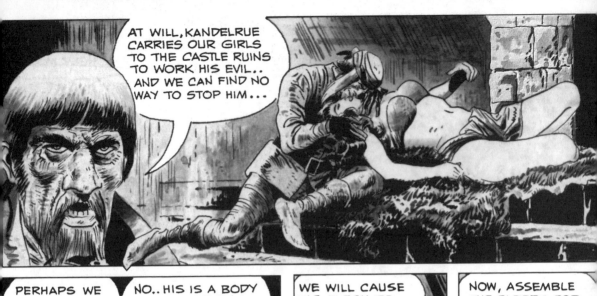

AT WILL, KANDELRUE CARRIES OUR GIRLS TO THE CASTLE RUINS TO WORK HIS EVIL.. AND WE CAN FIND NO WAY TO STOP HIM...

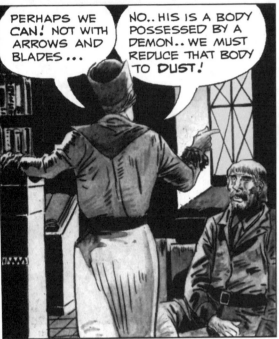

PERHAPS WE CAN! NOT WITH ARROWS AND BLADES...

NO.. HIS IS A BODY POSSESSED BY A DEMON.. WE MUST REDUCE THAT BODY TO DUST!

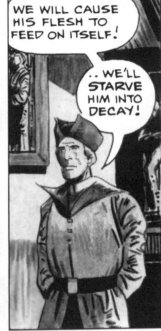

WE WILL CAUSE HIS FLESH TO FEED ON ITSELF!

.. WE'LL STARVE HIM INTO DECAY!

NOW, ASSEMBLE THE ELDERS FOR A LITTLE RIGHTEOUS LABOR.. AND TELL THAT HIDEOUS PEPE I WANT TO SEE HIM!

WHY HAS IT TAKEN ME FIVE YEARS TO TRUST MY OWN FAITH?

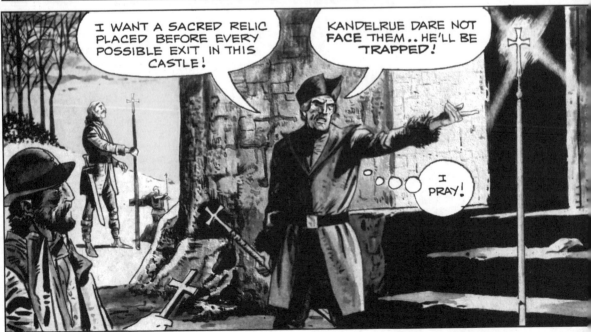

I WANT A SACRED RELIC PLACED BEFORE EVERY POSSIBLE EXIT IN THIS CASTLE!

KANDELRUE DARE NOT FACE THEM.. HE'LL BE TRAPPED!

I PRAY!

FOR THREE MONTHS, KANDELRUE HAD BEEN CONTAINED IN THE CASTLE! BISHOP KANE NOW KNEW HE WOULD BEAT THE DEMON!

IN PREPARATION FOR THE MOMENT, THE BISHOP TRACED A LARGE PENTACLE IN THE DIRT...

IF I CAN JUST PLACE KANDELRUE IN HERE WHILE HE'S TOO WEAK TO RESIST US..AND BEFORE HE ABANDONS THE BODY!

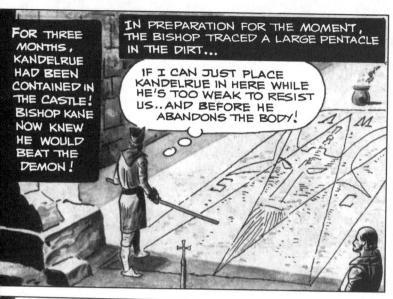

BISHOP KANE...THE TIME IS NOW! KANDELRUE CAN NO LONGER MOVE!

HURRY MEN... DRAG HIM OUT!

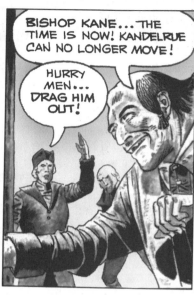

PLACE HIM IN THE PENTAGRAM... NOW WHEN THE DEMON RELEASES THAT BODY ..THE SPIRIT CAN'T ESCAPE FROM THE SYMBOL TO POSSESS ONE OF US...

THE SPIRIT WILL BE FORCED TO RETURN TO THE UNDERWORLD..

BISHOP... KANDELRUE.. HE'S TURNING TO DUST!

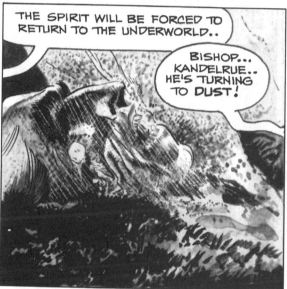

THEN IT'S DONE! THE DEMON IS GONE.. WE HAVE WON!

AIEEEE

SUDDENLY...THE HAPPY RELIEF WAS SHATTERED BY A SCREAM OF TORMENT...

BISHOP...LOOK .. THE GARGOYLE ..IT'S EYES!

AND SO IT HAPPENED...AN ETERNAL SPIRIT WAS ENTOMBED IN ETERNAL STONE! IT IS SAID THAT ON HIGH HOLY DAYS THE GARGOYLE WEEPS...

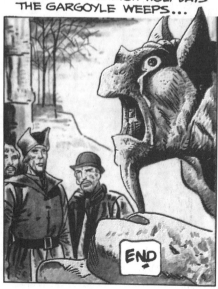

END

Spurlock: You have a reputation for being prolific and ambitious, so tell me – what makes Patrick run?

Boyette: It all started with the popular desire to be RICH and FAMOUS!! In the long ago, rose-colored days of my youth, I thought cartoonists were glamourous and must therefore also be wealthy! In those halcyon years, most magazines – large and small – used many **one panel cartoons**. It seemed to be a promising market with great opportunities for aspiring artists and joke writers. I submitted two or three pieces and then – one happy day, it was THERE – a magazine had printed one of my cartoons! All of this excitement was hi-lighted when, a few days later, I received a check for $8.00. WOW! Success was sweet! I wasn't yet in my teens! The bubble burst when I sent off

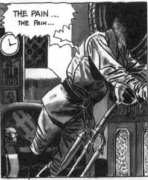
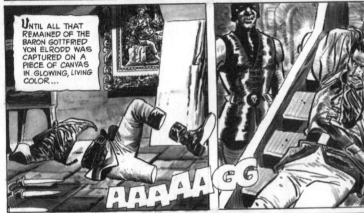

my second batch of cartoons. I had worked very hard on those panels, but, it was raining when I got to the mail box and the package was too big to fit through the mail slot! However, with just the right amount of shoving and bending, I got the box to swallow the oversized envelope – AHHH! My drawings were on the way and all I had to do was wait for more checks to arrive. BUT, what arrived was the postman returning a tattered, wet, soggy glop that had once been my beautiful drawings – my future! The thrill was gone. I never had the heart to produce any more panels, and I was too discouraged to re-work the ruined ones! One sale and I was suffering from burn out! Well, at least I had dodged the bullet of over exposure.

S: So **Collier's, Saturday Evening Post** and **New Yorker** cartoons inspired you?

B: Ohhh, yeah. Cartoons were a daily presence in most everybody's lives in those days – not only magazine cartoons but certainly **newspaper strips!** Those characters were alive and and readers became deeply involved. The developing stories were the most carefully guarded secrets in the paper! People would place bets on outcomes. "FUNNIES" were the topics of lively discussions and families had spirited confrontations over who would be the first to get those exciting, colorful gems. Alas.

S: When you first started earning a living, what work did you get into?

B: BROADCASTING! I started doing radio commercials as a kid. I was quite young and I don't remember most of them but, one stands out – **GEBHARTS CHILI**! I ate it then, it was sent to me overseas, and I eat it today. When radio needed a kid – I was their boy. At the end of the run, I was treated like a celebrity on campus – an exalted position that lasted about a month after my voice started changing. However, one thing that never changed was the excitement found in a broadcasting studio! **I was hooked!**

S: So – what did you do?

B: I went to work for WOAI radio as an office boy, but I couldn't stand that – I had to get on a microphone. I auditioned for KBAC (those call letters were then in San Antonio) . I got a job as announcer/newscaster!

S: Did you groom your voice for broadcasting?

B: You mean (deep speaker voice) "fifth floor please?" Oh, yes! There was a lot of ear-cupping and sipping of honey.

S: Was the new job what you were looking for?

B: The first couple of days were absolute terror.. When I arrived for shift, I was told, "Here's the book. That's the mic switch, and here's the tip of my hat to your good luck!" He left – I was ALONE! I didn't even know how to communicate with the control room, and further – I didn't even know how to read their programming log. Small problems compared to the fact that I didn't have a key to the men's room.

S: What did you do?

B: I'm not gonna tell you!

B: They only used that broom closet to store the boss's golf bag, anyway!

S: How rough was that first day?

B: Raw, I never forgot it. I read newscasts, announced musical shows with live western bands, endless booth commercials, and appeared in a film for the Catholic Hour. I was young, robust, and still in my teens – but I was exhausted! However, it smoothed out in a few days with many lessons yet to be learned and many laughs to be had.

S: Explain that.

B: **WAR** was coming and preparation was on the minds of many. Civil Defense ordered a city wide test blackout, and the station decided it would be much in the public service if we broadcast it. So-come sunset, Tommy Reynolds and I were atop one of the city's taller buildings...supplied with proper remote gear we were prepared to dispense the vital information that was about to unfold before us. Suddenly, but right on time-every light in town went out. The night was pitch black, and here were these two idiots sitting on top of a building and for the first time questioning, "What-do you talk about when there's nothing to see but nothing to see?"

It was too long ago to remember now, but the commentary must have been brilliant. I recall Tom saying: " You can't tell this over the radio, but trust me...it's really dark out. No kidding folks – I wish you could see it!" I said: "Maybe they can look through a window! Uh, Tom do you think I could light a cigarette?" Tom grasped the seriousness of my

suggestion and levelled a strong reprimand, "NO! The light from a single match can be detected by the enemy hundreds of yards away!" Well-obviously I just wasn't thinking...but honestly, I didn't know the enemy was that close.

Then, there was the time when we were creating out-of-town baseball games from ticker tape and we **lost** the **ninth** inning – we had no idea of the action or the score. We re-created for an eternity until some home folks had time to drive home and call us to report the outcome!

S: How did you fill all that time?

B: At some point, re-creation became creation. We tried everything. The park had a power failure – there was even a near riot between the fans and hotdog vendors. It was all good-fun-nonsense!

Then, in my memory, a dark uneasiness settled over the light and humor of those "days of our lives!" **THE DRAFT HAD BEGUN**–the lights were really going out. WOAI called and I returned to that station as editor of their 10:00 pm news – a prestige edition

heard in 40 states and 11 foreign countries. We had daily listeners in England. On the island of Guam, the station boomed in like a local. A powerful voice was that WOAI!

S: But how did you stand with the draft?

B: At that time, communications was a vital industry so I was deferred. But, after six months, I couldn't stand it any longer. I wouldn't let the station ask for a renewal of my deferment.

S: You wanted to go?

B: I felt I had to. Most of my friends had already shipped out. I was filled with a strange loneliness..

S: So?

B: So, I resigned my safe job and went to work as an announcer, newscaster, and disc jockey at station KONO. In six months, THEY DRAFTED ME!, However, at least I was assured of having a job with many doors of opportunity when "Johnny comes marching home again!"

S: You wanted to do entertainment programming?

B: I felt that after the war, NEWS would be down-scaled. I wanted to romp in more diverse fields.

S: Where did you spend most of your service time?

B: In the Pacific. I was in the Philippines, New Guinea, Guadalcanal, New Caledonia and others – including Japan.

S: The big story to come out of WW2 was – we WON.

B: Yes, and I returned to radio. The first assignment I had was to emcee a dance band remote from a nite-club. It had been a long time and I was on the nervous side. But, the theme started and I stepped to the microphone to say: "Ladies and gentlemen–from the beautiful Kopy Cat Club – the music of...." and this drunk reached up and hit me right in the mouth. I was a bloody mess. So, the genteel patrons were treated to an evening of, "The sweetest music this side of Madison Square Garden." Radio was a wild ride but it blessed me with a world of experience – from country/western music to state political conventions! All that ended in a beat as my fickle heart took off in pursuit of a new amour!

S: Another career change?

B: I was walking past a bar one evening when I saw this strange, blue, flickering light. TELEVISION! I knew stations were going on line, but this was my first time to see it! It was truly hallelujah time. I had to be part of it!

S: And – were you able to swing a deal?

B: I auditioned for KEYL – a new TV station, and was hired as news director and chief announcer. Thus began many years in a new and exciting industry. Those days of

discovery and inge-nuity can never hap-pen again in just the same way!

S: During all this you were still reading comics?

B: I still enjoyed them, but I hadn't thought of trying to draw any. Then one day, this very distinguished man about fifty came into the station's art department and introduced himself as Charlie Plumb. I immediately recognized him as the artist on **Ella Cinders** – once a very popular newspaper strip. I was delighted, and the occasion called for many cups of coffee. We became good friends, and when Charlie wanted to start a small syndicate I agreed to go along for the ride. I did a strip, written by Charlie, called **CAPTAIN FLAME---** a WESTERN. Eventually, Charlie sold the syndicate and the new owner wanted me to continue the feature, but there were other projects I wanted to try. TV still offered countless challenges and there were a couple of laughs left.

S: Like?

B: My 6pm news was preceded by a children's program with a live audience. Since my news used the same studio, the host had fifteen minutes to vacate, but on that day he was passing out candy and the room was still full of kids when I started the news.. I had just launched my opening remarks when this little boy came over and leaned on my desk – between me and the camera. The little boy said, "You're Pat Boyette." I said, "Yes I am." He said, "My daddy just can't stand you on TV." It brought the house down..

S: What about your **MOVIES**?

B: Oh, yeah – the movies. I did three films and wrote a fourth. All but one have long since dropped from view – the **DUNGEON OF HARROW** is still being played after all these years... I have to say that making those low-budget films gave me some of the happiest moments of my life. A little later, Alan Dale, a premier talk show man, and I pro-duced a syndicated radio series called, **THE STENDEC REPORT.** It was collection of five minute stories from the bizarre, weird, and strange!

S: Where did the title come from?

B: During one of those Bermuda–like disappearing plane episodes – the pilot broadcast a frantic distress call: "STENDEC, STENDEC!" No one could decipher the mean-ing – but it sounded like a good title to me.

Warren Publishing carried the art of the great and the less than great. I was always very proud to have Pat Boyette's work; he fit very comfort-ably into the cate-gory of the great.
– Jim Warren

Boyette's work has a wonderfully organic quality –similar in that regard to the work of John Severin and Wally Wood. The macabre atmosphere which permeates his horror work (stories and art) might only be comparable to "Ghastly" Graham Ingels. His tales strike me as storyboards for Hammeresque horror films.
– J. David Spurlock

Boyette has been a highly original master of colorful story, unique characters, and atmosphere. No piece that has ever left his hand has been ordinary. He's one of a kind.
– Kenneth Smith

S: What were the stories like?

B: One day, the pastor of a small church in California called and said, "I don't care if you believe me or not, but I'm going to tell this story anyway." He went on to explain that he had never had an interest in the "Bermuda Triangle," in fact, he was not certain he had even heard of it before the time of a vacation on the Island of Bimini. While deep-sea fishing, his line snared a piece of pottery – decorated with with unfamiliar writing. He sent the piece to several universities and they were unable to identify it. However, during frustration from getting "no answers," the pastor became interested in Atlantis and the mysterious happenings in the Triangle. He prevailed upon his congregation to finance an underwater exploration in the area in which the pottery had been hooked. They went first-class with an unmanned submarine out-fitted with TV cameras and sonar. Here is what he said they found: a 1,000', three sided pyramid. It had a light burning on the apex. On the first day, they photographed a tractor-appearing machine. On the second day, the tractor was gone. They also brought up a statue of a man with six fingers on each hand. The pastor turned his findings over to the government. He has never been able to get his tapes and photos returned. Sounds like another tall tale, doesn't it? Well, we checked the pastor out, and as best we could tell, he was everything he said he was – but the story hangs in limbo in the good company of UFOs, aliens, ghosts and pyramid power. But...one day... one day...!

GHOSTS; On a sinister San Antonio back-road in the late 1930's, a schoolbus made it's lumbering way toward a railroad crossing. As the bus tried to negotiate a rise and clear the tracks, the engine stalled. Suddenly, almost seeming to appear out of nowhere a Southern Pacific engine smashed into the bus with tragic results... ten children died! Through the years following the unfortunate event, a weird belief has evolved.

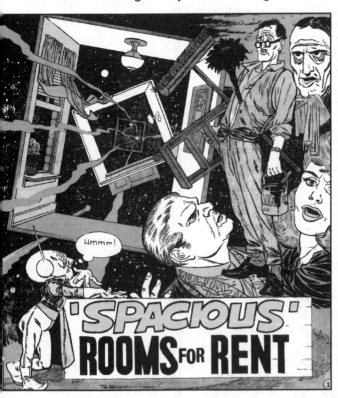

It is said by those who claim to have experienced the phenomenon, that if you park your car before the crossing and leave the brakes off, the car will slowly begin to move forward - up the incline - cross the tracks and roll down the other side to safety from the deadly crossing. Some say if your car is dusty, the hand-prints of small children can be seen. If you don't believe it – some early evening drive down desolate, and ominous Shane Road – park ten or fifteen feet from the crossing, and then, let us know what happens.

S: So how did all that lead into comics?

B: My transient soul was having another occlusion, and I needed a by-pass; needed a new project! There was a Charlton comic book laying on the coffee table..I called them and asked if they considered freelance work. They said they were always interested – so I sent some samples. Soon, I got a letter saying that they could use me and I would get a script in about a week. The week came and went, and finally – I got a letter saying they were reorganizing their operation and I wouldn't be getting an assignment for a year! Too long – I dismissed it from my mind. However, almost a year to the day later, I got a letter from Dick Giordano stating that if I was still interested–he had a script for me.

S: **Shadows from Beyond** was the book, and Spacious Rooms for Rent was the story. First book and you got the lead story.

B: I designed the Gypsy hostess for the book as well. I did a couple of short war stories, and Dick then asked if I'd like to try a superhero. I agreed. They sent me The Peacemaker..

S: Did you not create The Peacemaker?

B: Joe Gill wrote the script and I designed the character..

S: You also designed the

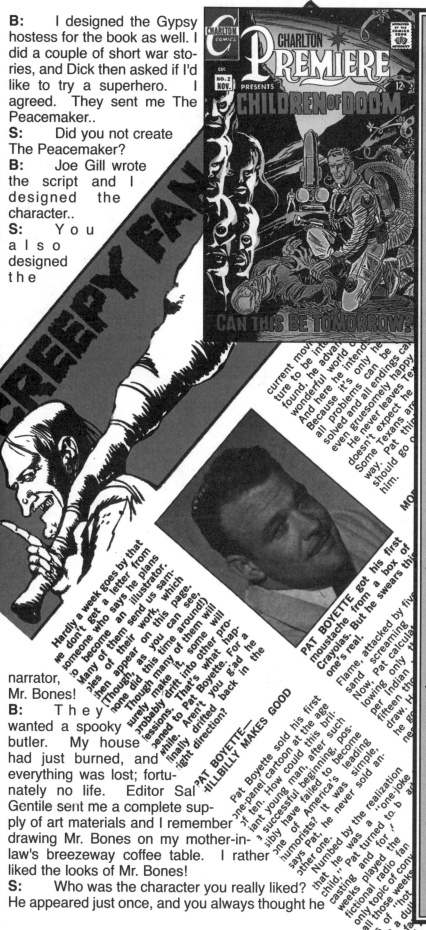

narrator, Mr. Bones!

B: They wanted a spooky butler. My house had just burned, and everything was lost; fortunately no life. Editor Sal Gentile sent me a complete supply of art materials and I remember drawing Mr. Bones on my mother-in-law's breezeway coffee table. I rather liked the looks of Mr. Bones!

S: Who was the character you really liked? He appeared just once, and you always thought he

Hardly a week goes by that we don't get a letter from someone who says he plans to become an illustrator. Many of them send us samples of their work, which then appear on this page. (Though, as you can see, none did this time around!) Though many of them will surely make it, some will probably drift into other professions. That's what happened to Pat Boyette. For a while. Aren't you glad he finally drifted back in the right direction?

PAT BOYETTE— HILLBILLY MAKES GOOD

Pat Boyette sold his first one-panel cartoon at the age of ten. How could this brilliant young man, after such a successful beginning, possibly have failed to become one of America's leading humorists? It was simple. says Pat, he never sold another one. Numbed by the realization that he was a "one-joke child," Pat turned to broadcasting and for several weeks played the only topic of conversation...

current movie to be interpreted. found, he advanced wonderful world of And here he intended he Because it's only he all problems can be solved and all endings happy even gruesomely happy. He never leaves Texans doesn't expect he Some Texans are way. Pat think should go him.

MO

PAT BOYETTE got his first moustache from a box of Crayolas. But he swears this one's real. Flame, attacked by five sand, screaming Now, Pat calcula lowing only fifteen Indian per draw. H he nea

should have had a longer life.

B: The Spookman in **Charlton Premier**.

S: **Charlton Premier** also carried Children of Doom – written by Denny O'Neil it's been called the best Charlton story ever.

B: It was well received. Denny was / is a very energetic and exciting writer.

S: What about other writers?

B: Oh, David, there are so many whose talents I salute, I wouldn't attempt to discuss them in our limited space; I most certainly would over-look someone. I'll pass on that.

S: Okay. What was your connection with Rocke Mastroserio?

B: Rocke had started drawing for Warren's **Creepy** and **Eerie** and was having

CREEPY MAGAZINE 1971

FROM THE MOMENT MY MOTHER SUBMITTED TO THE SUPERIOR WILL OF MY DEMON SIRE.. I HAVE NEVER WAVERED IN MY DEDICATION TO ENNOBLE THE LIFE OF THE WORLD!

trouble with deadlines so he asked me to pencil for him. With his Charlton work, Rocke had a heavy schedule. On the third story, Rocke suddenly died from a heart attack. I regret that we were unable to meet face-to-face.

S: When you worked together, it was all by phone.

B: Yes, at the time of his passing, we had a job on the board so I called Jim Warren and asked him if I should finish it. He gave the go-ahead and I had an understanding that I would be permitted to do more. Jim liked the job so I wrote a story for **Eerie** and painted a cover to go with it. He said the work was fine. From then on, he printed almost everything I sent him. I was writing my own material, and Jim didn't require approval before I completed the work. Jim was / is a nice guy and always up front with me.

S: You did a lot for Warren – all three magazines, **Creepy**, **Eerie** and **Vampirella**.

B: I did as much as I could accommodate along with my other work.

S: How about Atlas and Skywald?

B: Sol Brodsky of Skywald called and said he had a cover and a title, could I write and draw a story to fit it? I said I'd give it a turn. He sent a copy of the cover and the title which was The Vow. It turned out pretty well, I thought.

S: The Vow issue of **Psycho** (Skywald) is a particularly strong issue. It had a Jeff Jones story, The Vow, a Segrelles cover and the back cover by Bill Everett. In the mid 70's you did some work for Atlas.

B: Tarantula which appeared in **Weird Suspense**.

S: Who contacted you to do Tarantula?

B: Jeff Rovin.

S: At Charlton, other than The Peacemaker, horror, and war stories, you did a number of King Features characters: Flash Gordon, Jungle Jim and your probably best known for work on The Phantom.

DRYING BLOOD HAD TURNED THE STREETS THE COLOUR OF DULL RUSSET AND THE NIGHT LIGHT RENDERED TERRIFYING SHADOWS AS HUMAN JACKALS VENTURED FROM THEIR SEWER BURROWS,....

B: I never settled down in an approach to The Phantom. It was inconsistent.

S: It had a good run. Who was writing?

B: I always felt the Phantom was writing them. No, Joe Gill did the scripts.

S: Out of the three, do you have a favorite?

B: My problem is that I'm one of those guys who should not be doing established characters for the simple reason that I don't want to be placed in a position of having to imitate somebody else's art style which you have to do to make Flash Gordon Flash Gordon or Jungle Jim Jungle Jim. Therefore, when I make changes, the characters are not presented in the concept familiar to the average reader, and I have immediately opened myself to all sorts of criticism. I am at fault, certainly not the characters, because they have been established. Shouldn't take liberties, Patrick, but darn if I can resist it!

S: One of the things that Al Williamson found refreshing about your Flash Gordon was that you didn't try to imitate him or Raymond, but just did it your way..

B: Williamson is so positive in his approach and execution that it seems a little foolhearty to try to duplicate his expertise. His work is brilliant.

S: Again – which is your favorite?

B: At the time I was doing them, I enjoyed them all. If I had the opportunity to do them over would I do them differently? Of course!

S: Although you may have taken some criticism at the time on The Phantom, in hindsight people recognize you as a major contributor to The Phantom's history.

B: Thank you.

S: Dick Giordano moved from Charlton to DC and took some guys with him, and you were one of them. You did two excellent issues of **Blackhawk**. How did that come about.

B: When Dick arrived at DC, **Blackhawk** was close to his first assignment. Reed Crandall was to do the book, but it looked like he was going to default. Dick asked if I would do it, and when I agreed, he had Reed send the script to me. I received it very close to the date the completed job was due. It was panic time, with a lot of determination and little sleep, the deadline was met – under a week!

S: Over 20 pages! Did you know the book was to be cancelled in two issues when you took the assignment?

B: Dick said he had thrown up a protest, but that's what we got – two issues.

S: All amazing work despite the deadline!

B: And I still think Darth Vader looks like one of the **Blackhawk** bad guys. After that I started getting anthology scripts, and to tell the truth, I couldn't tell the difference between those and what I had been doing for Charlton. It was enjoyable working for Charlton, under no heavy editorial hands with license to do most anything I wanted – that was what I needed at that time. I always had a stack of scripts in the house, and the pay was very reliable.

S: In the 80's you got involved in publishing.

B: Not so much in publishing - I was interested in color separation. At that stage, I was bored with the regular, flat coloring on most comic book covers. Editor Sal Gentile also wanted a "new look!" So I asked, "what would happen if I put a grey, half-tone wash on the original and then ran process color on top of it?" We tried it on a couple of issues of **The Phantom**. It was interesting, but not all that great. At the time, the cost of straight separation was too expensive However, a group of old friends had put together a pilot magazine called **Cowboy**! It was to be a slick magazine like **Playboy** with a country/western slant. Bill Klise of BK Graphics had just installed a new scanner and pulled the separations on a cover I had painted for that magazine. It was just what we were looking for. Charlton was enthusiastic, so Bill bought a new Stetson, shined his boots and took off for Derby, Connecticut. Following a few rounds of horse-trading, They signed a contract and Charlton was in the painted cover business.

S: In the 90's you worked for Classics Illustrated...

B: Yes, I illustrated **Robinson Caruso, Count of Monte Cristo**, and **Treasure Island**.

S: You were a fan of the great illustrators – Wyeth, Pyle, Booth, Fawcett, etc. Did Wyeth's Illustrations for **Treasure Island** influence you?

B: I was very much aware of the fantastic portrayals painted by Wyeth, but I tried not to let that direct me too much... I wanted to reflect the story as it appeared to me. In any case, it was a fun project

S: Even more recently you did **Marty Stuart in Outer Space** for Marvel's music line and quite a bit of inking for Valiant. Have we forgotten anything?

B: KORG! Korg and his family were Neanderthals from a Hanna-Barbera live-action series. When I adapted it, I punched up the conflicts that may have occurred between Korg and emerging Cro-Magnon. I never tired of that book.

S: Any final thoughts?

B: Well, David – it's been a good run, and through all the ups-and-downs, I never lost sight of my original goal. I'd still like to be rich and famous.

To all the aspiring cartoonists out there with like dreams let me just say; "Dig up those Lucky Bucks! boys," ...COMICS WILL RISE AGAIN!

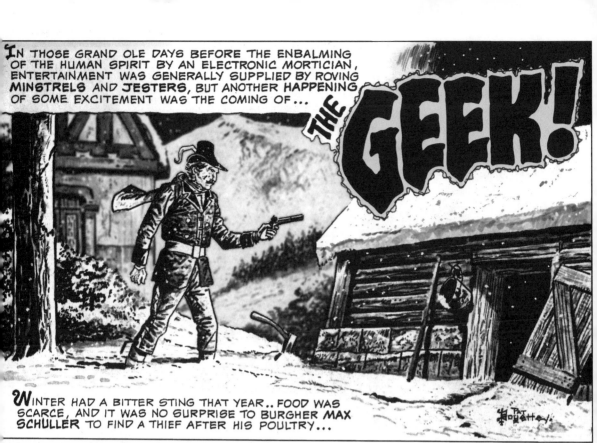

IN THOSE GRAND OLE DAYS BEFORE THE ENBALMING OF THE HUMAN SPIRIT BY AN ELECTRONIC MORTICIAN, ENTERTAINMENT WAS GENERALLY SUPPLIED BY ROVING MINSTRELS AND JESTERS, BUT ANOTHER HAPPENING OF SOME EXCITEMENT WAS THE COMING OF... **THE GEEK!**

WINTER HAD A BITTER STING THAT YEAR.. FOOD WAS SCARCE, AND IT WAS NO SURPRISE TO BURGHER **MAX SCHULLER** TO FIND A THIEF AFTER HIS POULTRY...

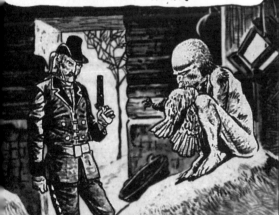

BUT, HE WAS **NOT PREPARED** FOR THE THIEF **HIMSELF!** HERE WAS THE **ODDEST CREATURE** HE HAD EVER SEEN! BLUE FROM THE COLD, THE **WEIRD** INTRUDER WAS EATING A HEN ...RAW!

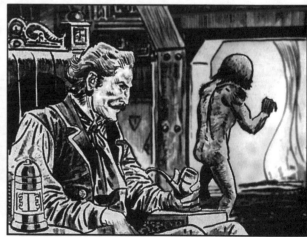

HOWEVER, THERE WAS **NO** HOSTILITY HERE, AND BEING A MAN OF DEEP COMPASSION, BURGHER SCHULLER OPENED HIS COTTAGE TO THE TRAGIC THING WHO WAS AT ONCE TAKEN WITH THE **FIRE**.. APPARENTLY UNFAMILIAR WITH THE BLESSING!

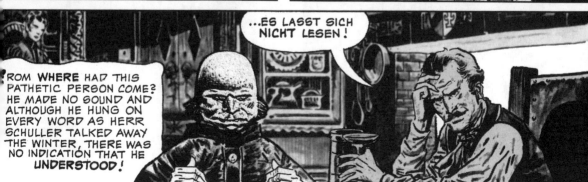

...ES LASST SICH NICHT LESEN!

FROM **WHERE** HAD THIS PATHETIC PERSON COME? HE MADE NO SOUND AND ALTHOUGH HE HUNG ON EVERY WORD AS HERR SCHULLER TALKED AWAY THE WINTER, THERE WAS NO INDICATION THAT HE **UNDERSTOOD!**

THE LITTLE VISITOR WAS AN ENDLESS SOURCE OF AMUSEMENT, AND HERR SCHULLER QUICKLY DEVELOPED A WARM AFFECTION FOR HIM...

..LIKE A CHILD!!

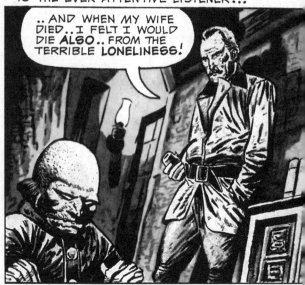

THE BURGHER FOUND IT EASY TO BARE HIS SOUL TO THE EVER ATTENTIVE LISTENER...

..AND WHEN MY WIFE DIED..I FELT I WOULD DIE ALSO..FROM THE TERRIBLE LONELINESS!

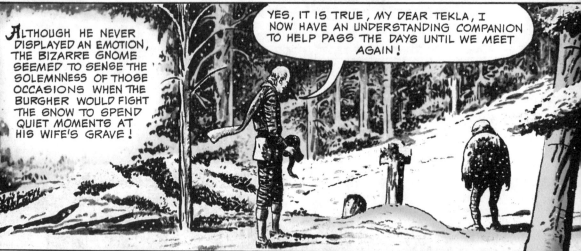

ALTHOUGH HE NEVER DISPLAYED AN EMOTION, THE BIZARRE GNOME SEEMED TO SENSE THE SOLEMNNESS OF THOSE OCCASIONS WHEN THE BURGHER WOULD FIGHT THE SNOW TO SPEND QUIET MOMENTS AT HIS WIFE'S GRAVE!

YES, IT IS TRUE, MY DEAR TEKLA, I NOW HAVE AN UNDERSTANDING COMPANION TO HELP PASS THE DAYS UNTIL WE MEET AGAIN!

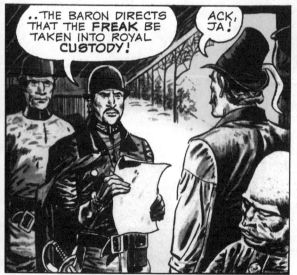

BY THE FIRST THAW, WORD OF THE BURGHER'S UNUSUAL GUEST HAD SPREAD, AND SO IT WAS A MATTER OF SHORT TIME UNTIL THE CAPTAIN OF THE BARON'S GUARD APPEARED!

..THE BARON DIRECTS THAT THE FREAK BE TAKEN INTO ROYAL CUSTODY!

ACK, JA!

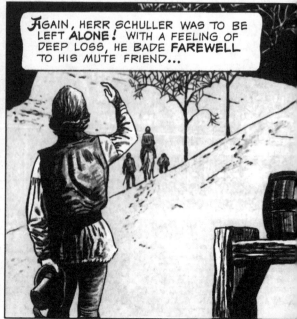

AGAIN, HERR SCHULLER WAS TO BE LEFT ALONE! WITH A FEELING OF DEEP LOSS, HE BADE FAREWELL TO HIS MUTE FRIEND...

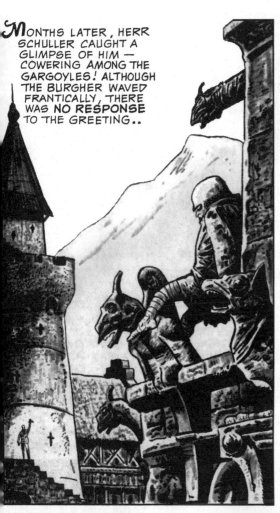

MONTHS LATER, HERR SCHULLER CAUGHT A GLIMPSE OF HIM — COWERING AMONG THE GARGOYLES! ALTHOUGH THE BURGHER WAVED FRANTICALLY, THERE WAS NO RESPONSE TO THE GREETING..

SERVANTS BEING WHAT THEY WERE, ACCOUNTS OF THE CREATURE'S GENERAL FATE WERE COMMON KNOWLEDGE! THE BARON DELIGHTED THE COURT BY FEEDING HIS 'PET' LIZARDS AND SPIDERS OR ANY CRAWLING THING THAT WOULD EFFECT A THRILL!

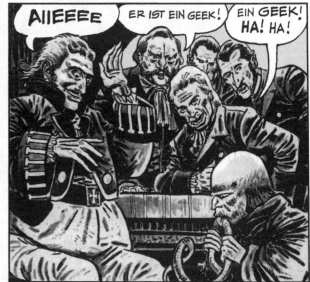

AIIEEEE

ER IST EIN GEEK!

EIN GEEK! HA! HA!

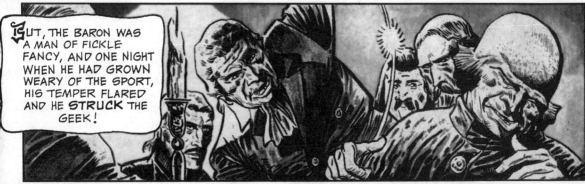

BUT, THE BARON WAS A MAN OF FICKLE FANCY, AND ONE NIGHT WHEN HE HAD GROWN WEARY OF THE SPORT, HIS TEMPER FLARED AND HE STRUCK THE GEEK!

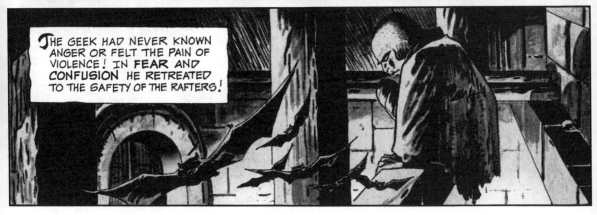

THE GEEK HAD NEVER KNOWN ANGER OR FELT THE PAIN OF VIOLENCE! IN FEAR AND CONFUSION HE RETREATED TO THE SAFETY OF THE RAFTERS!

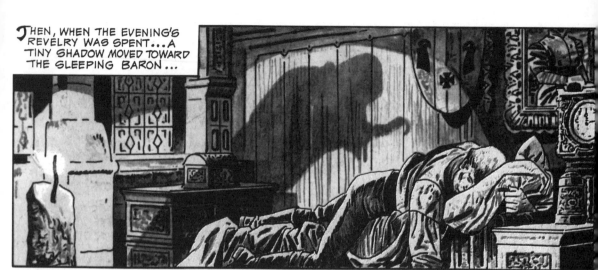

THEN, WHEN THE EVENING'S REVELRY WAS SPENT...A TINY SHADOW MOVED TOWARD THE SLEEPING BARON...

THERE WERE SOME AMONG THE GUESTS WHO VAGUELY RECALLED A SCREAM THAT SEEMED TO DISTURB THEIR STUPOR, BUT..

VOT...?

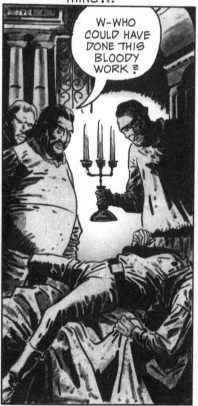

...THERE WAS NONE TO POINT AN ACCUSING FINGER TO THE ONE GUILTY OF THIS HORRIBLE THING...

W-WHO COULD HAVE DONE THIS BLOODY WORK?

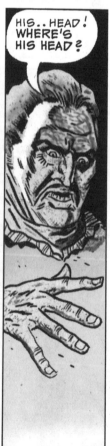

HIS..HEAD! WHERE'S HIS HEAD?

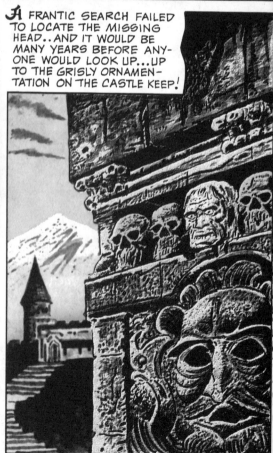

A FRANTIC SEARCH FAILED TO LOCATE THE MISSING HEAD..AND IT WOULD BE MANY YEARS BEFORE ANYONE WOULD LOOK UP...UP TO THE GRISLY ORNAMENTATION ON THE CASTLE KEEP!

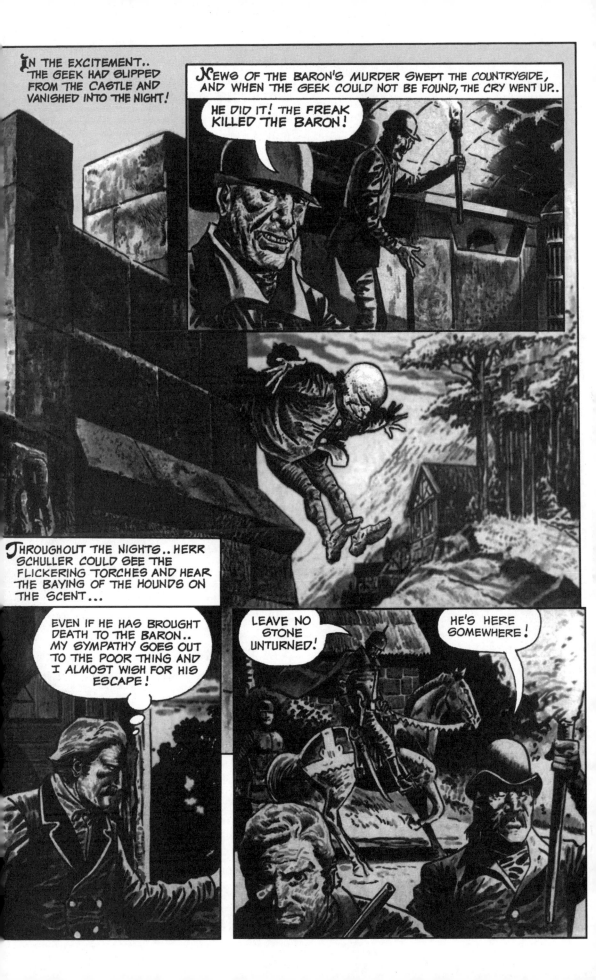

AS THE MANHUNT ENDED A FULL WEEK ...THE BURGHER ENTERTAINED A GROWING BELIEF THAT THE GEEK HAD ELUDED HIS PURSUERS...

AH.. RAIN ..THEY'LL NEVER CATCH HIM NOW... HE'S AWAY!

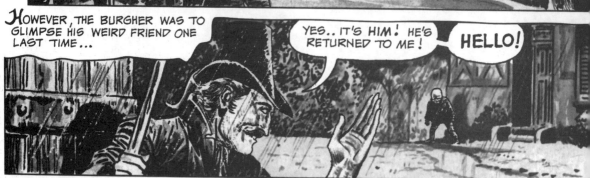

HOWEVER, THE BURGHER WAS TO GLIMPSE HIS WEIRD FRIEND ONE LAST TIME...

YES.. IT'S HIM! HE'S RETURNED TO ME!

HELLO!

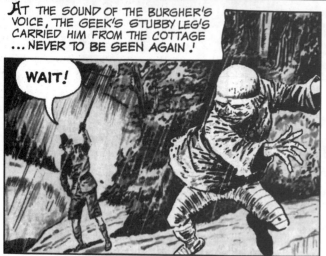

AT THE SOUND OF THE BURGHER'S VOICE, THE GEEK'S STUBBY LEG'S CARRIED HIM FROM THE COTTAGE ...NEVER TO BE SEEN AGAIN.!

WAIT!

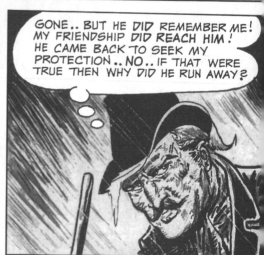

GONE.. BUT HE DID REMEMBER ME! MY FRIENDSHIP DID REACH HIM! HE CAME BACK TO SEEK MY PROTECTION.. NO.. IF THAT WERE TRUE THEN WHY DID HE RUN AWAY?

THEN, AS HERR SCHULLER OPENED THE COTTAGE DOOR..HE SUDDENLY KNEW WHY! THOUGHTS OF THE MANY TIMES HE HAD CONFESSED LONELINESS EXPLODED IN HIS MEMORY..

OH, MY DEAR GOD! THAT MINDLESS THING DID UNDERSTAND! HE'S TRIED TO REPAY MY KINDNESS! HE DIDN'T WANT ME TO BE ALONE ANYMORE SO...

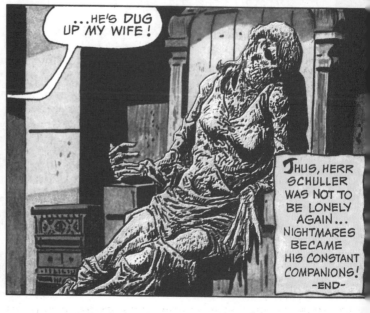

...HE'S DUG UP MY WIFE!

THUS, HERR SCHULLER WAS NOT TO BE LONELY AGAIN... NIGHTMARES BECAME HIS CONSTANT COMPANIONS!
-END-

A FRIGHT-FEST OF FILMS BY PAT BOYETTE
Marty Baumann

Author, producer, director, historian, broadcaster and comic-book artist Pat Boyette fits anyone's definition of a modern Renaissance man. Yet as unpretentious a fellow as you'd ever meet.

Of the cult films he produced – including **The Dungeon of Harrow**, for which he may be best known – he says, "Making those films were the happiest moments of my life. In my mind, what I have always been is a television anchor man," Boyette clarifies. "That's how I spent my life. WOAI was one of the most influential 50,000 watt radio stations in the country. I started off there in my teens, editing the 10 o'clock news. I loved the business so much that I put in 60 and 70 hours a week. At that time, television was still the thing that loomed in the future. That was still Buck Rogers."

Boyette was irrevocably smitten with the infant medium, and nostalgically recalls his introduction to it. "I'll never forget the night I was walking down St. Mary's Street in San Antonio," he begins, voice gliding into a lower register. "It was just at twilight and all the lights were on in the buildings. I passed this oyster bar and there was a strange, flickering, blue light coming out of it. I looked inside and saw a television screen for the first time. I said, 'My God, that is for me.' Within a few weeks, I got my first job in television. I went to work as chief announcer and news director for KENS in San Antonio."

As the medium matured, Boyette demonstrated a tenacious professionalism. "I absolutely cannot stand to start a project that I can't finish," he states, explaining his determination to

Hewitt (**Wizard of Mars**, **The Mighty Gorga**). "It takes place in the Georgia uplands during the hippie invasion," Boyette remembers. "All these hippie motorcycle riders come into the south where they run across these gals who are running stills. It was a pretty good film with Jody McCrea." But once more, Pat found that there was no safeguarding his vision. "Hewitt had a guy who was a pretty good actor," he laughs, "but he thought he was a better ad-libber than he was. He started ad-libbing script nobody had written and it didn't turn out well. Like living room comedians at a party — boy they are funny. But you put them on a stage and say, 'Okay, now be funny,' nothing happens. That's the way it was with this guy."

Though tampering of this nature tried his patience, nothing compared to the financial headaches involved in B movie making. "When you go into making a film, you want it to be the best you can," Pat states. "What you do is take every dollar you've got and put it on the screen. That leaves you with no money to have pre-screenings or publicity — all those things that are so damn vital to successfully marketing a film. By the time you go to a distributor with your product, you're flat broke, you need money and he knows you need money. He can write incredible contracts that favor him so he's in beautiful shape. It's not a pleasant experience. I realized that there was no way that I could beat the marketing. There was no way I could get my money out. That's what discouraged me from making any more films."

master the varied tasks that presented themselves. "Most guys, somewhere along the line, will give up. But I can't do that. I have to finish. That's why I've never missed a deadline on a comic strip. Push, push, push." It wasn't long before Boyette trained this tenacity on the film business, where such qualities would be sorely tested.

"I'd been in love with motion picture-making for a long time," Boyette recalls. "When television came in, suddenly there was a big market for films. I thought, 'This is the thing to do. You can make some schlock and get by with it at this early stage.' Not that you purposely go out to make schlock. But the fact is, with limited resources, that's the best you can hope for."

While the filming of **Dungeon of Harrow** was a happy experience, disillusionment lay just around the corner. Following a war drama called **No Man's Land** (1962), Pat began work on a second thriller called **The Weird Ones**, a film that met with a fate not uncommon to the work of maverick filmmakers. "**The Weird Ones** got taken away from me," Boyette recalls. "It got butchered and practically turned into a porno movie. I won't want to see it because I would be absolutely infuriated."

Soon after, one of Boyette's scripts, **The Girls From Thunder Strip**, was picked up by another renegade filmmaker, David

Likewise, broadcasting had begun to lose its charm. "Television was really wearing on me," Pat sighs. "I'd been in the game a long time and I was getting tired of the discipline it required of me. I was waiting to go on one night. I looked at the monitor and thought, 'I don't have to watch myself grow old.' "

Boyette soon marshaled his most tenacious qualities and focused his talents in a new, artistic direction. "The next day a friend of mine came to my house," he recalls. "I was feeling real low and so was he. He was an account executive at a newspaper and was a pretty damn good artist. I said 'Do you want to draw comic books?' The pair thumbed through a Charlton comic that was lying nearby, and placed a call to their offices. They were assured that Charlton purchased freelance art. The phone call solidified his decision. As quickly as he'd closed the curtain on his previous career, a new door of opportunity opened, and Boyette prepared to master another medium.

A CAVALCADE OF COMICS BY PAT BOYETTE
Checklist Compiled by Don Mangus

THIS IS A PORTRAIT OF HERR MAX VON GRAU — A TRUE IMAGE OF THE KINKY ELITE — THOSE WHO LIVE FREE FROM HUNGER AND STRIFE AND MUST SEEK OUT LITTLE TENSIONS AND ANXIETIES TO SPICE UP THEIR PAMPERED LIFESTYLES! AND, WHAT MORE FERTILE GROUND THAN THE OCCULT AND SUPERNATURAL TO GAIN 'ONE UP' IN THE SPORT OF...

SOCIAL CLIMBING!

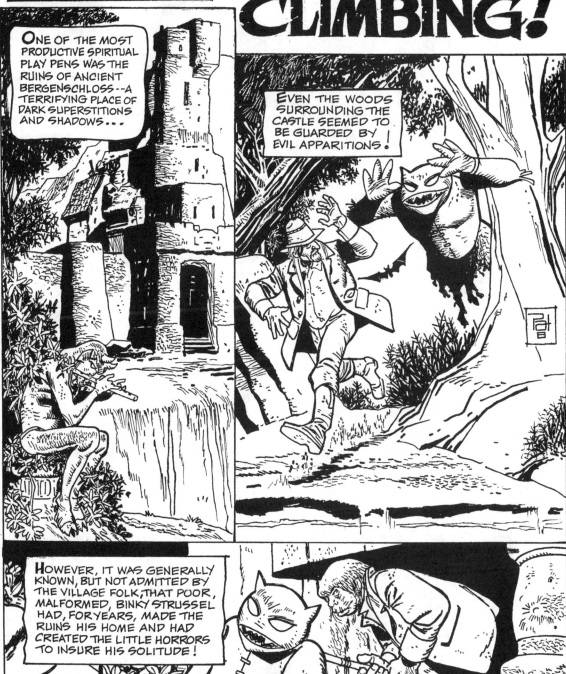

ONE OF THE MOST PRODUCTIVE SPIRITUAL PLAY PENS WAS THE RUINS OF ANCIENT BERGENSCHLOSS — A TERRIFYING PLACE OF DARK SUPERSTITIONS AND SHADOWS...

EVEN THE WOODS SURROUNDING THE CASTLE SEEMED TO BE GUARDED BY EVIL APPARITIONS!

HOWEVER, IT WAS GENERALLY KNOWN, BUT NOT ADMITTED BY THE VILLAGE FOLK, THAT POOR, MALFORMED, BINKY STRUSSEL HAD, FOR YEARS, MADE THE RUINS HIS HOME AND HAD CREATED THE LITTLE HORRORS TO INSURE HIS SOLITUDE!

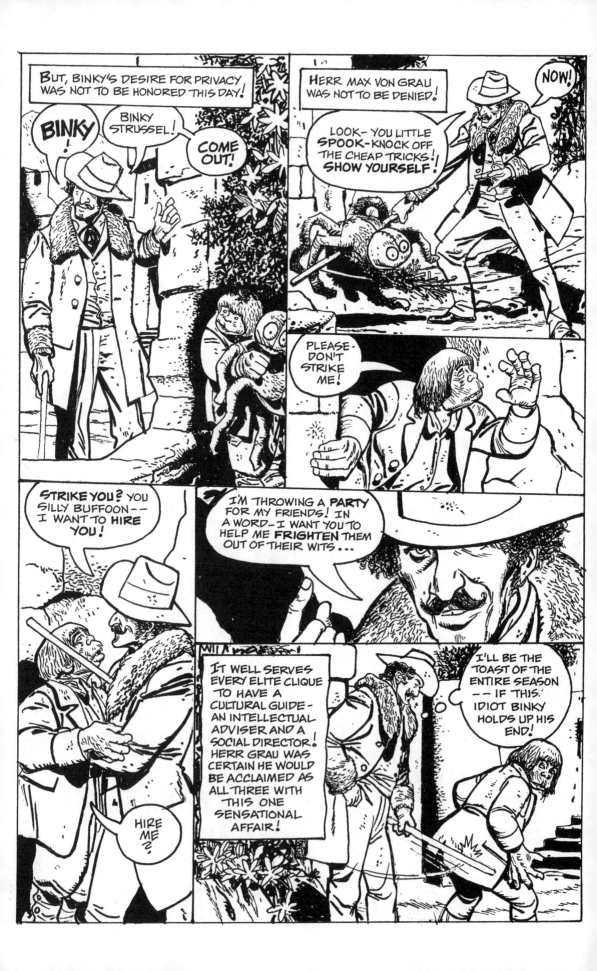

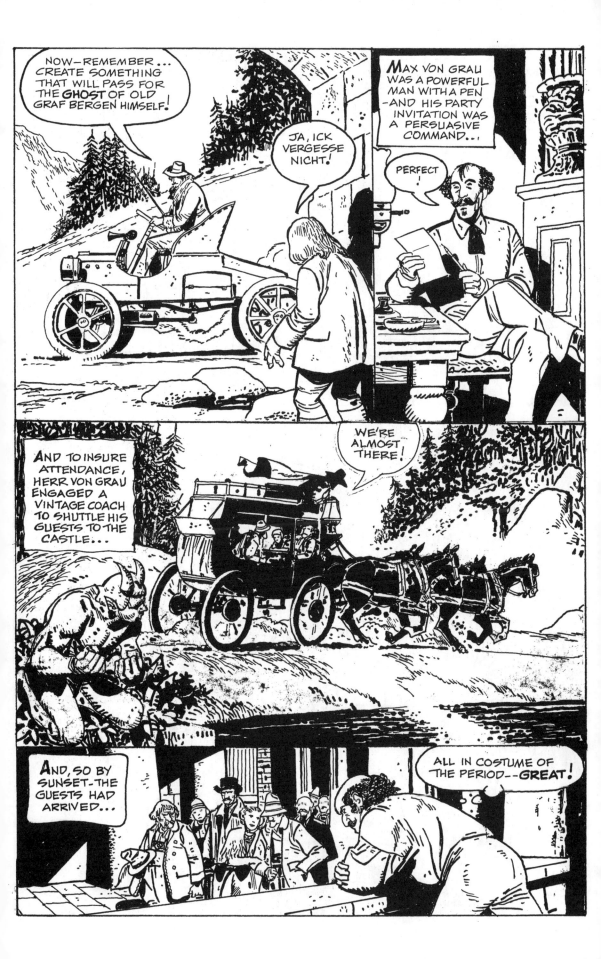

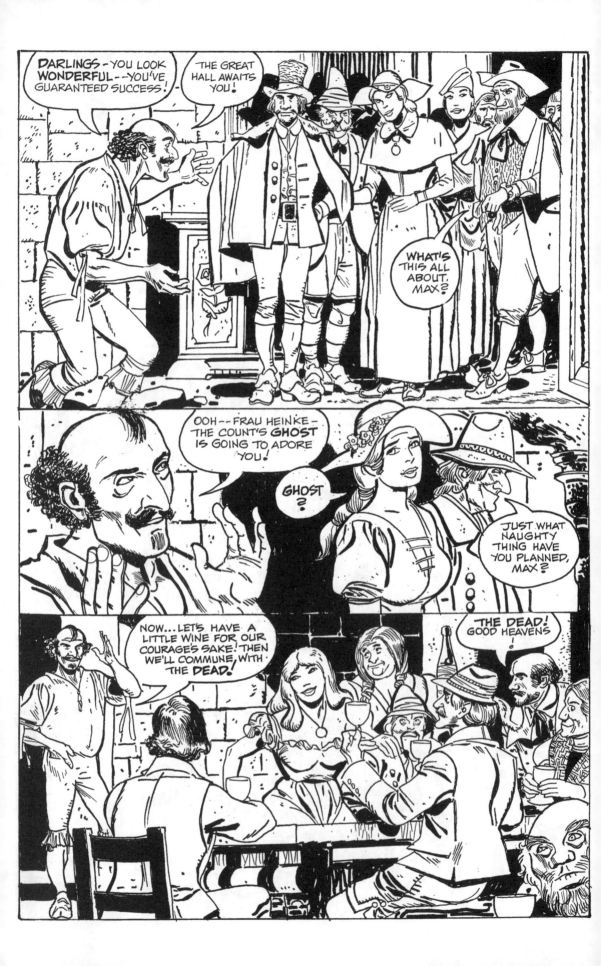

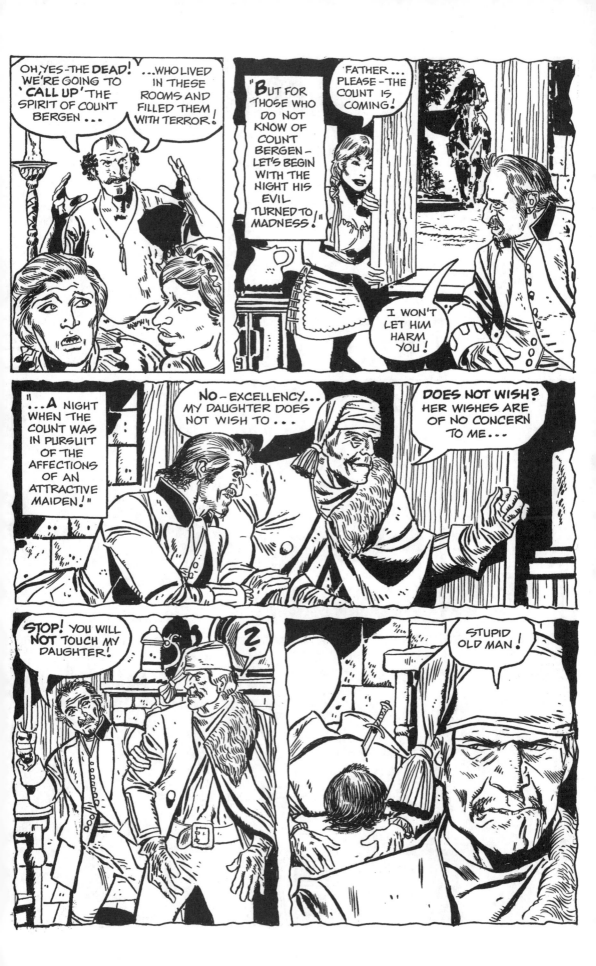

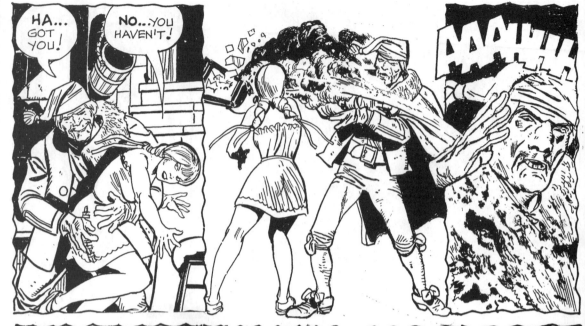

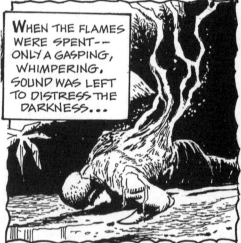

When the flames were spent-- only a gasping, whimpering, sound was left to distress the darkness...

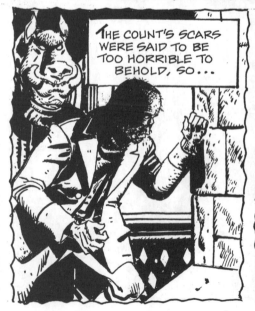

The Count's scars were said to be too horrible to behold, so...

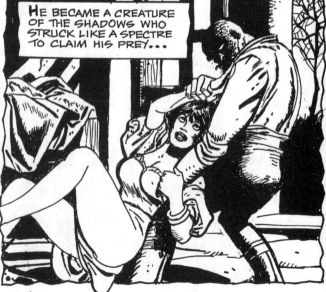

He became a creature of the shadows who struck like a spectre to claim his prey...

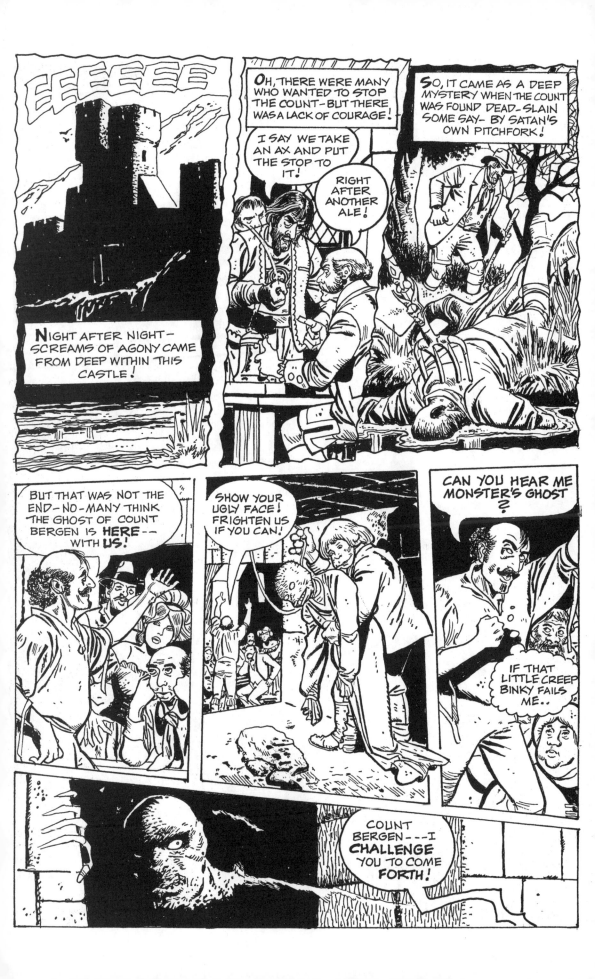

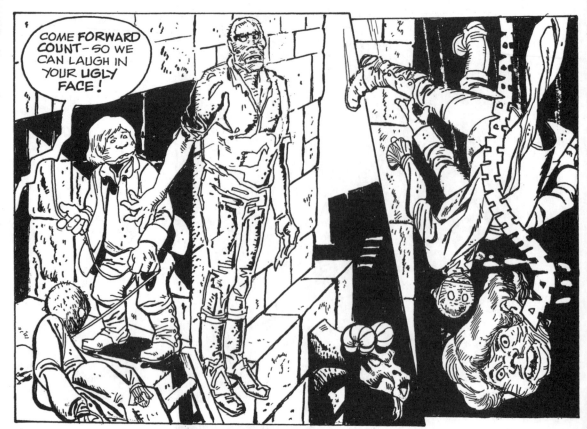

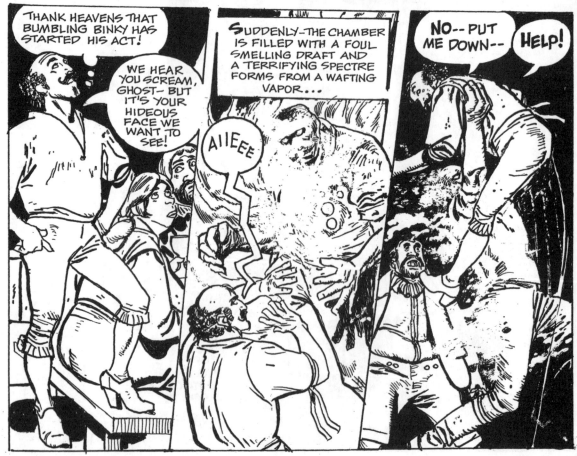

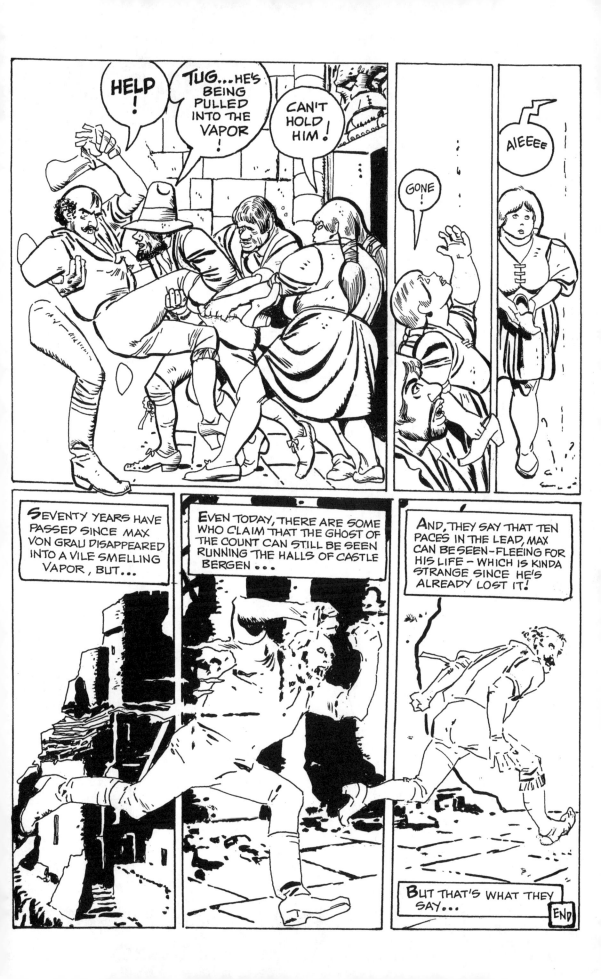

Pat Boyette Portfolio

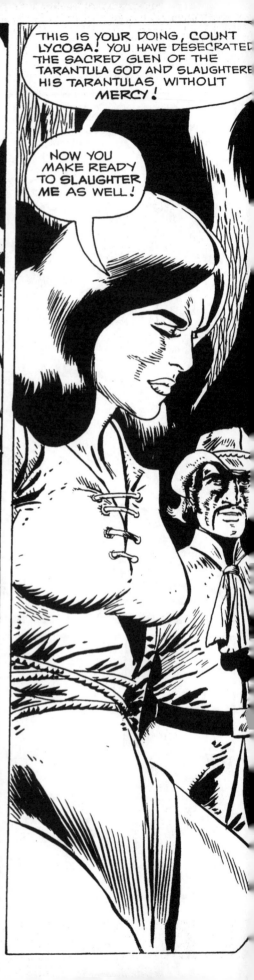

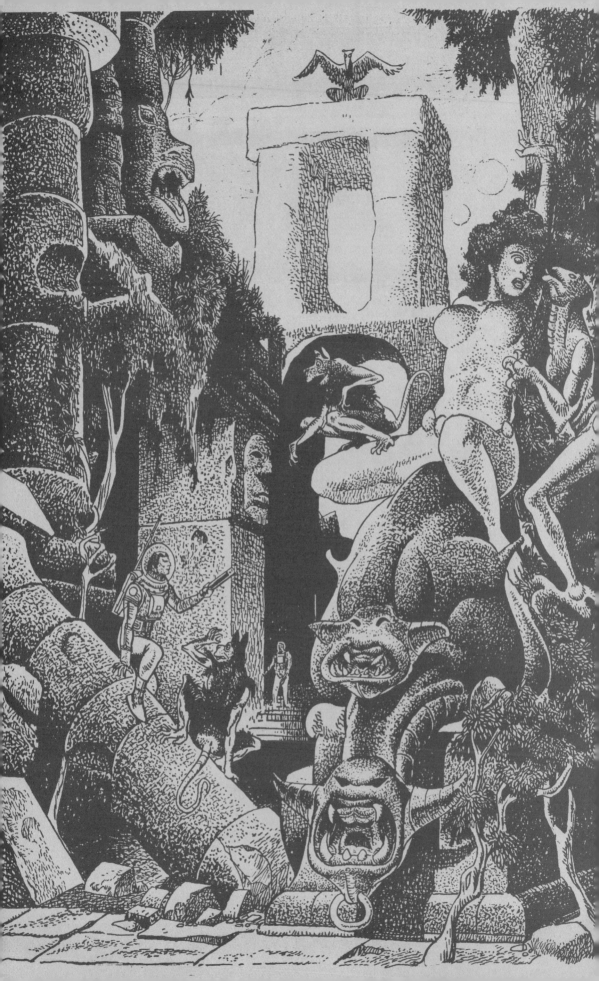

PAT BOYETTE PORTFOLIO

VANGUARD PRODUCTIONS

PAT BOYETTE PORTFOLIO

VANGUARD PRODUCTIONS

THORNTON PEAVY WAS A TRUANT OFFICER, AND HE WAS VERY GOOD AT HIS JOB! THE ONLY PROBLEM WAS— HE WAS A MEMBER OF A...

VANISHING BREED

WELL, WELL!

FE FI FO FUM—I HEAR A TRUANT HAVIN' FUN!

NOW, THE WAR WAS ALWAYS SPIRITED, AND OLD THORNTON WAS A RELENTLESS GLADIATOR!

AND MANY A DELINQUENT YOUTH VENTURED TO TEST HIS JURISDICTIONAL PROWESS!

BUT, MISTER PEAVY, AS HE WAS CALLED BY THE VANQUISH ALWAYS GOT U'

WELL, I CAN'T FEEL A THING!

YOU'RE PULLING MY EAR!

THORNTON HAD A NOSE FOR THE WORK, AND FOR SOME TIME, THE OLD CATTO PLACE HAD FALLEN UNDER HIS SUSPICIOUS EYE!

I JUST KNOW IT—THERE'S A YOUNG'UN IN THAT HOUSE—AND THAT YOUNG'UN AIN'T IN SCHOOL!

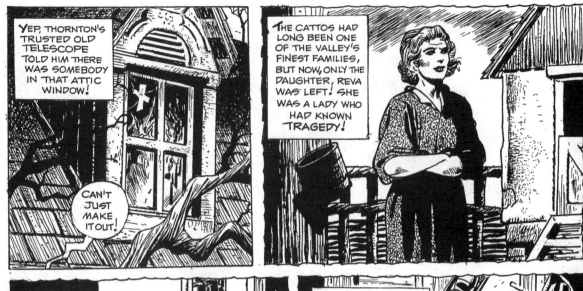

YEP, THORNTON'S TRUSTED OLD TELESCOPE TOLD HIM THERE WAS SOMEBODY IN THAT ATTIC WINDOW!

CAN'T JUST MAKE IT OUT!

THE CATTOS HAD LONG BEEN ONE OF THE VALLEY'S FINEST FAMILIES, BUT NOW, ONLY THE DAUGHTER, REVA WAS LEFT! SHE WAS A LADY WHO HAD KNOWN TRAGEDY!

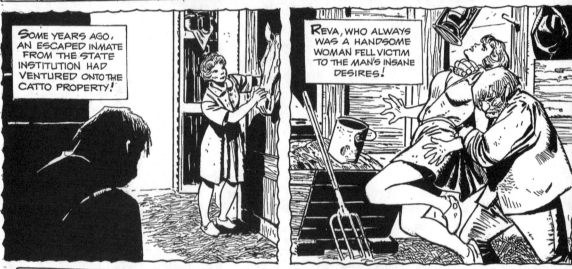

SOME YEARS AGO, AN ESCAPED INMATE FROM THE STATE INSTITUTION HAD VENTURED ONTO THE CATTO PROPERTY!

REVA, WHO ALWAYS WAS A HANDSOME WOMAN FELL VICTIM TO THE MAN'S INSANE DESIRES!

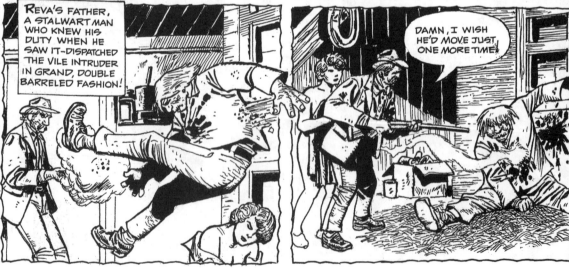

REVA'S FATHER, A STALWART MAN WHO KNEW HIS DUTY WHEN HE SAW IT—DISPATCHED THE VILE INTRUDER IN GRAND, DOUBLE BARRELED FASHION!

DAMN, I WISH HE'D MOVE JUST ONE MORE TIME!

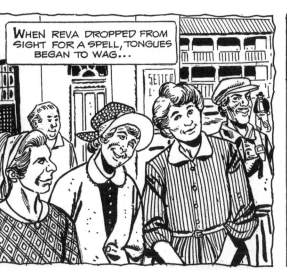

WHEN REVA DROPPED FROM SIGHT FOR A SPELL, TONGUES BEGAN TO WAG...

BUT EVENTUALLY, SHE REAPPEARED AND WAS SEEN FROM TIME TO TIME AROUND THE HOMESTEAD, BUT SHE HAD BECOME A DEDICATED RECLUSE!

MAYBE IT WAS AS THE GOSSIPS HAD SAID, "THERE WAS A CHILD IN THE HOUSE!"

GOT TO BE SURE!

OH, HO!

YEH-YEH-THERE'S A FACE AT THAT WINDOW!

WHO'S THERE? WHAT'S YOUR NAME?

HELLO! TALK TO ME!

COME CLOSER TO THE WINDOW!

I CAN'T SEE YOUR FACE!

ACTUALLY, IT WASN'T MUCH OF A SCHOOL; ONLY ONE ROOM. MR. PEAVY WOULD HAVE BEEN DISAPPOINTED BY THE ATTENDANCE THIS DAY!

ALTHOUGH THE TURNOUT WAS GOOD—THE STUDENTS LEFT AS SOON AS THEIR NEW CLASSMATE HERBIE ARRIVED!

NOT THE TEACHER, OF COURSE, SHE JUST STOOD THERE IN THE CORNER—PETRIFIED!

FOR HERBIE, IT WAS A PERFECT BEGINNING; HIS MOTHER HAD DEVISED A WAY TO LESSEN HIS APPEARANCE PROBLEM—LEAVING HIM UNINTIMIDATED TO RECITE HIS LESSONS!

E=MC²

1812 England

3,674 X 614 = 2255836

HERBIE WAS ACTUALLY HAPPY...HE LOVED SCHOOL, AND HE WAS VERY GOOD AT IT! MAYBE BECAUSE HE FELT SO SAFE...

THE CAPITAL OF TEXAS IS AUSTIN!

TECOU IS IN THE YUCATAN!

AHHH GGGH

...JUST HOLDING MR. PEAVY'S HAND!

BUTTER IS THICKER THAN AIR!

END

IN THOSE HALCYON DAYS, KING JANUS, COULD HAVE BEEN THE ROOT SOURCE OF THE BELIEF THAT FAT MEN ARE JOLLY! CERTAINLY, HIS VERY BEING BEAMED AN AURA OF HAPPINESS!

BUT, THEN, PERHAPS IT WAS BECAUSE HE WAS SO DEEPLY IN LOVE WITH HIS YOUNG QUEEN.

YOU ENRICH ME BEYOND BELIEF!!

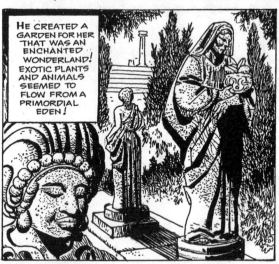

HE CREATED A GARDEN FOR HER THAT WAS AN ENCHANTED WONDERLAND! EXOTIC PLANTS AND ANIMALS SEEMED TO FLOW FROM A PRIMORDIAL EDEN!

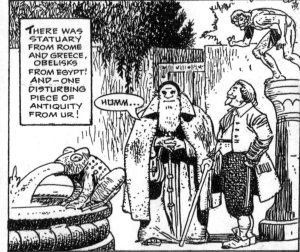

THERE WAS STATUARY FROM ROME AND GREECE, OBELISKS FROM EGYPT! AND — ONE DISTURBING PIECE OF ANTIQUITY FROM UR!

HUMM...

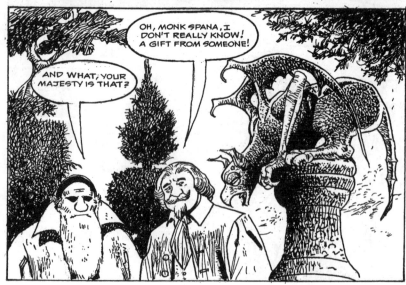

OH, MONK SPANA, I DON'T REALLY KNOW! A GIFT FROM SOMEONE!

AND WHAT, YOUR MAJESTY IS THAT?

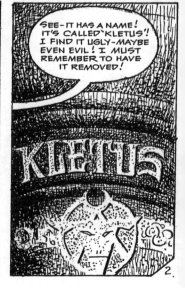

SEE—IT HAS A NAME! IT'S CALLED `KLETUS'! I FIND IT UGLY—MAYBE EVEN EVIL! I MUST REMEMBER TO HAVE IT REMOVED!

KLETUS

2

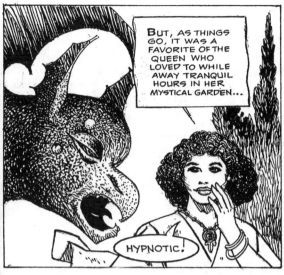

BUT, AS THINGS GO, IT WAS A FAVORITE OF THE QUEEN WHO LOVED TO WHILE AWAY TRANQUIL HOURS IN HER MYSTICAL GARDEN...

HYPNOTIC!

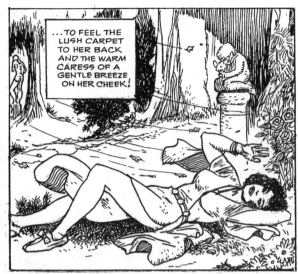

...TO FEEL THE LUSH CARPET TO HER BACK AND THE WARM CARESS OF A GENTLE BREEZE ON HER CHEEK!

THERE WAS ONE MOMENT WHEN THE SERENITY WAS INTERRUPTED BY A STAB OF EXCRUCIATING PAIN AS A COLD DARK SHADOW FELL ACROSS HER LANQUID FORM!

IT LASTED ONLY A SECOND AND IT WAS GONE!

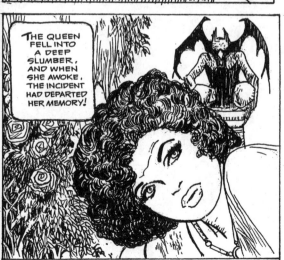

THE QUEEN FELL INTO A DEEP SLUMBER, AND WHEN SHE AWOKE, THE INCIDENT HAD DEPARTED HER MEMORY!

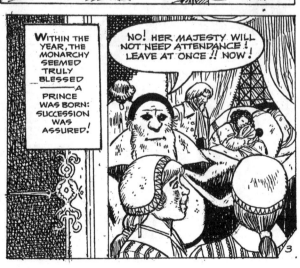

WITHIN THE YEAR, THE MONARCHY SEEMED TRULY BLESSED —A PRINCE WAS BORN: SUCCESSION WAS ASSURED!

NO! HER MAJESTY WILL NOT NEED ATTENDANCE! LEAVE AT ONCE!! NOW!

3

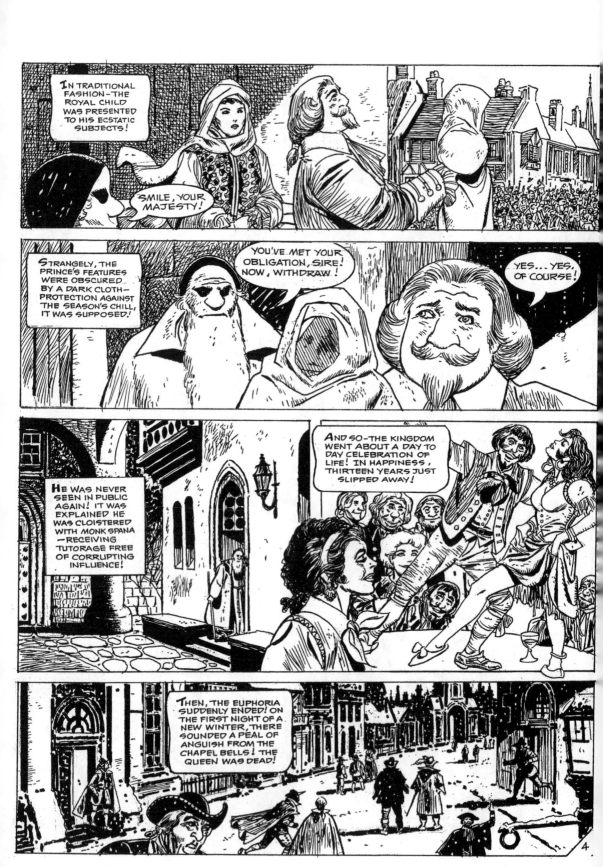

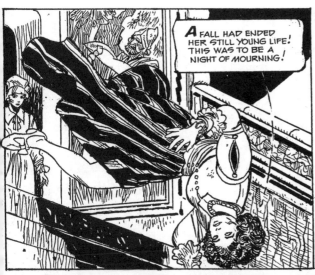

A FALL HAD ENDED HER STILL YOUNG LIFE! THIS WAS TO BE A NIGHT OF MOURNING!

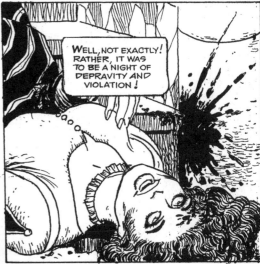

WELL, NOT EXACTLY! RATHER, IT WAS TO BE A NIGHT OF DEPRAVITY AND VIOLATION!

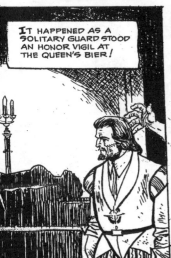

IT HAPPENED AS A SOLITARY GUARD STOOD AN HONOR VIGIL AT THE QUEEN'S BIER!

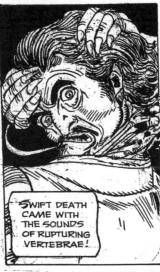

SWIFT DEATH CAME WITH THE SOUNDS OF RUPTURING VERTEBRAE!

THE BODY OF THE QUEEN WAS CHOSEN FOR THE MOST UNHOLY ABUSE!

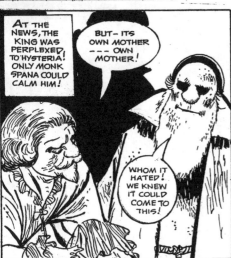

AT THE NEWS, THE KING WAS PERPLEXED, TO HYSTERIA! ONLY MONK SPANA COULD CALM HIM!

BUT— ITS OWN MOTHER ——— OWN MOTHER!

WHOM IT HATED! WE KNEW IT COULD COME TO THIS!

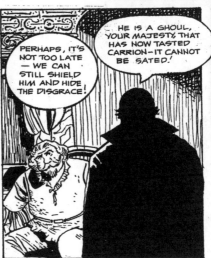

PERHAPS, IT'S NOT TOO LATE — WE CAN STILL SHIELD HIM AND HIDE THE DISGRACE!

HE IS A GHOUL, YOUR MAJESTY, THAT HAS NOW TASTED CARRION—IT CANNOT BE SATED!

AND IT'S LOOSE SOMEWHERE IN THE VILLAGE!

5

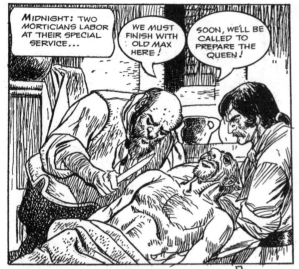

6

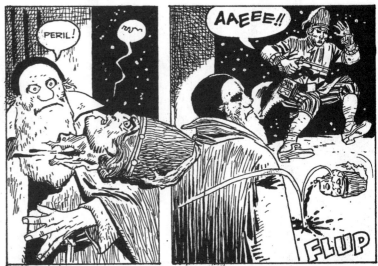

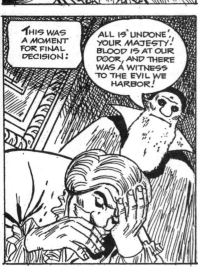

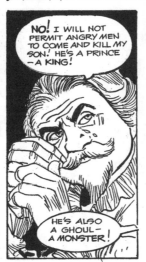

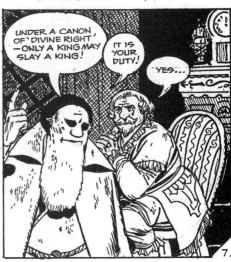

7.

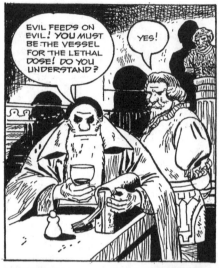

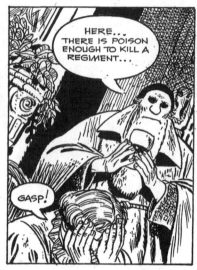

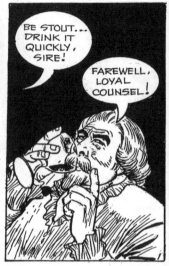

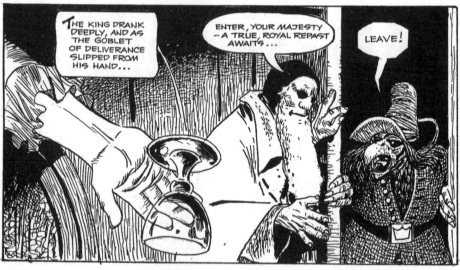

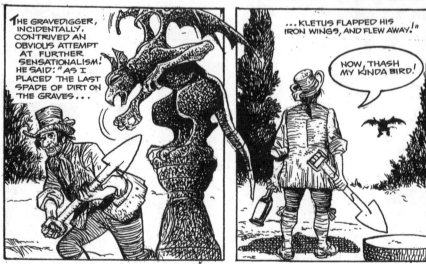

8

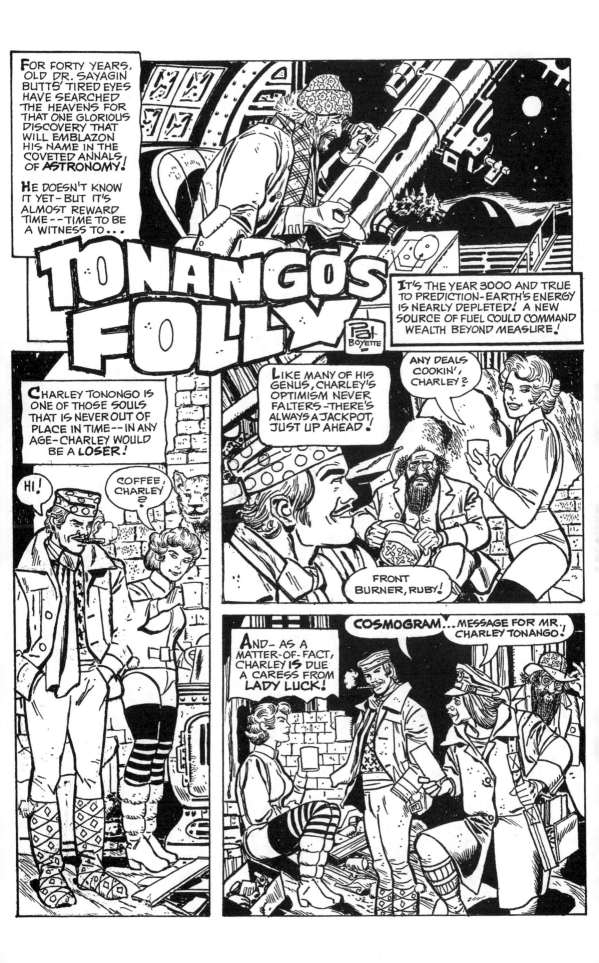

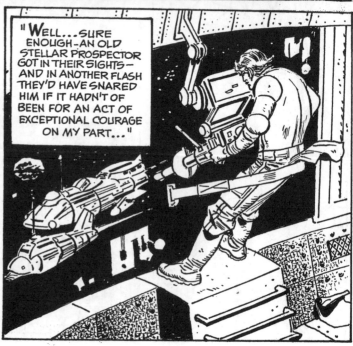

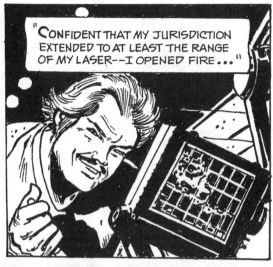

"CONFIDENT THAT MY JURISDICTION EXTENDED TO AT LEAST THE RANGE OF MY LASER--I OPENED FIRE..."

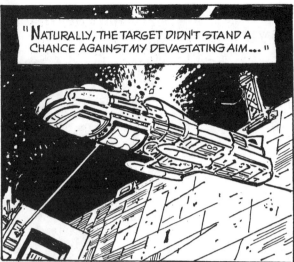

"NATURALLY, THE TARGET DIDN'T STAND A CHANCE AGAINST MY DEVASTATING AIM..."

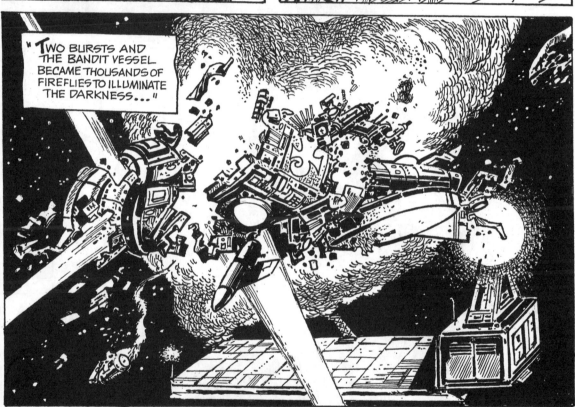

"TWO BURSTS AND THE BANDIT VESSEL BECAME THOUSANDS OF FIREFLIES TO ILLUMINATE THE DARKNESS..."

"THEN I WAS ABLE TO BRING A BRUISED, FRIGHTENED AND GRATEFUL RABBIT INTO TOW..."

DANG, BOY ...YOU SAVED ME!

...FIGHTING NATURE AND CREATURE! BUT, I NEVER DOUBTED THAT AN HONEST COUNT WAS ON THE WAY...

YBOOOOOO

AND **NOW**—IT'S **HERE**! LISTEN: "CONGRATULATIONS ON AN ENERGY FIND TO STAGGER THE IMAGINATION!"

"COME IMMEDIATELY TO INSPECT AND EVALUATE YOUR FORTUNE AND TO HELP WITH EXPLOTATION! PLEASE CONVERT NAVIGATION CODE TO GUIDANCE DISC SO WE CAN MAINTAIN SECURITY. SIGNED—LUCKY."

I JUST DON'T BELIEVE THIS!

"BY MORNING, BROTHER—I'LL HAVE THAT GUIDANCE DISC AND I'M ON MY WAY..."

I MAY COMMISSION A WHOLE FLEET OF THESE CHARTER SHIPS AND TOUR THE ENTIRE UNIVERSE! HOW LONG IS THIS GONNA TAKE?

SHIPS UNDER DISC CONTROL, SIR! NO WAY I CAN TELL!

SO--

SIR! I THINK WE'VE REACHED OUR DESTINATION! THAT'S YOUR PLANET JUST AHEAD!

IT'S SO DARK!

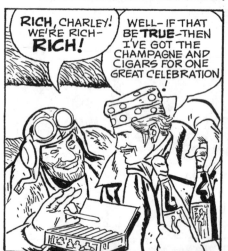

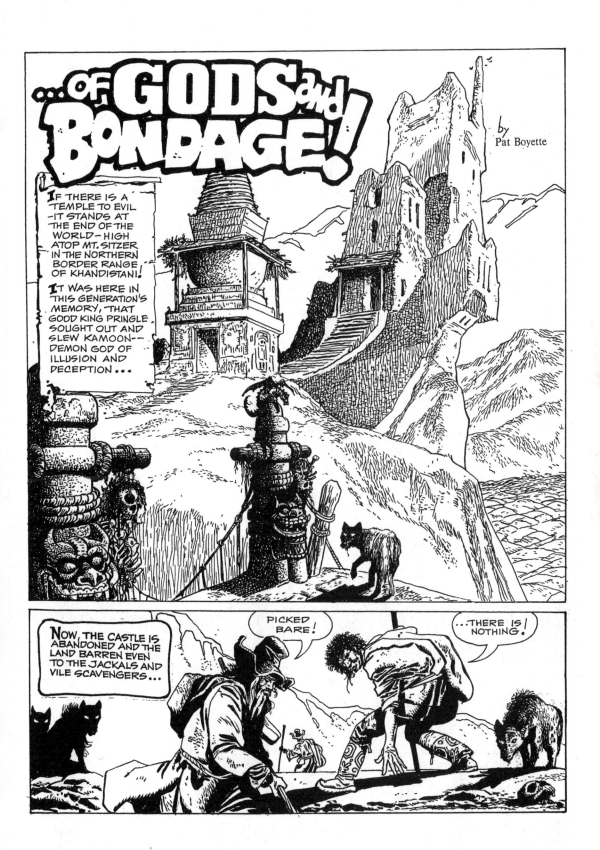

...OF GODS and BONDAGE!

by Pat Boyette

IF THERE IS A TEMPLE TO EVIL —IT STANDS AT THE END OF THE WORLD— HIGH ATOP MT. SITZER IN THE NORTHERN BORDER RANGE OF KHANDISTANI!

IT WAS HERE IN THIS GENERATION'S MEMORY, THAT GOOD KING PRINGLE SOUGHT OUT AND SLEW KAMOON-- DEMON GOD OF ILLUSION AND DECEPTION ...

NOW, THE CASTLE IS ABANDONED AND THE LAND BARREN EVEN TO THE JACKALS AND VILE SCAVENGERS...

PICKED BARE!

...THERE IS NOTHING.

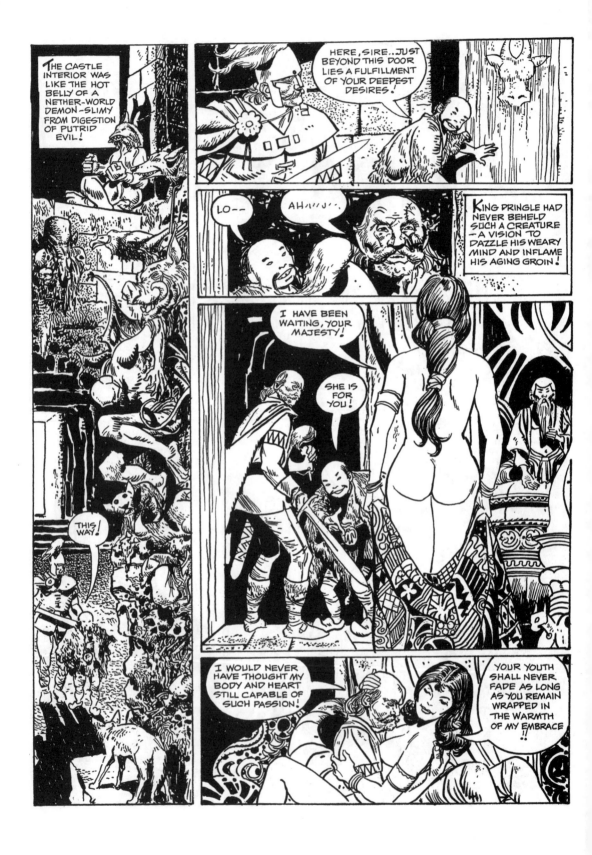

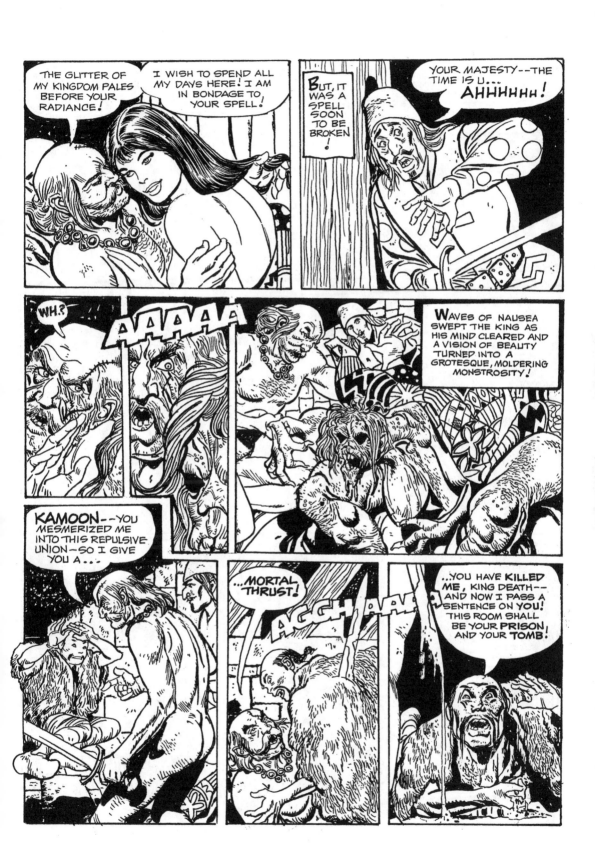

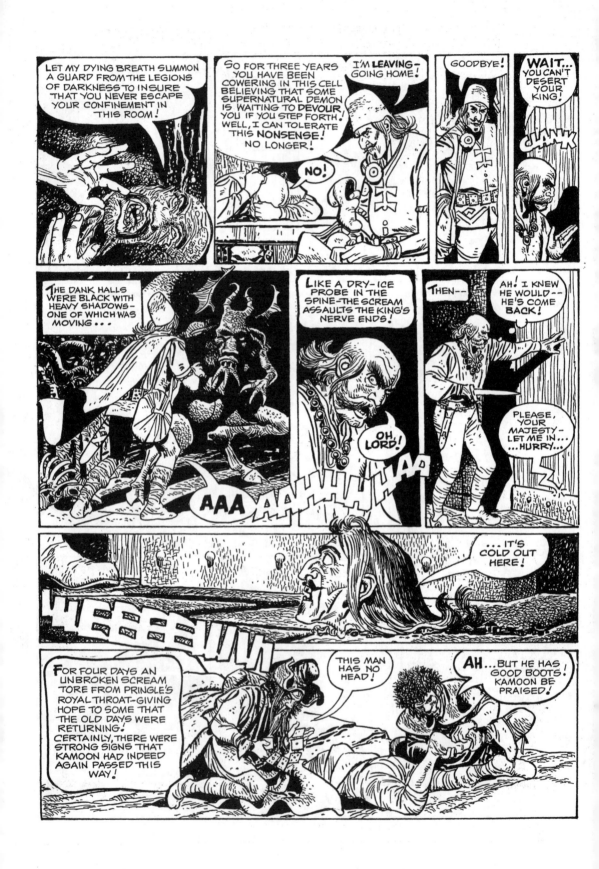

THERE ARE MANY TERRORS THAT LIE JUST BEYOND OUR VISION!

WE WALK WITH BEINGS THE SIGHT OF WHOM WOULD RUPTURE OUR SANITY!

AND, ON PRECEDED OCCASIONS, THERE IS A JUNCTURE WHERE WE'RE JOLTED BY THE HAVOC FOUND IN...

MY NAME IS PYWAKET!

I DON'T KNOW WHAT OR WHERE I AM!

IT'S VERY DARK IN HERE!

BUT, AT TIMES, THE DARKNESS IS ROLLED BACK AND—

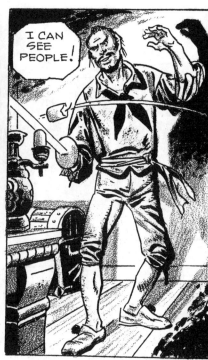

I CAN SEE PEOPLE!

THE WAKE OF A MONSTER!

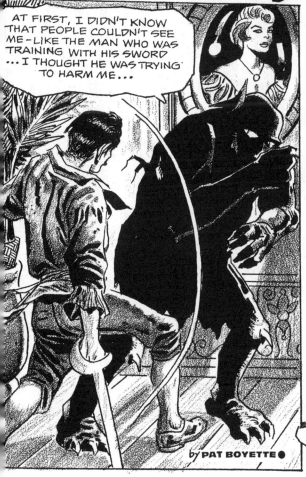

AT FIRST, I DIDN'T KNOW THAT PEOPLE COULDN'T SEE ME—LIKE THE MAN WHO WAS TRAINING WITH HIS SWORD ...I THOUGHT HE WAS TRYING TO HARM ME...

by PAT BOYETTE

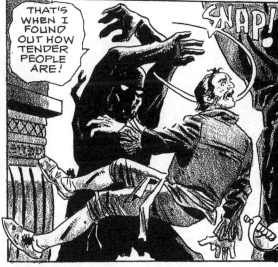

THAT'S WHEN I FOUND OUT HOW TENDER PEOPLE ARE!

SNAP!

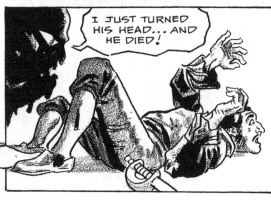

I JUST TURNED HIS HEAD... AND HE DIED!

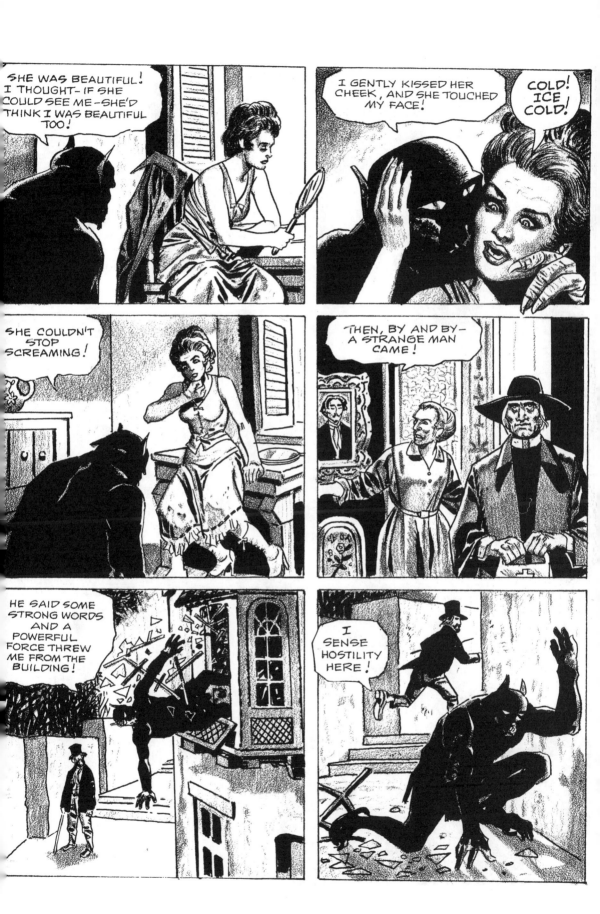

YAHOO!

...IT'S COLOR!

—IT'S A VEIN, JASON—WE'RE RICH!

STINKIN' RICH!

WHEN THE DARKNESS LIFTED ON THE AMERICAN WEST— IT WAS MY CHANCE TO OBSERVE PEOPLE AT THEIR MOST ENTERTAINING!

I'M GONNA BUY ME THAT WHOLE DARN TOWN OF PHOENIX!

WE'LL NEED TOOLS AN' MULES!

I'M RIDIN' T'TOWN TO GET 'EM!

I DON'T THINK SO, JOSH!

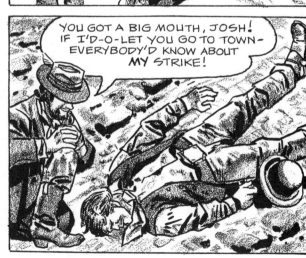

YOU GOT A BIG MOUTH, JOSH! IF I'D-O-LET YOU GO TO TOWN— EVERYBODY'D KNOW ABOUT MY STRIKE!

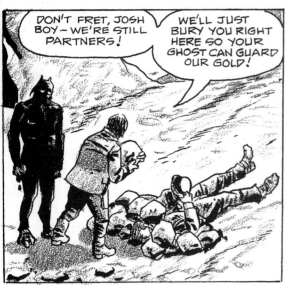

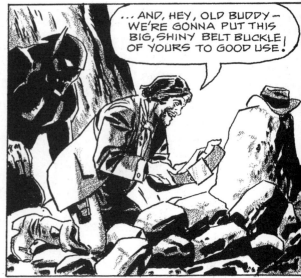

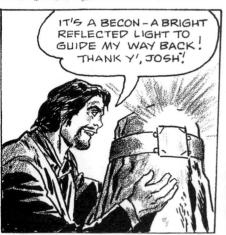

..AND HERE WE HAVE A 17TH CENTURY TAPESTRY THAT DEPICTS THOSE VILE WEAVERS OF GRIEF ...WITCHES!

OH, YES... WITCHES ARE NOT MERELY HANDMAIDENS TO THE PRINCE OF DARKNESS.. THEY ARE POSSESSORS OF VERY REAL AND INDEPENDENT POWERS! AND ONLY THE BLACKEST OF THEIR EVILS COULD HAVE REDUCED THE AGGRESSIVE WARRIOR, TASULA TO THE SIMPERING, WHIMPERING COWARD WE FIND HIM TO BE IN...

THE MALEDICTION

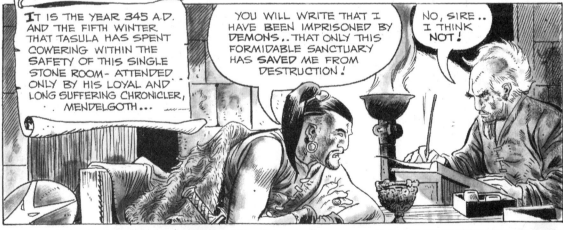

IT IS THE YEAR 345 A.D. AND THE FIFTH WINTER THAT TASULA HAS SPENT COWERING WITHIN THE SAFETY OF THIS SINGLE STONE ROOM- ATTENDED ONLY BY HIS LOYAL AND LONG SUFFERING CHRONICLER, . MENDELGOTH...

YOU WILL WRITE THAT I HAVE BEEN IMPRISONED BY DEMONS.. THAT ONLY THIS FORMIDABLE SANCTUARY HAS SAVED ME FROM DESTRUCTION!

NO, SIRE.. I THINK NOT!

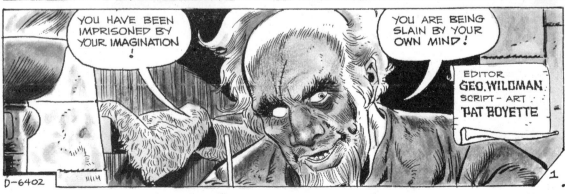

YOU HAVE BEEN IMPRISONED BY YOUR IMAGINATION!

YOU ARE BEING SLAIN BY YOUR OWN MIND!

EDITOR
GEO. WILDMAN
SCRIPT - ART
PAT BOYETTE

D-6402

1

NOW..I BEG YOU... IF **YOU** WILL NOT LEAVE THIS RANCID PLACE..PERMIT **ME** TO DO SO! I AM WEARY AND HAVE NEED TO SEE MY HOME AGAIN...

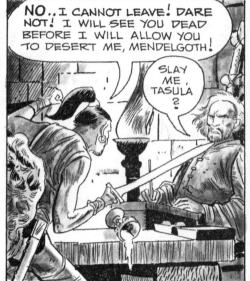

NO..I CANNOT LEAVE! DARE NOT! I WILL SEE YOU DEAD BEFORE I WILL ALLOW YOU TO DESERT ME, MENDELGOTH!

SLAY ME, TASULA ?

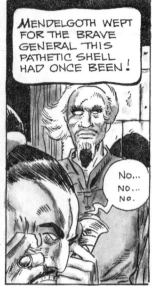

MENDELGOTH WEPT FOR THE BRAVE GENERAL THIS PATHETIC SHELL HAD ONCE BEEN!

NO... NO... NO.

AND HE CURSED THE DAY TASULA HAD LED HIS GALLANT ARMY TO THIS VALLEY OF DIABOLICALISM!

SIRE..TURN BACK...THIS IS BARREN LAND AND THERE ARE FORCES HERE THAT ARE BEYOND YOUR CHALLENGE!

THERE IS NO BULWARK ENVISIONED BY MAN THAT TASULA CANNOT STORM!

2.

THERE IS NO LAW KNOWN TO ME THAT FORBIDS MY ENTERING HERE AND RAISING MY STANDARD OF DOMINION!

NO LAW, SIRE!

BUT I FEEL THERE ARE POWERS WE CANNOT COMPREHEND!

HA.. THEN LET THOSE POWERS COME TO COMPREHEND THE AUTHORITY OF MY AX!

WE... MARCH!

KEEP THE DRUMS BEATING... LET ANY RESISTANCE KNOW THE CADENCE OF THE FEAR I BRING!

BOOMBO

SIRE.. NO ARMY AWAITS US.. ONLY AN OLD WOMAN STANDS AT THE CASTLE GATE!

3.

TASULA'S HEART SANK .. BEFORE HIM STOOD A PILE OF ANCIENT STONES THAT OBVIOUSLY HOUSED NO TREASURE!

THERE WAS NO OPPOSING ARMY TO GIVE HIM THE SPORT OF CONFLICT .. ONLY THIS OLD FROG FACED HAG WHOSE LIFE WAS NOT WORTH THE WETTING OF HIS BLADE!

OH .. DO NOT BE MISLEAD, MIGHTY WARRIOR .. THERE IS THE GREATEST OF TREASURES HERE IF YOU ARE BRAVE ENOUGH TO ACCEPT IT!

HAH ... WITH AN ARMY SUCH AS MINE .. IT DOES NOT REQUIRE MY PERSONAL BRAVERY TO SEIZE YOUR VALUABLES!

NO .. THIS TREASURE IS NOT FOR YOUR ARMY - BUT FOR YOUR OWN PLEASURE .. IF YOU HAVE THE COURAGE TO ENTER MY CASTLE ALONE TO CLAIM IT!

4

TASULA NO!

TASULA-YES! SINCE THERE IS NO WAR TO FIGHT..THEN IT IS SILLY GAMES TIME!

...BESIDES - IF ASSASSINS SHOULD AWAIT ME IN THERE ..THIS OLD CRONE KNOWS YOU WILL BURN HER ALIVE!

IN HALF AMUSEMENT, TASULA FOLLOWED THE OLD WOMAN THROUGH THE MOLDERING HALLS THAT LED TO A HEAVY OAK DOOR...

IN HERE YOU WILL FIND MY TREASURE, WARRIOR!

AND WHAT IS THE NATURE OF THIS REWARD?

ECSTASY! YOU HAVE DISCOVERED WHAT OTHER MEN CAN ONLY DREAM OF.. ENTER, SIRE!

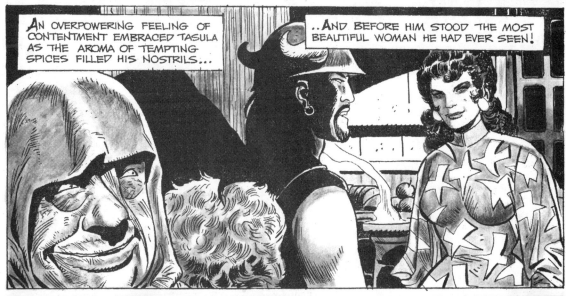

AN OVERPOWERING FEELING OF CONTENTMENT EMBRACED TASULA AS THE AROMA OF TEMPTING SPICES FILLED HIS NOSTRILS...

..AND BEFORE HIM STOOD THE MOST BEAUTIFUL WOMAN HE HAD EVER SEEN!

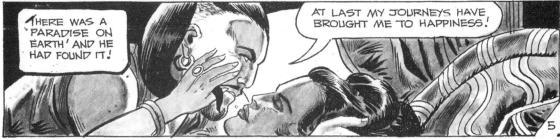

THERE WAS A 'PARADISE ON EARTH' AND HE HAD FOUND IT!

AT LAST MY JOURNEYS HAVE BROUGHT ME TO HAPPINESS!

5.

MENDELGOTH AGONIZED FOR THREE DAYS.. AND WHEN HIS CONCERN BECAME UNBEARABLE... HE MUSTERED HIS COURAGE AND ENTERED THE CASTLE!

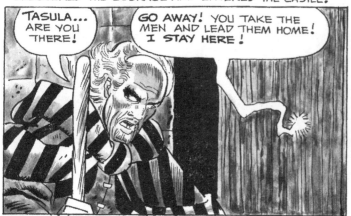

TASULA... ARE YOU THERE!

GO AWAY! YOU TAKE THE MEN AND LEAD THEM HOME! I STAY HERE!

THE DOOR WAS UNBOLTED... CAUTIOUSLY, MENDELGOTH SWUNG IT INWARD...

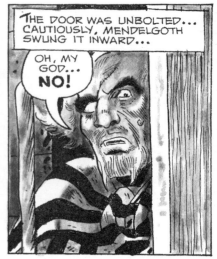

OH, MY GOD... NO!

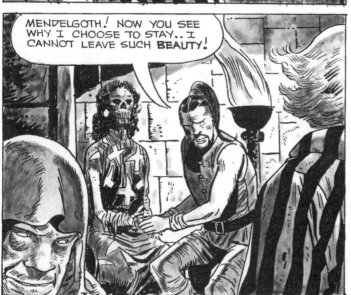

MENDELGOTH! NOW YOU SEE WHY I CHOOSE TO STAY.. I CANNOT LEAVE SUCH BEAUTY!

MENDELGOTH RECOILED IN REVULSION.. THEN IN A DESPERATE BID TO BREAK THE TRANCE.. HE STRUCK VIOLENTLY WITH HIS STAFF...

TASULA REELED FROM THE BLOW.. AND WHEN HIS EYES BEGAN TO CLEAR....

AAHHH.. WHAT HORRIBLE THING HAS THAT WITCH DONE TO ME?

THEN HIS ATTENTION TURNED TO THE OLD WOMAN IN THE DOORWAY! HIS BLADE SPOKE HIS ANGER!

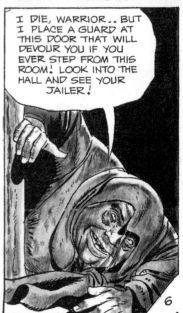

I DIE, WARRIOR.. BUT I PLACE A GUARD AT THIS DOOR THAT WILL DEVOUR YOU IF YOU EVER STEP FROM THIS ROOM! LOOK INTO THE HALL AND SEE YOUR JAILER!

6.

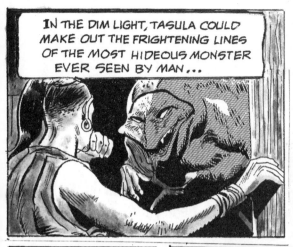

IN THE DIM LIGHT, TASULA COULD MAKE OUT THE FRIGHTENING LINES OF THE MOST HIDEOUS MONSTER EVER SEEN BY MAN...

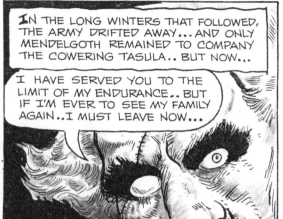

IN THE LONG WINTERS THAT FOLLOWED, THE ARMY DRIFTED AWAY... AND ONLY MENDELGOTH REMAINED TO COMPANY THE COWERING TASULA.. BUT NOW...

I HAVE SERVED YOU TO THE LIMIT OF MY ENDURANCE.. BUT IF I'M EVER TO SEE MY FAMILY AGAIN.. I MUST LEAVE NOW...

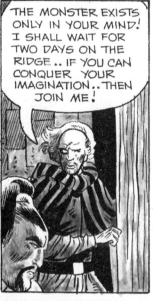

THE MONSTER EXISTS ONLY IN YOUR MIND! I SHALL WAIT FOR TWO DAYS ON THE RIDGE.. IF YOU CAN CONQUER YOUR IMAGINATION.. THEN JOIN ME!

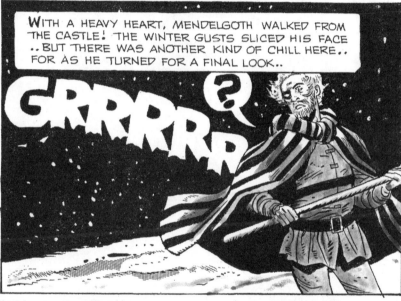

WITH A HEAVY HEART, MENDELGOTH WALKED FROM THE CASTLE! THE WINTER GUSTS SLICED HIS FACE .. BUT THERE WAS ANOTHER KIND OF CHILL HERE.. FOR AS HE TURNED FOR A FINAL LOOK..

GRRRRR?

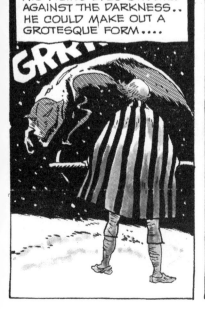

HIS AGING EYES STRAINED AGAINST THE DARKNESS.. HE COULD MAKE OUT A GROTESQUE FORM....

GRRR

THE PAINFUL SCREAMS EVEN PENETRATED THE CASTLE WALLS AND TURNED TASULA'S MARROW TO ICE...

AIEEE

...AND SO HE WAITS.. WAITS FOR THE RAVAGES OF TIME - OR THE NIGHT WHEN THE DESPERATION OF LONELINESS PROMPTS HIM TO STEP FROM HIS SANCTUARY!

the END

7.

AN OLD MAN

EDITOR GEORGE WILDMAN

STORY PAT BOYETTE

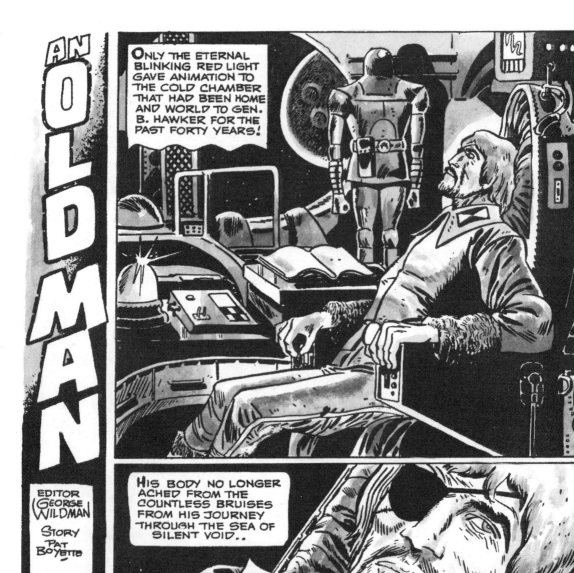

ONLY THE ETERNAL BLINKING RED LIGHT GAVE ANIMATION TO THE COLD CHAMBER THAT HAD BEEN HOME AND WORLD TO GEN. B. HAWKER FOR THE PAST FORTY YEARS!

HIS BODY NO LONGER ACHED FROM THE COUNTLESS BRUISES FROM HIS JOURNEY THROUGH THE SEA OF SILENT VOID..

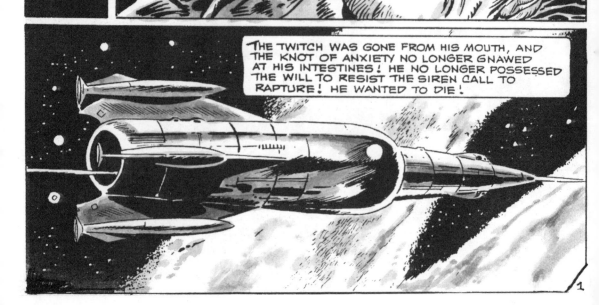

THE TWITCH WAS GONE FROM HIS MOUTH, AND THE KNOT OF ANXIETY NO LONGER GNAWED AT HIS INTESTINES! HE NO LONGER POSSESSED THE WILL TO RESIST THE SIREN CALL TO RAPTURE! HE WANTED TO DIE!

1

HOW PEACEFUL IT ALL WAS.. HE HAD NOT HEARD THE VOICE OF COMPUTER CONTROL IN WEEKS, AND HIS OLD FRIEND, XONY WAS SILENT.. DEAD FROM THE RUST OF RETICULI 4! WHAT A DELIGHT THE ROBOT HAD BEEN...

AND - HARRY THE TIRELESS, INDUSTRIOUS WORKER WHO WOULD NEVER BEND TO OLD AGE - NEVER SURRENDER TO DEATH!

I'VE GOT TO PUT AN "X" ON THE ATMOSPHERE, GENERAL ..I DON'T KNOW IF WE CAN BREATHE IT!

WE'LL FIND OUT WHEN WE GET THERE!

HAWKER KNEW IT WAS ENDING AND HE WAS GLAD.. BUT HE HAD TO ADMIT.. IT WAS ONE `RIP-SNORTIN' AFFAIR.. HE COULD NEVER DENY THE EXCITEMENT OF HIS FIRST GLIMPSE OF AN ALIEN WORLD!

WE ?

OF COURSE! YOU DON'T THINK I'D MISS THIS FIRST EXPLORATION, DO YOU ?

THE SHUTTLE 1 WAS A COMPETENT BUS.. HOW BEAUTIFULLY IT FUNCTIONED...

THINK WHAT IT WILL MEAN IF WE FIND LIFE ON THE FIRST TRY!

THINK WHAT IT WILL MEAN IF WE NEVER FIND IT!

2

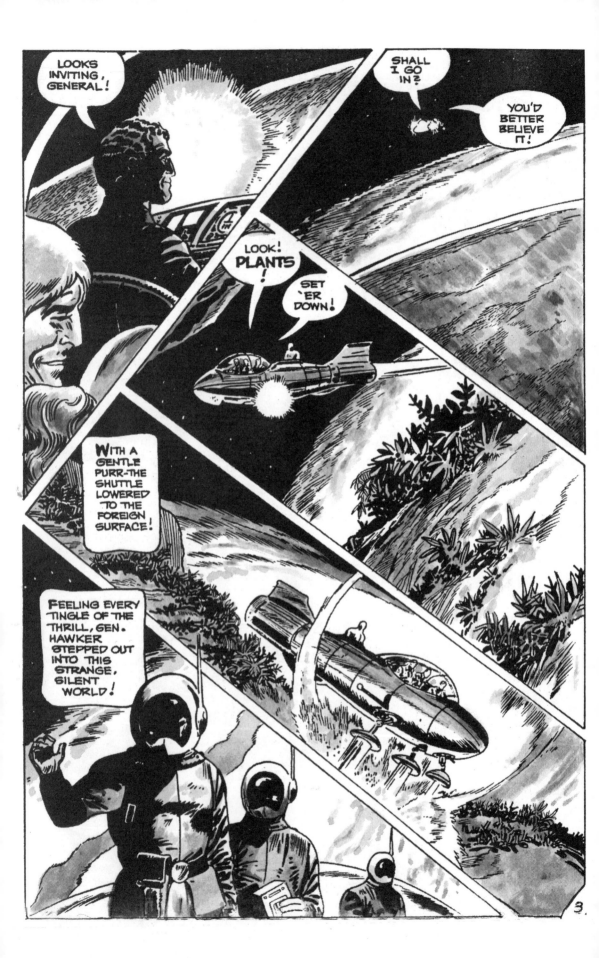

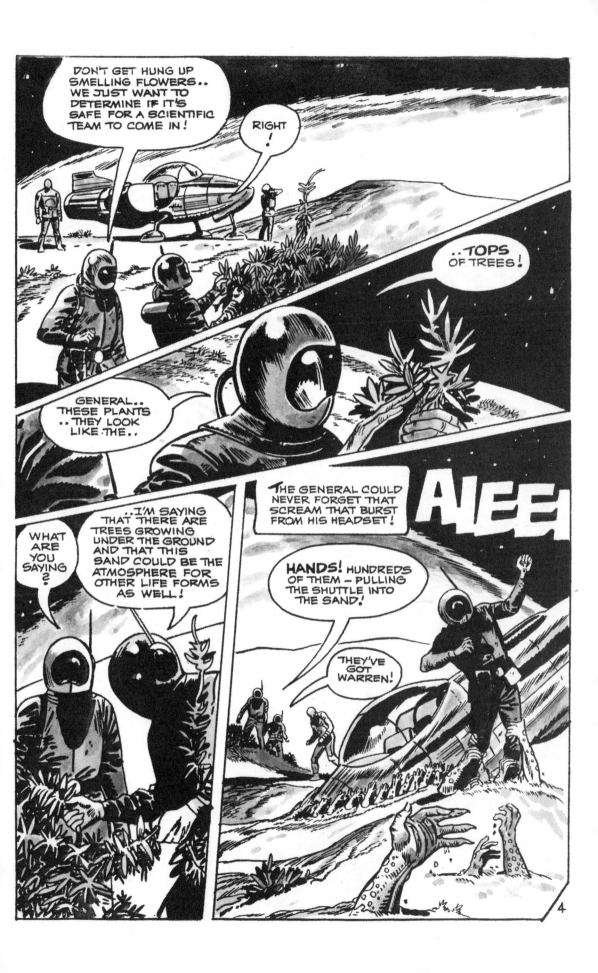

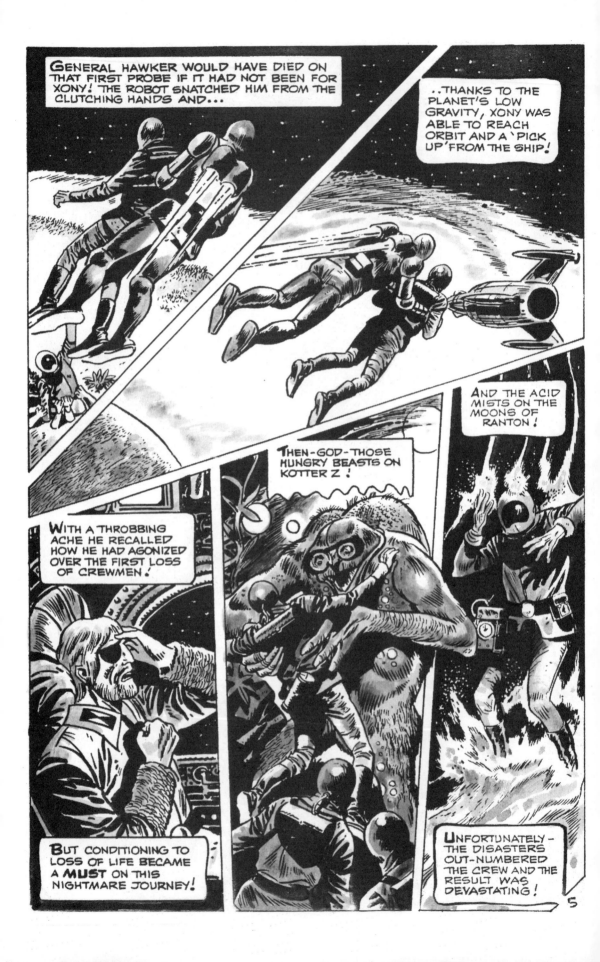

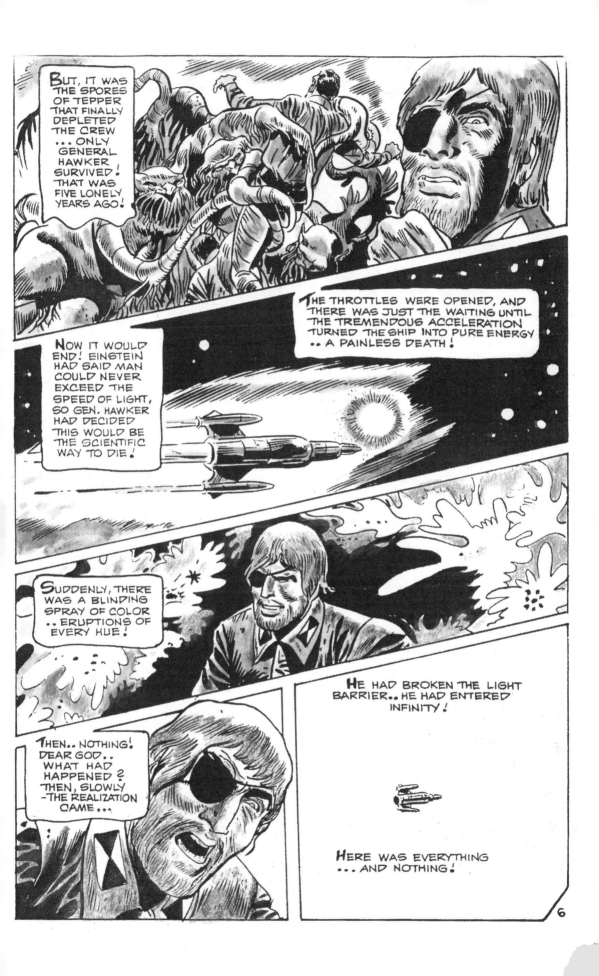

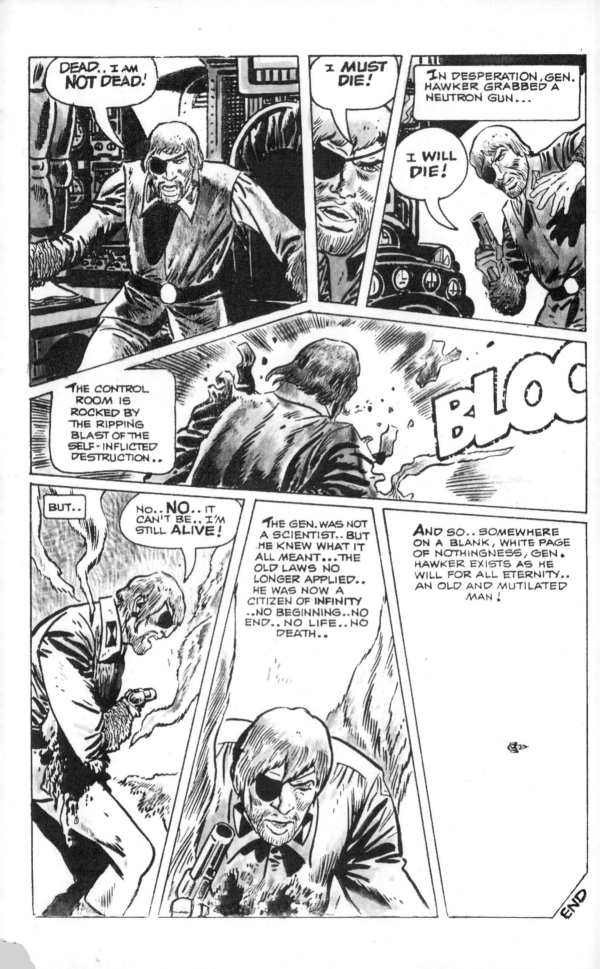

Contents

Getting the most from this guide

This guide is designed to help you to develop your understanding and critical appreciation of the concepts and issues raised in *El laberinto del fauno*, as well as your language skills, fully preparing you for your Paper 2 exam. It will help you when you are studying the film for the first time and also during your revision.

A mix of Spanish and English is used throughout the guide to ensure you learn key vocabulary and structures that you will need for your essay, while also allowing you to develop a deep understanding of the work.

The following features have been used throughout this guide to help build your language skills and focus your understanding of the film:

Activity

A mix of activities is found throughout the book to test your knowledge of the work and to develop your vocabulary and grammar. Longer writing tasks will help prepare you for your exam.

Build critical skills

These offer an opportunity to consider some more challenging questions. They are designed to encourage deeper thinking and analysis to take you beyond what happens in the film in order to explore why the director has used particular techniques, and the effects they have on you. These analytical and critical skills are essential for success in AO4 in the exam.

Answers

Answers to every activity, task, and critical skills question can be found online at **www.hoddereducation.co.uk/mfl-study-guide-answers**

el ahínco heart and soul

For every paragraph in Spanish, key vocabulary is highlighted and translated. Make sure you know these words so you can write an essay with accurate language and a wide range of vocabulary, which is essential to receive the top mark for AO3.

TASK

Short tasks are included throughout the book to test your knowledge of the film. These require short written answers.

GRADE BOOSTER

These top tips advise you on what to do, as well as what not to do, to maximise your chances of success in the examination.

Key quotation

These are highlighted as they may be useful supporting evidence in your essay.

1 Synopsis

El laberinto del fauno is a critically acclaimed fantasy film written and directed by the renowned Mexican filmmaker Guillermo del Toro. It is set in northern Spain in 1944, during the tense and repressive early years of the Franco regime and following the victory of the Nationalists in the Spanish Civil War. The principal cinematic technique of the film is the interweaving of two distinct worlds: one rooted in the harsh environment of the postwar, the other in a mythical world of labyrinths and supernatural beings.

In the opening scene, Princess Moanna of the Underworld has left her supernatural kingdom and, blinded by the sunlight, becomes mortal forgetting who she is and is fatally struck down by illness. Her father, the King, affirms that one day her spirit will return through one of the many portals he built around the world for this purpose. Meanwhile, in postwar Spain, Ofelia, an astute young girl and the main character of the film, is chauffeured with her heavily pregnant mother, Carmen, to a bleak rural mill commandeered by the sadistic Captain Vidal, who is the father of the unborn child and Ofelia's new stepfather. On their way through the forest, the car stops and Ofelia comes across a stone monolith, where a large mantis-like insect appears. Soon after her arrival, the large mantis-like insect appears again and leads Ofelia into an ancient labyrinth, but she is interrupted by Mercedes, the mill's housekeeper. Later that night, the insect reappears in Ofelia's room becoming a fairy and once again takes her to the labyrinth, this time introducing her to a large, grotesquely featured faun. The faun believes Ofelia to be Princess Moanna of the Underworld, and sets her three tasks to be completed before the arrival of the full moon to prove that she still has her immortal essence and her claim to the throne. The faun also gives Ofelia a magical book that will guide her in her endeavours, and explains that the labyrinth is the last portal left for her to return to the Underworld. Meanwhile, in the real world, Captain Vidal gives a brutal insight into his ruthlessness by murdering two suspected rebels, who turn out to be farmers innocently hunting rabbits in the forest.

To fulfil her first task, Ofelia wades fearlessly into the bowels of an ancient tree, home to a huge, slimy toad, and retrieves a key from its belly. As the lines between myth and reality begin to blur, the faun gives Ofelia a mandrake root that successfully soothes her mother's pregnancy pains. For the second task, Ofelia must retrieve a dagger from the ornately decorated lair of the Pale Man, a frightening, child-eating monster, on the proviso that she does not eat any of the food from the banquet laid out on the table in the room. Foolishly, Ofelia eats two grapes, awakening the Pale Man and incurring his wrath. He devours two fairies that accompanied Ofelia and almost catches the girl. Having escaped, Ofelia is reunited with the faun, who is enraged by her actions and refuses to give her the opportunity to complete the third task.

Away from these mythical confrontations, Captain Vidal mercilessly tortures a rebel to elicit strategic information, and then kills Doctor Ferreiro, who, by administering a drug that humanely puts the rebel to death, reveals his own Republican sympathies. On returning to the house, Vidal is repulsed by the sight of the mandrake root and when Carmen feels compelled to throw it on the fire, the root appears to die and its magical properties are nullified. Carmen then dies following a distressing labour in which she gives birth to a boy.

Thinking he has uncovered her spying network and collaboration with the rebels, Captain Vidal prepares to torture Mercedes, but with fearlessness and determination, she manages to evade torture and return to the rebel base, severely injuring Vidal's face with a knife in the process. The faun returns to Ofelia and orders her to take her new baby brother into the labyrinth. Ofelia does so, though Vidal pursues her. The faun orders Ofelia to draw her brother's blood as a sacrificial gesture in order to open the portal, but she refuses to do so. Vidal then seizes the baby and mercilessly shoots Ofelia. He returns to the labyrinth entrance, though as a result of the rapid rebel advance, Vidal is faced with no escape and after giving the baby to Mercedes, Vidal himself is killed.

Mercedes enters the labyrinth and cradles the dying Ofelia in her arms, whose blood trickles downwards to reveal Ofelia in a throne room. Ofelia's father explains that the third task was a test of morals, seeking to discover if Ofelia would choose to spill her own blood over the blood of an innocent. By successfully completing the three tasks, Ofelia is invited by her mother, the Queen of the Underworld, to sit by her father's side once again as a princess. Her father's prophetic statement at the start of the film has been proved true. The viewer is then taken back to the labyrinth, where Ofelia, cradled by Mercedes, dies peacefully, content with her fate.

2 Historical and social context

La guerra civil española

La acción de la película tiene lugar en el año 1944, cinco años después del fin de la guerra civil española que tuvo a España dividida entre el bando fascista liderado por el general Francisco Franco y los republicanos. La guerra civil española duró 2 años y 8 meses concretamente, y comenzó al **fracasar** el **golpe de estado** de parte del ejército contra el gobierno de la segunda república española. La guerra acabó con las vidas de cientos de miles de personas en ambos bandos y empezó una **dictadura** de 36 años que marcaría el país para siempre.

fracasar to fail

el golpe de estado coup d'état

la dictadura dictatorship

el poder power

esconder(se) to hide

los víveres supplies, provisions

el ahínco heart and soul

Con la victoria de Franco y él mismo en el **poder**, los republicanos eligieron, o bien vivir **escondidos** o emigrar a otros países, o bien llevar una doble vida negando sus ideales políticos. En la película vemos a un grupo de republicanos que vive en las montañas, en los Pirineos de la región de Aragón, en el norte de España. Su situación es crítica, ya que estos guerrilleros están faltos de comida y **víveres** en general, como medicinas y agua. Muchos de ellos están enfermos, pero la mayoría creen en sus ideales y se enfrentan al ejército con **ahínco**.

The Civil War (1936–39) created deep ideological divisions across Spanish society. It is generally portrayed as a struggle between democracy and fascism, or Republicanism and Nationalism, although on each side a range of political

groups and ideologies were represented, such as anarchists, communists and socialists on the Republican side, and Falangists (followers of the Falange fascist movement in Spain), monarchists and Catholics on the Nationalist side. It was a time of fervent political debate, of increased political consciousness among the people, and a sense among many that they had a real hand in shaping the society of the future. The rest of the world watched eagerly as Spain was regarded as a potential microcosm of a New World order.

The Republicans received military support primarily from Russia and Mexico, the Nationalists much more extensive support from fascist Germany and Italy. The victory of the Nationalists in 1939 led to harsh reprisals against Franco's enemies in the years that followed, including summary executions, forced exile and internment in labour camps. It is this postwar period that is the setting for *El laberinto del fauno*, which depicts the brutal enforcement of the Franco regime amidst the backdrop of pockets of Republican resistance in Northern Spain.

La sociedad española del momento

En 1944 la sociedad española estaba muy dividida, así que el éxito del **bando sublevado agudizó** la división entre ricos y pobres, y entre clase alta y clase trabajadora.

En la película se puede observar muy bien cómo los militares son considerados ciudadanos de primera clase, con muchos privilegios sociales y una vida cómoda. Los oficiales de la época, como el capitán Vidal, viven en grandes **caseríos** con personal de limpieza y mantenimiento en la casa, al que generalmente no pagan muy bien. La clase más alta y el **ejército** tuvieron una relación muy estrecha en este momento de la historia en España con la Iglesia, y sus **curas** y **sacerdotes**. En su casa, el capitán Vidal ofrece una opulenta comida a miembros **destacados** de la sociedad local de la zona donde vive para presentar a su mujer, mientras en los pisos más bajos de la casa, las cocineras preparan el menú.

The battle of ideals so evident throughout the war continued in the postwar period. Captain Vidal embodies many of the values of the fascists: anti-communist, pro-Catholic and with a strong belief in a unified Spain. His role is to make sure the last traces of Republican resistance are vanquished, and on numerous occasions he aims to do so with extreme cruelty and ruthlessness.

Near the start of the film, Captain Vidal's pregnant wife, Carmen, arrives via a convoy of expensive, chauffeur-driven cars, and within her new residence, a clear hierarchy is present, with servants, cooks and other workers all pandering to the needs of the Captain, his family and high-ranking officials. Carmen has a doctor who tends to her meticulously, while the Republican fighters who hide in

GRADE *BOOSTER*

When analysing *El laberinto del fauno*, it is important to have a good historical knowledge of Spain during the Civil War and post-Civil-War period. Nevertheless, any reference to historical events in your essay must be relevant to the film and the question you have chosen.

el bando sublevado rebel side (name for the pro-Franco Nationalists in the Civil War)

agudizar to exacerbate

el caserío group of country houses

el ejército army, armed forces

el cura priest, pastor

el sacerdote priest

destacado/a prominent, distinguished

Key quotation

Quiero que mi hijo nazca en una España limpia y nueva. Esta gente parte de una idea equivocada: que somos todos iguales.

(Capitán Vidal)

the mountains are forced to procure medicines and other supplies from those who are sympathetic to their cause, such as the housekeeper Mercedes, who smuggles items out of the Captain's residence.

Many of the characters in the film have strong political convictions, and there is palpable resentment between those with opposing views. Mercedes risks her own life to maintain the covert supply line to the Republican resistance, and her passionate hatred for Vidal and all he represents ultimately manifests itself through physical violence, when she attacks him with a knife. Doctor Ferreiro is murdered for coming to the aid of a tortured Republican loyalist, and this brutally tortured man is himself fiercely loyal to his political beliefs and comrades, doggedly refusing to provide key strategic information to his torturer, Vidal, before finally succumbing as the pain becomes too much to bear.

Los maquis

los maquis the resistance

el guerrillero guerrilla

luchar to fight

refugiarse to take refuge

debilitar to weaken

el enlace link

proporcionar to provide

el ama (f) de llaves housekeeper

Es importante destacar la figura de los **maquis** durante la posguerra española y la dictadura franquista. Los maquis eran **guerrilleros** que **lucharon** en el bando republicano que se quedaron con ganas de luchar por sus ideales y contra la dictadura. Principalmente, se escondieron y **se refugiaron** en las montañas, y desde allí se reunían y planeaban sus siguientes movimientos contra el ejército franquista. Lo más importante para los maquis, además de planear cómo **debilitar** al ejército, era estar cerca de pueblos para tener **enlaces** con familiares o amigos que les **proporcionasen** ayuda, comida e información. En la película está claro que Mercedes, el **ama de llaves** y persona de confianza del capitán Vidal, es la principal espía y ayuda para el grupo de guerrilleros en las montañas, en el que se encuentran su hermano y numerosos amigos.

Build critical skills

1 ¿Qué crees que pasó con la resistencia al régimen de Franco con el transcurso de los años, al consolidarse Franco en el poder?

For much of the film, the viewer, like Vidal and his troops, knows little of the movements of the Republican guerrillas. Clues are left which indicate their presence: a small bottle of antibiotics, a lottery ticket, a wisp of smoke in the sky. As the film progresses, the guerrillas come to the fore, launching an assault to break into the mill and steal supplies with the help of the key provided by Mercedes. In a counter-offensive by Vidal and his troops, one of the guerrillas is captured, interrogated and tortured. Characters such as Mercedes, Pedro and Doctor Ferreiro are depicted in just enough depth to make the viewer greatly sympathise with the Republican cause and their plight. They seem to have moral integrity, heroism and humanity. These characteristics are in stark contrast to the wickedness of Captain Vidal.

El machismo y la misoginia

En esta película se puede observar como tres de los pilares fundamentales de la historia son femeninos: Ofelia, su madre, Carmen, y Mercedes. Por otro lado, el gran personaje masculino, el capitán Vidal, hace uso de su poder para **despreciarlas** y tratarlas como **ciudadanas** de segunda clase.

En 1944, en España la mujer no tenía las posibilidades que tiene hoy en día. Era muy normal que la **burguesía** del momento tuviese en casa sirvientas, cocineras, limpiadoras, amas de llave e incluso niñeras, que en muchos casos, cuidaban a los hijos de la familia más y mejor que sus propias madres.

La miseria de la **posguerra** tuvo un efecto aún más agudo en la mujer que en el hombre. Por ejemplo, hubo un aumento de la prostitución, algo que hizo que la iglesia católica fuera aún más opresiva y moralizante con la mujer, especialmente en su papel de madre y ama de casa.

El franquismo asumió el principio fascista de "niños, hogar, Iglesia", lo que **sumía** a la mujer en un papel únicamente de madre, cuidadora y buena católica, siempre sirviendo al hombre de la casa. En 1942, **se lanzó** la Ley de Reglamentaciones, que obligaba a la mujer a abandonar su trabajo al casarse, y solo aquellas que tuvieran un permiso escrito por su marido para volver al trabajo podrían incorporarse al mundo laboral. Así pues, la madre de Ofelia, viuda y embarazada, comienza una nueva vida con el capitán Vidal, esperando que este también acepte a su hija como propia, algo que nunca ocurrirá.

despreciar to look down on

el/la ciudadano/a citizen

la burguesía the bourgeoisie, middle-classes

la posguerra postwar era

sumir to plunge

lanzar to launch, initiate

Captain Vidal is undoubtedly the main source of *machismo* in the film. For him, a man should be strong, stoic and fearless. He insists his unborn child must be a boy, and his pregnant wife is obliged to make the arduous journey so the child can be born at the father's side. Since a boy, Vidal has known the story that his father, fatally wounded in battle, smashed his watch so his son would know the exact time he died in battle. Not one for sentiment, Vidal himself dismisses this story, but it is clear he carries the symbolism of the gesture with him.

Key quotation

Es solo una mujer.
(Capitán Vidal)

Key quotation

Un hijo debe nacer donde quiera que esté su padre.
(Capitán Vidal)

TASK

Busca información sobre el *Manual de la Sección Femenina* que se escribió durante el régimen de Franco. ¿Qué revela sobre la sociedad de la época?

el franquismo
Francoism

Key quotation

*Perdonen a mi mujer...
no ha visto mucho
mundo, ¿saben?...
Cree que a todos nos
interesan estas cosas.*
(Capitán Vidal)

Key quotation

Es la otra mano, Ofelia.
(Capitán Vidal)

suministrar to supply
proveer to provide

humilde humble
la cola queue

Build critical skills

2 Escucha con atención lo que la guardia civil dice al distribuir el pan a los campesinos en la escena 5, minuto 37–38. ¿Qué crees que quieren conseguir con lo que dicen?

Vidal is also a misogynist; the product of a society profoundly under the influence of **franquismo**. The *Sección Femenina* manual of the 1950s detailed what the regime considered an 'ideal woman' to be, and Vidal's attitude certainly aligns with the views expounded in the manual. He dismisses his wife's comments as worthless and naïve in front of the guests during the banquet, and underestimates the intelligence and resourcefulness of Mercedes, first believing her incapable of stealing provisions for the resistance, and then scoffing at the notion that she may pose any danger under torture. Furthermore, he treats his new stepdaughter, Ofelia, with disdain, even chiding her for offering her left hand when she greets him.

Las cartillas de racionamiento

Desde 1939 y hasta 1952 en España se **suministraban** estas cartillas para **proveer** y también controlar los alimentos que se consumían. Había dos tipos, una para carne y otra para el resto de alimentos. A veces, el pan y la leche se suministraban aparte. A lo largo de la película hay referencias a estas cartillas. Por ejemplo, Vidal y sus hombres hablan de ellas en la cena con el resto de invitados y el cura menciona que si son cuidadosos, les durarán tiempo, sabiendo que no son nada generosas y solo cubren lo mínimo, incluso para alguna familia numerosa no sería suficiente. Más tarde hay una escena interesante en la que se puede observar a mucha gente de apariencia **humilde** en una **cola** esperando para recibir el pan y su cartilla. La supuesta buena intención superficial de estas cartillas escondía una manera de controlar al pueblo, y de recordarles quién estaba al mando de todo, hasta de lo que comían.

The military were generally in charge of rationing, and they would grant preferential treatment to individuals of high social status, or whose ideology more markedly reflected that of the State. Items were often distributed in such a way as to exacerbate social divisions. Upper classes would have access to more provisions, and lower classes would have to resort to the black market or even hunt wild animals, as witnessed in the scene where the farmer and his son are arrested and murdered while out hunting rabbits.

Key quotation

Serrano: Vamos, vamos, la cartilla en la mano. A la vista.
Guardia civil: Este es el pan de cada día en la España de Franco.

Actividades

1 Empareja estas palabras clave con sus definiciones.

1 la burguesía
2 la cartilla de racionamiento
3 la dictadura
4 el ejército
5 el golpe de estado
6 la guerra civil
7 el franquismo
8 la posguerra

A dictadura de carácter totalitario impuesta por el general Francisco Franco hasta su muerte en 1975

B conflicto que tienen entre sí los habitantes de una nación, frecuentemente por diferencias políticas

C grupo social constituido por personas de la clase media acomodada

D intervención violenta por parte de fuerzas militares o rebeldes, por la que un grupo determinado se apodera del gobierno, desplazando a las autoridades existentes

E periodo inmediato a la terminación de una guerra

F documento en el que se especifican qué productos y qué cantidades se pueden adquirir en el mercado

G conjunto de tropas militares

H régimen político y autoritario que, por la fuerza o violencia, concentra todo el poder en una persona, reprimiendo los derechos humanos y las libertades individuales

2 Completa el texto con las palabras del recuadro. Luego traduce el texto al inglés.

Esta película tiene 1.......... en plena posguerra. Franco y los nacionalistas se alzan con el poder y los que luchaban 2.......... la república (por lo general la clase trabajadora, que a su vez era en su mayoría de ideales 3.......... al régimen) sufren persecución, hambre y una 4.......... de oportunidades. El régimen les considera ciudadanos de 5.......... categoría. Muchos republicanos 6.......... a América, Francia, Inglaterra o Portugal, pero muchos otros son abatidos por el 7.......... .Gran parte del bando ganador, la Iglesia y el ejército 8.......... de beneficios sociales y de una vida más fácil.

ejército	lugar
por	segunda
falta	emigran
disfrutan	opuestos

3 Usa la información de la película y explica cinco maneras en las cuales la sociedad de la posguerra española está dividida.

4 "En el 1944 sucede que todavía hay resistencia… Pensé que era un momento idóneo para hacer una fábula sobre la desobediencia. La desobediencia es totalmente lo contrario del fascismo." (Guillermo del Toro)

Con referencia a la película, ¿de qué manera es la resistencia "desobediente" y cómo imponen la obediencia los fascistas?

5 Según la Sección Femenina, la rama femenina del partido Falange Española que trató de controlar la libertad de la mujer en aquel entonces: "A través de toda la vida, la misión de la mujer es servir."

Comenta el papel de la mujer en la sociedad de la España de la posguerra tal y como se muestra en la película.

El contexto histórico y social

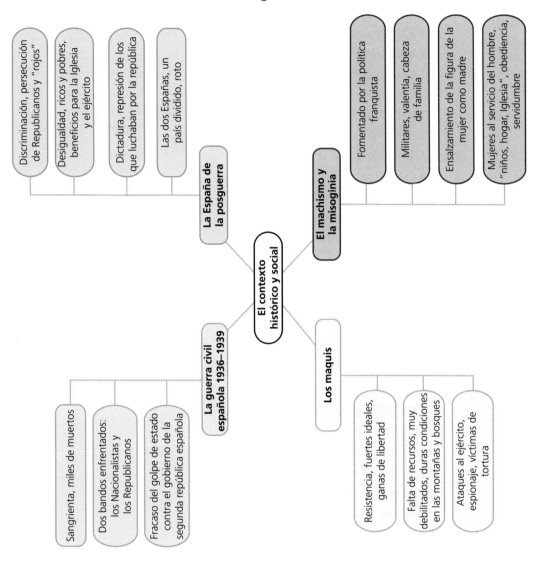

El contexto histórico y social

La España de la posguerra
- Discriminación, persecución de Republicanos y "rojos"
- Desigualdad, ricos y pobres, beneficios para la Iglesia y el ejército
- Dictadura, represión de los que luchaban por la república
- Las dos Españas, un país dividido, roto

El machismo y la misoginia
- Fomentado por la política franquista
- Militares, valentía, cabeza de familia
- Ensalzamiento de la figura de la mujer como madre
- Mujeres al servicio del hombre, "niños, hogar, Iglesia", obediencia, servidumbre

La guerra civil española 1936–1939
- Sangrienta, miles de muertos
- Dos bandos enfrentados: los Nacionalistas y los Republicanos
- Fracaso del golpe de estado contra el gobierno de la segunda república española

Los maquis
- Resistencia, fuertes ideales, ganas de libertad
- Falta de recursos, muy debilitados, duras condiciones en las montañas y bosques
- Ataques al ejército, espionaje, víctimas de tortura

Vocabulario

agudizar to exacerbate

el ahínco heart and soul

el ama (f) de llaves housekeeper

el bando sublevado rebel side (name for the pro-Franco Nationalists in the Civil War)

la burguesía the bourgeoisie, middle-classes

el caserío group of country houses

el/la ciudadano/a citizen

la cola queue

el cura priest, pastor

debilitar to weaken

la desigualdad inequality

despreciar to look down on

destacado/a prominent, distinguished

la dictadura dictatorship

el ejército army, armed forces

el enlace link

el ensalzamiento extolling, praise

esconder to hide

fomentar to promote, to incite

fracasar to fail

el franquismo Francoism

el golpe de estado coup d'état

el guerrillero guerrilla

humilde humble

lanzar to launch, to initiate

luchar to fight

los maquis the resistance

el poder power

la posguerra postwar era

proporcionar to provide

proveer to provide

la rama branch

el sacerdote priest

sangriento/a bloody

la servidumbre servitude
suministrar to supply
sumir to plunge
la valentía courage, bravery
los víveres supplies, provisions

3 Scene summaries

Escena 1
(00:01:00–00:09:38)

sangrar to bleed

La primera escena da comienzo a la película de una manera inusual, mostrando parte del final. No muchos espectadores se darán cuenta de que la niña que yace en el suelo **sangrando** es Ofelia, la protagonista principal. Luego se ven imágenes de una niña corriendo por una ciudad de piedra, en un mundo subterráneo, hasta desaparecer por una larga escalera mientras una voz masculina nos cuenta algo que suena a cuento de hadas, sobre una princesa y un reino. Tras esta introducción, el espectador conoce a Ofelia y a Carmen, que viajan en coche camino de la casa donde se aloja el capitán Vidal. Carmen está embarazada y no se encuentra muy bien debido al avanzado estado. Al pararse el coche, Ofelia da unos pasos por el bosque que van atravesando, desobedeciendo a su madre, que le dice que no se vaya muy lejos.

el monolito de piedra stone monolith

volador/a flying

Aquí es donde la niña ve por primera vez un **monolito de piedra** de apariencia azteca, que más tarde se unirá al resto de un antiguo laberinto de piedra. Aparece, además, un insecto **volador** un tanto sospechoso, que también reaparecerá más tarde. La madre advierte a la niña que quiere que llame "padre" al capitán Vidal al llegar al molino. Parece que a Vidal le encanta la precisión, porque mientras espera la llegada de Carmen, señala para sí mismo que los coches llegan 15 minutos tarde. Cuando Ofelia le saluda tímidamente con la mano izquierda, Vidal, de una manera muy **grosera**, le reprocha que es la otra mano.

grosero/a rude, coarse

El insecto volador que Ofelia ha visto en el bosque anteriormente reaparece. La niña se distrae con él y lo sigue hasta acabar en un laberinto de piedra. Es en este momento cuando Mercedes, el ama de llaves del **molino**, le advierte que podría perderse y que no debe entrar al laberinto.

el molino mill

Además, el espectador entra en contacto con la meticulosa ofensiva que Vidal planea en contra de la guerrilla que se esconde en el monte. Mientras Mercedes entra en la habitación donde Vidal y sus hombres planean sus ataques a llevar un poco de comida, es capaz de **echar un vistazo** a los mapas que están sobre la mesa, una información que le será muy útil más tarde.

echar un vistazo to take a look

→

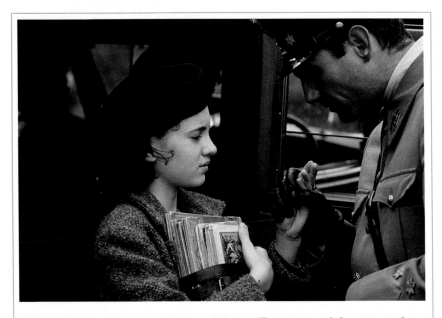

Al final de la escena se puede ver al doctor Ferreiro en el dormitorio de Carmen, a la que le suministra una medicina para que se mejore, ya que su embarazo es complicado y la mujer se encuentra cada vez peor y muy débil. Al salir de la habitación, el doctor mantiene una breve conversación con Mercedes sobre el estado de la pierna de uno de los guerrilleros del monte, mientras le da un pequeño paquete a la mujer. Todo ello ocurre bajo la atenta **mirada** de Ofelia, que justamente va a cerrar la puerta de la habitación, pero ve y escucha toda la conversación. En este momento la niña ya es consciente de las relaciones personales que existen en el molino.

la mirada look, gaze

Activity

1 Empareja cada frase con su terminación correcta según el sentido del texto. ¡Cuidado! Sobran dos terminaciones.

1 Después del largo viaje…	A …tendrá lugar en el monte.
2 El capitán Vidal se queja de…	B …entre en el laberinto.
3 Mercedes no quiere que Ofelia…	C …apoya la causa republicana.
4 El ataque en contra de la guerrilla…	D …Carmen se siente mal.
	E …tiene una herida.
5 Parece que uno de los guerrilleros…	F …un mundo subterráneo.
	G …la llegada tardía de los coches.
6 El doctor Ferreiro…	H …podría perderse.

Escenas 2 y 3

(00:09:38–00:28:04)

nacido/a born

el varón male

TASK
¿Qué piensas que se quiere decir con el término "rojos"?

cazar to hunt

el hada (f) fairy

el/la súbdito/a subject

el charol patent leather
el atuendo outfit

Al volver a la habitación, Ofelia le pregunta a su madre por qué se ha casado otra vez, ya que la niña piensa que su madre no estaba sola porque ella le hacía compañía. En ese momento, Ofelia habla con el vientre de su madre para comunicarse con su hermano aún no **nacido**, y a quien ella espera ansiosa y con ilusión. La niña le cuenta un cuento fantástico sobre una rosa y la inmortalidad, mientras el espectador también se sumerge en primera persona en el cuento.

A continuación, el doctor Ferreiro habla con el capitán Vidal y le dice que Carmen está muy débil. Tras un comentario del capitán, el médico le pregunta cómo sabe que el bebé es un **varón**. Vidal le responde de manera sarcástica, dando a entender su machismo y el hecho de que no querría tener una hija de ninguna manera, ya que solo contempla la opción de tener un hijo, algo que para él es muy importante.

Después, otros miembros de la tropa encuentran a dos granjeros, padre e un hijo, que son acusados de "rojos" por el capitán Vidal. Tras interrogarles sin dejarles que puedan explicarse, Vidal los mata cruelmente, dándose cuenta después de que simplemente estaban **cazando** un conejo para comer, y no eran culpables de nada. En esta escena se puede ver la falta de escrúpulos de Vidal, y su ansia de sangre sin razón.

Ofelia, que duerme en la habitación con su madre, recibe la visita del insecto volador que ha visto antes. Este se convierte en un **hada** para fascinación de la niña. Entonces la criatura fantástica lleva a Ofelia hasta el laberinto de piedra en plena noche, donde conoce por primera vez al fauno. Allí el fauno se presenta como **súbdito** de la niña, a la que llama "alteza" y trata con mucho respeto en todo momento. El fauno le cuenta que ella es, en realidad, la princesa Moanna, y que la pequeña tiene una marca en el hombro izquierdo que confirma su procedencia. El fauno también le explica a Ofelia que tendrá que pasar tres pruebas antes de la luna llena para poder volver a su reino, y le entrega un libro con instrucciones, pero que está en blanco por el momento, ya que en sus páginas no hay nada escrito.

Más tarde, Carmen le enseña a Ofelia el vestido nuevo que le ha hecho ella misma y unos zapatos de **charol**, **atuendo** que la niña llevará en la cena que tendrá lugar después. El vestido es verde y blanco, muy bonito, y llama la atención de las cocineras y sirvientas de la casa. En esta cena, el capitán Vidal presentará en sociedad a madre e hija a miembros importantes de la zona. Mientras Ofelia se prepara para bañarse, abre el

→

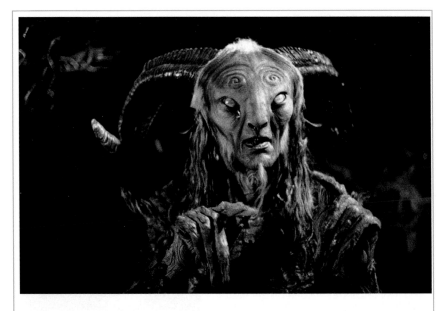

libro que el fauno le dio la noche anterior, y entonces ve cómo comienzan a aparecer unas instrucciones y dibujos en sus páginas. Después del baño, y ya con su vestido nuevo puesto, Mercedes le da a Ofelia un poco de leche mientras la pequeña le cuenta que la noche anterior ha estado en compañía de varias hadas y un fauno. Mercedes, lejos de sorprenderse, reacciona con normalidad. Mercedes y Ofelia empiezan a llevarse cada vez mejor, se entienden muy bien y comparten un **vínculo** especial.

el vínculo bond

Activity

2 Lee el resumen de las escenas 2 y 3. Luego decide si las siguientes frases son verdaderas (V), falsas (F), o no se mencionan (NM).
 1 Ofelia no quería que su madre se casara de nuevo.
 2 Carmen no está en buen estado de salud.
 3 Los granjeros son comunistas.
 4 El fauno se llama "alteza".
 5 En esta escena, Ofelia pasa tres pruebas.
 6 Carmen va a llevar un nuevo vestido para la cena.
 7 En la cena habrá unos invitados muy importantes.
 8 La noche anterior Ofelia y Mercedes conocieron a un fauno.

Escenas 4 y 5
(00:28:04–00:48:33)

el granero barn, grain silo

Tras la conversación entre Mercedes y Ofelia, el capitán Vidal ordena a Mercedes que vaya con él al **granero**. Vidal le pide la única llave que hay, y que tenía Mercedes hasta ese momento, para quedársela él. Allí se guardan muchas provisiones, comida y las cartillas de racionamiento que Vidal tendrá que distribuir entre la población según órdenes de Franco. En este momento el ejército observa un poco de humo que sale de la montaña, lo que hace que la tropa se monte en sus caballos y **se dirija** al **bosque** para intentar capturar a la guerrilla que allí se esconde. Esta es la misión principal de Vidal y su tropa, y la razón por la que están instalados en el molino en mitad de la montaña.

dirigirse to head for
el bosque forest

Al mismo tiempo, Ofelia está caminando sola por el bosque mientras lee el libro del fauno. El libro la dirige hasta un árbol viejo que está muriendo, en cuyo interior vive un **sapo** gigante y malhumorado. La primera prueba que debe superar la niña consiste en introducir tres piedras de ámbar mágicas en la boca del animal, y recuperar así una llave dorada que este **oculta** en su vientre. Al hacer esto, el árbol volvería a florecer. En el interior del árbol, todo está lleno de **barro** y de **bichos**, así que Ofelia se quita su vestido nuevo y lo deja fuera para que no se ensucie. Entonces se adentra en el interior del árbol deseando pasar la prueba, sin miedo.

el sapo toad

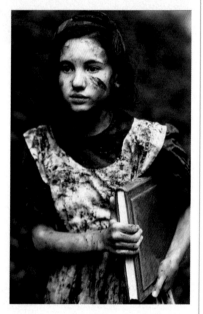

ocultar to hide

el barro mud
el bicho bug, creature

la fogata fire, bonfire

Mientras tanto, Vidal encuentra una **fogata** aún humeante en el bosque, una ampolla de antibiótico y un billete de lotería de los guerrilleros. Entonces Vidal grita **a los cuatro vientos**, en mitad del bosque para que todos le puedan escuchar, que tiene su medicina y su lotería. Mientras Vidal y los suyos se alejan, se puede ver a los guerrilleros observándoles a distancia a través de los árboles, sin ser descubiertos. Esta es la primera vez que el espectador contempla a los guerrilleros y es más **consciente** de su presencia en el bosque.

a los cuatro vientos to the world

consciente aware

→

Al mismo tiempo, Ofelia continúa en el interior del árbol. Después de avanzar entre el barro y las cucarachas, consigue darle al sapo las tres piedras. El animal las vomita y muere, y así Ofelia finalmente encuentra la llave dorada. Al salir, se encuentra su vestido en el suelo, muy sucio y cubierto de barro. Entonces comienza a llover.

Justo en ese instante, llegan los invitados a la cena del capitán Vidal. Una vez sentados a la mesa, Vidal enseña a los **comensales** las cartillas de racionamiento, así como el antibiótico que encontró en el bosque. Esto parece sorprender al doctor Ferreiro, quien permanece callado sentado a la mesa. Vidal explica entonces que él está allí porque quiere capturar a los guerrilleros, quienes, según él, están equivocados al pensar que todas las personas son iguales. Entretanto, Mercedes sale un momento del molino para hacer señales de luz con un **farol** que lleva en la mano. Entonces se encuentra con Ofelia, que regresa a casa, sucia, cubierta de barro y con el vestido de su madre estropeado. La niña se baña y su madre le confiesa, triste, que Ofelia la ha decepcionado. Después, la pequeña vuelve al laberinto para ver al fauno y le muestra la llave dorada. El fauno le dice que Ofelia necesitará la llave muy pronto y también le da una **tiza**.

A la mañana siguiente, mientras los soldados distribuyen las cartillas de racionamiento y pan entre los campesinos, Ofelia abre el libro del fauno para ver las nuevas instrucciones para la segunda prueba. Sin embargo, el libro se llena de sangre cuando su madre, de pronto, **empeora** y empieza a sangrar a causa del embarazo. Vidal le pide al doctor Ferreiro que cure a Carmen cueste lo que cueste.

el/la comensal dinner guest

el farol lamp, light

una tiza a piece of chalk

empeorar to get worse

Activity

3 Lee el resumen de las escenas 4 y 5. Luego decide a quién se refiere cada frase: Ofelia (O), Vidal (V), Ferreiro (F) o Mercedes (M).

1 Recupera la llave que está dentro del sapo.
2 Descubre una ampolla de antibiótico en el bosque.
3 Guardaba la llave del granero.
4 Recibe una tiza.
5 Los guerrilleros le observan a distancia.
6 Ahora tiene la llave del granero.
7 Ensucia su elegante ropa.
8 Da antibiótico a los guerrilleros.

Escenas 6, 7 y 8
(00:48:33–01:15:00)

consolar to comfort
la nana lullaby

la mandrágora mandrake

la cueva cave

el recuadro square
acceder to gain access

proteger to protect

Ofelia tiene que cambiarse a otro dormitorio donde estará ella sola. Allí Mercedes la **consuela** y le canta una **nana** sin letra, con una melodía muy agradable que calma a la niña. Ofelia le dice que ella sabe que ayuda a los rebeldes. Después, Mercedes y el doctor se dirigen al monte para reunirse con los guerrilleros, entre los que se encuentra Pedro, el hermano de Mercedes. En ese momento, el fauno visita a Ofelia en su dormitorio, y la niña le explica que su madre está enferma. El fauno le da una **mandrágora** a la niña para que cure a su madre, y le pide que lleve a cabo su segunda prueba. También advierte a Ofelia del peligro que habrá y que no debe comer o beber nada del banquete que verá.

En el monte, Mercedes les da provisiones a los guerrilleros que se esconden en una **cueva** y donde viven en muy malas condiciones. Allí el doctor cuida de uno de ellos que tiene la pierna en muy mal estado, y decide amputársela, en una escena desagradable y cruel. Ya en el monte, Mercedes les da provisiones a los guerrilleros.

Por otro lado, Ofelia dibuja con la tiza en la pared de su habitación un **recuadro** que se convierte en una puerta, por la que **accede** a un pasillo. Al final del pasillo, la niña observa una gran mesa en la que hay mucha comida y bebida, así como un monstruo sin ojos que permanece sentado e inmóvil. Tras conseguir una daga usando la llave dorada, Ofelia decide comerse unas uvas de la mesa antes de regresar a su habitación. Esto hace que el monstruo despierte y vaya tras ella en una angustiosa persecución. Además, el monstruo mata y se come a dos de las hadas que acompañaban a Ofelia y que intentaban **protegerla** sin demasiado éxito. Al final Ofelia consigue volver a su habitación sana y salva.

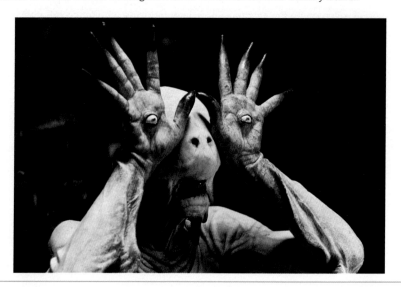

A la mañana siguiente, Mercedes y el doctor vuelven al molino y Mercedes entrega a su hermano una llave que le ayudará a terminar con Vidal. Ofelia visita a su madre y **coloca** la mandrágora con leche y unas **gotas** de su sangre debajo de su cama, como le había indicado el fauno, lo que hace que la mujer mejore. La mandrágora parece tener vida propia y tiene apariencia de bebé. En ese momento, el capitán le comunica al doctor que si hay complicaciones en el parto, debe salvar al bebé y no a la madre. Ofelia entonces vuelve a hablar con su hermano y le pide que no lastime a su madre. Entonces, las tropas franquistas ven a través de los árboles la explosión de un tren que se ha salido de la vía. Vidal se aleja del molino para hablar con los maquinistas del tren accidentado. Entretanto, la guerrilla aprovecha para atacar el molino y robar provisiones de la bodega, gracias a la llave que Mercedes le ha dado a Pedro. Inmediatamente, Vidal y sus hombres se dirigen armados al monte y muchos de ellos son **abatidos** por los guerrilleros, aunque muchos rebeldes también mueren en el violento ataque. Tras el combate, Vidal lleva a un guerrillero herido a la bodega del molino para interrogarlo y obtener así información valiosa.

El doctor, mientras tanto, cuida de Carmen en su dormitorio, y se sorprende de su mejoría. Vidal descubre que su prisionero **es tartamudo** y le **amenaza** con torturarlo si no le da información sobre la ubicación de su grupo.

colocar	to place
la gota	drop
abatido/a	shot down
ser tartamudo/a	to have a stutter
amenazar	to threaten

Activity

4 Lee el resumen de las escenas 6, 7 y 8. Luego contesta a las preguntas.
 1 ¿Qué secreto de Mercedes sabe Ofelia?
 2 ¿Qué hace el fauno para ayudar a la madre de Ofelia?
 3 ¿Qué hace el doctor para salvar a un guerrillero herido en la cueva?
 4 ¿Cómo accede al pasillo Ofelia?
 5 ¿Por qué se despierta el monstruo?
 6 ¿Cómo sabemos que la escena del banquete tiene un final feliz?
 7 ¿Qué cruel orden le da Vidal al doctor?
 8 ¿Por qué la guerrilla puede atacar el molino?
 9 ¿Qué nota el doctor al ver a Carmen en su dormitorio?
 10 ¿Qué tipo de defecto del habla tiene el guerrillero herido?

Escenas 9, 10 y 11
(01:15:00–01:42:00)

regañar to scold, tell off

entristecer to sadden

suministrar to provide, supply

Esa noche, el fauno vuelve a visitar a Ofelia. La niña le cuenta el accidente ocurrido durante su segunda prueba y el fauno se enfada mucho. Se siente traicionado y **regaña** a la niña, lo que **entristece** a Ofelia.

A la mañana siguiente, Vidal llama a Ferreiro para que cure al prisionero tartamudo, muy herido después de sus torturas. El capitán se da cuenta de que los antibióticos que el doctor lleva en su maletín son idénticos a los que encontró en el bosque, y que pertenecían a la guerrilla. El prisionero le pide al doctor que lo mate antes de que lo torturen más, y Ferreiro le **suministra** una inyección letal para que muera sin dolor rápidamente.

Vidal va al dormitorio de Carmen, donde descubre a Ofelia escondida bajo la cama junto a la mandrágora. El capitán siente asco al ver la mandrágora y se enfurece con la niña. Carmen tira la mandrágora a la chimenea mientras le dice a su hija que la magia no existe y que debe de ser más adulta. Mientras la mandrágora grita en el fuego y parece morirse, Carmen cae al suelo sufriendo fuertes dolores en el vientre.

En la bodega, Vidal le pregunta a Ferreiro por qué no le obedeció y prefirió ayudar a morir al prisionero. El médico le contesta que no puede cumplir sus órdenes así, sin pensar, y sale de la bodega. Entonces Vidal le dispara por la espalda y el doctor cae al suelo. Ferreiro muere con dignidad tras haber cuestionado la **fe ciega** en Vidal.

la fe ciega blind faith

fallecer to die, to pass away

dar a luz to give birth

En el dormitorio, el parto de Carmen se complica y la mujer **fallece** mientras **da a luz** a su hijo. Tras el funeral de su madre, Ofelia guarda sus pertenencias en una maleta. Por la noche, Vidal le comenta a Mercedes que el guerrillero tartamudo confesó que una persona dentro del molino pasaba información a la guerrilla, pero Mercedes permanece inexpresiva. Vidal le pide que vaya a la bodega a por más **aguardiente** y le da la única llave que él guarda. También le dice a Mercedes que cuando los guerrilleros entraron en la bodega, el candado no estaba forzado, insinuando que quizás alguien en el molino les ha ayudado. Entonces, Mercedes decide escapar del molino esa noche y va a la habitación de Ofelia para despedirse. La niña le **ruega** que la lleve con ella, a lo que Mercedes accede. Una vez fuera del molino, cuando Mercedes y Ofelia van andando por el río camino de la cueva secreta, Vidal y sus hombres las encuentran y las llevan de vuelta a la casa. Vidal da instrucciones de vigilar a Ofelia y de matarla primero si alguien intenta entrar en la habitación donde la retienen.

el aguardiente liquor

rogar to beg

→

Después, en la bodega, cuando Vidal se dispone a torturar a Mercedes para conseguir información, ella le **apuñala** varias veces con un cuchillo de cocina que lleva escondido y escapar.

apuñalar to stab

Mercedes entonces corre hacia el monte mientras los hombres de Vidal la persiguen a caballo. Cuando consiguen **rodearla,** aparece la guerrilla con su hermano Pedro a la cabeza. Los rebeldes aniquilan al grupo de franquistas y salvan a Mercedes.

rodear to surround

Mientras, el fauno visita a Ofelia y le dice que ha decidido darle otra oportunidad. Así pues, le pide que recoja a su hermano y lo lleve al laberinto inmediatamente. Ofelia dice que la puerta de su habitación está cerrada, y el fauno le da otra tiza para que la niña pueda dibujar su propia puerta.

En su habitación, Vidal está intentando curarse el corte que Mercedes le ha hecho en la **mejilla** cuando Ofelia entra para coger a su hermanito sin que él se dé cuenta. Sin embargo, Vidal ve una tiza sobre la mesa y sospecha que Ofelia está en la habitación. En ese momento, otro oficial entra a buscar al capitán para que vaya a hablar con Serrano, un **superviviente** del **tiroteo** de la guerrilla. Cuando Vidal sale de la habitación, Ofelia pone unas **gotas** de la medicina que tomaba su madre en su bebida. Al volver Vidal a su habitación, bebe el contenido del vaso. Entonces, descubre a Ofelia con el bebé en sus brazos y saca su pistola con intención de matarla. La niña sale corriendo con su hermano en brazos y se dirige al laberinto de piedra, seguida por el capitán que está mareado a causa de la bebida.

la mejilla cheek

el/la superviviente survivor
el tiroteo gunfire, shooting
la gota drop

Activity

5 Lee el resumen de las escenas 9, 10 y 11. Luego pon las frases en el orden correcto.
 1 El fauno quiere que Ofelia lleve a su hermanito al laberinto.
 2 Mercedes le corta la mejilla a Vidal.
 3 Mercedes y Ofelia huyen del molino.
 4 Vidal asesina al doctor Ferreiro.
 5 Vidal trata de suturar su herida.
 6 El doctor Ferreiro eutanasia al prisionero torturado.

Escena 12
(01:42:00–final)

Una vez que Ofelia llega al centro del laberinto, el fauno le dice que necesita un poco de sangre de su hermano para abrir el portal y regresar así a su reino. Ofelia **se niega** a darle el bebé al fauno, y este se enfada mucho. En ese momento aparece Vidal y el fauno desaparece. Vidal toma al bebé en sus brazos y **dispara** a Ofelia, matándola.

negarse to refuse

disparar to shoot

Cuando Vidal abandona el laberinto, toda la guerrilla, con Pedro y Mercedes a la cabeza, está fuera esperando. Al ver que no tiene **escapatoria**, Vidal le entrega su hijo a Mercedes. Ella le asegura que el bebé nunca sabrá nada de su padre. Entonces, Pedro le dispara y Vidal finalmente muere.

la escapatoria way out

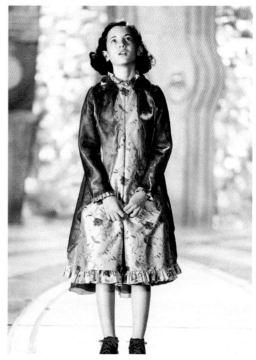

Después, Mercedes y los guerrilleros encuentran a Ofelia, que está muriendo desangrada en el centro del laberinto. La sangre **derramada** de la niña hace que se abra el portal, y así Ofelia se reúne con el fauno, las hadas, su

derramado/a spilt

padre, su madre y su hermano en el reino mágico, donde sus súbditos la reciben con un gran aplauso. Allí, en el salón del trono, su padre le da la bienvenida y le pide que se siente con ellos, mientas que se ve a Ofelia vestida con una ropa diferente, muy colorida, y unos zapatos rojos que contrastan con la **vestimenta** más gris y triste que llevaba en el molino.

la vestimenta clothing

A pesar de la felicidad de Ofelia, se ve a Mercedes llorando al lado del cuerpo sin vida de Ofelia. Esta es la misma imagen que se ve al comienzo de la película, en la que la pequeña yace sangrando en el suelo.

TASK
Describe la apariencia y el comportamiento de las hadas que aparecen en la película con Ofelia y el fauno.

Activity

6 Lee el resumen de la última escena y completa las frases con las palabras del recuadro. ¡Cuidado! Sobran algunas palabras.

1 Para al reino subterráneo, Ofelia necesita un poco de de su hermanito.
2 Vidal de un disparo a Ofelia.
3 Al del laberinto, Vidal está por los guerrilleros.
4 de su muerte, Ofelia puede con todos en el mundo subterráneo.
5 En el mundo , Mercedes la muerte de Ofelia.
6 El final de la película lo que pasó al comienzo.

repite	lamenta	ocurre	después
fantástico	reunirse	mata	sangre
muere	enfrente	volver	
salir	real	rodeado	

Actividades

1 ¿Por qué es inusual el comienzo de la película?

2 Describe el primer encuentro entre Ofelia y Vidal.

3 ¿Por qué Mercedes echa un vistazo a los mapas que están sobre la mesa?

4 ¿Cómo trata Ofelia al niño aún no nacido?

5 ¿Por qué es tan injusto el asesinato de los granjeros?

6 Menciona al menos tres cosas que hace el fauno en su primer encuentro con Ofelia.

7 ¿Por qué Ofelia tendrá que llevar un vestido nuevo?

8 Explica una razón por la que es tan importante el granero.

9 En la escena 4, ¿cómo sabe la tropa fascista que la guerrilla está en el bosque?

10 ¿Cómo se puede recuperar la llave que está dentro del sapo?

11 ¿Por qué la tropa del capitán Vidal ha sido desplegada en esta parte del país?

12 ¿Qué pasa cuando Ofelia abre el libro del fauno por primera vez?

13 Con respecto a la segunda prueba, ¿qué le advierte el fauno a Ofelia?

14 Menciona dos características del monstruo que está sentado a la mesa del banquete.

15 ¿Qué hace Ofelia con la mandrágora para que mejore el estado de su madre?

16 Describe la estrategia de la guerrilla para atacar el molino.

17 ¿Cómo reacciona el fauno al oír lo que pasó en la segunda prueba?

18 Explica dos consecuencias que tiene la decisión de Carmen de echar la mandrágora al fuego.

19 ¿Qué información da el guerrillero torturado a Vidal?

20 ¿Cómo reacciona Mercedes cuando está a punto de ser torturada?

21 ¿Por qué sospecha Vidal que Ofelia está en su habitación?

22 ¿Qué hace Ofelia para adormecer y aturdir a Vidal?

23 ¿Por qué está enfadado el fauno en la última escena?

24 ¿Qué hace Vidal antes de que le disparen?

La película paso a paso

Carmen y Ofelia llegan al molino para vivir con el capitán Vidal. Carmen está embarazada y Vidal no siente simpatía por Ofelia.

↓

Ofelia descubre un laberinto de piedra antiguo y entabla una buena relación con Mercedes, el ama de llaves.

↓

Vidal prepara un ataque con sus hombres para terminar con la guerrilla que se esconde en el bosque. Pedro, uno de los guerrilleros, es el hermano de Mercedes y ella les pasa información y víveres.

↓

Carmen está muy débil y tiene un embarazo complicado. Ofelia no quiere vivir en el molino y muestra su descontento continuamente.

↓

Ofelia entra en contacto con un fauno, un ser mitológico que asegura que la niña es una princesa y le explica que tiene que pasar tres pruebas para volver a su reino.

↓

La niña pasa la primera prueba al acabar con un sapo gigante que vive en el interior de un árbol, pero disgusta a su madre porque ensucia su vestido de barro.

↓

En su segunda prueba, Ofelia desobedece al fauno y prueba la comida de un banquete. Como consecuencia, es perseguida por un monstruo que mata a dos hadas, lo que enfada luego al fauno.

↓

La guerrilla entra al molino de Vidal a robar provisiones gracias a la llave que Mercedes le dio a Pedro. Vidal captura y tortura a un guerrillero que es tartamudo.

↓

Vidal mata al doctor Ferreiro porque ayuda a morir dignamente al guerrillero capturado.

↓

Carmen muere al dar a luz a su hijo y Ofelia se queda sola, pero acaba huyendo a la cueva de la guerrilla con Mercedes esa misma noche.

↓

Los hombres de Vidal encuentran a Mercedes y a la niña, y las llevan de vuelta al molino. Vidal pretende torturar a Mercedes, pero ella le hiere en la cara con un cuchillo y escapa.

↓

Ofelia escapa del molino con su hermano en brazos, y se dirige al laberinto de piedra. El fauno le pide unas gotas de sangre inocente del bebé para volver a su reino mágico.

↓

Ofelia se niega a hacer daño al bebé, pero entonces aparece Vidal, que coge al niño, y mata a Ofelia de un tiro.

↓

Al derramarse la sangre inocente de Ofelia, el portal del laberinto se abre y la niña aparece en un reino lleno de color con su padre, su madre y su hermanito. El fauno y las hadas también están allí.

↓

En realidad, Ofelia está muerta. Mercedes y toda la guerrilla que esperaba a Vidal fuera del laberinto le matan y Mercedes se queda con el bebé. Todos lamentan la muerte de la pobre niña.

Vocabulario

a los cuatro vientos to the world

abatido/a shot down

acceder to gain access

advertir to warn

adormecer to send to sleep

el aguardiente liquor

amenazar to threaten

el asesinato murder

el atuendo outfit

aturdir to knock out

el barro mud

el bicho bug, creature

el bosque forest

cazar to hunt

el charol patent leather

el/la comensal dinner guest

colocar to place

consciente aware

consolar to comfort

la cueva cave

dar a luz to give birth

derramar to spill

desplegar(se) to deploy

dirigirse to head for

disparar to shoot

echar un vistazo to take a look

empeorar to get worse

entristecer to sadden

la escapatoria way out

fallecer to die, to pass away

el farol lamp, light

la fe ciega blind faith

la fogata fire, bonfire

la gota drop

el granero barn, grain silo

grosero/a rude, coarse
el hada (f) fairy
la mandrágora mandrake
la mejilla cheek
la mirada look, gaze
el molino mill
el monolito de piedra stone monolith
la nana lullaby
nacido/a born
negarse to refuse
ocultar to hide
el recuadro square
regañar to scold, to tell off
rodear to surround
rogar to plead
sangrar to bleed
el sapo toad
ser tartamudo/a to have a stutter
el/la súbdito/a subject
suministrar to provide, to supply
el/la superviviente survivor
el tiroteo gunfire, shooting
una tiza a piece of chalk
el varón male
la vestimenta clothing
el vínculo bond
volador/a flying

Fantasía frente a realidad

Está claro que la gran imaginación de Ofelia y su pasión por la literatura fantástica la llevan a mundos imaginarios fuera del horror que son la posguerra española y la dictadura franquista. En todo momento la película se sostiene en la **dualidad** del mundo real y el mundo fantástico. La dura realidad no perdona, y en ella se pueden ver la muerte, la injusticia y la violencia más **despiadada**. Por el contrario, en el mundo fantástico de hadas, el esfuerzo y la dedicación de Ofelia son **premiadas** al final, y la justicia tiene allí un papel importante. No ocurre lo mismo en la España en la que vive la niña, donde muchos inocentes sufren sin motivo, como los **perdedores** de la guerra civil, que no ven **recompensados** sus esfuerzos igual que como Ofelia.

Esta dualidad explica que la película, en realidad, pueda tener dos finales. El primero, en el mundo fantástico lleno de color donde Ofelia se reúne con su familia al completo. Por fin se reencuentra con su padre, al que tanto **echaba de menos** y que está sentado en el **trono** al lado de su madre, quien vuelve a la vida como reina y tiene a su hermanito en brazos. El segundo, el que le quita la vida sin razón. El mundo de Ofelia, las tres pruebas, las hadas, el fauno, la mandrágora y el libro mágico la transportan a otra realidad, lejos de la violencia y la crueldad que **se imponían** en España en ese momento. La realidad y la fantasía **van de la mano**.

la dualidad duality

despiadado/a wicked, cruel

premiado/a rewarded

el/la perdedor/a loser
recompensado/a rewarded

echar de menos to miss, long for

el trono throne

imponer to impose

ir de la mano to go hand in hand

In the first scene, Ofelia clutches her storybooks under her arm as she meets Captain Vidal for the first time. The Captain is preoccupied with timekeeping and protocol, and is irritated when Ofelia offers him her left hand as a greeting. This represents the first clash between fantasy and reality, with Ofelia keen to reside in the realm of fantasy through her stories, and the Captain rooted in the reality of postwar Spain. He too, however, is not untouched by storytelling. During the banquet, he is uncomfortable with any suggestion of sentiment, and appears burdened by the story he carries with him, that of his dying father smashing his watch against a rock in battle so his son would know the exact time of his death. This heroic, almost mythological act is closer to fantasy than reality, and for this reason, Vidal is uncomfortable acknowledging it. The significance of the gesture is underlined when Vidal, knowing he is about to die, smashes his own watch against the floor and then implores Mercedes to tell his son the time he died. His request will be emphatically denied, as she declares to him, moments before his assassination, that the child will never even know his name.

Key quotation

Decidle a mi hijo— decidle la hora en que morí.
(Capitán Vidal)

Mercedes also seems to straddle both worlds. She admits to Ofelia that she once read stories, but does not any longer, alluding to an unforgiving postwar reality that has no time for anything other than grim survival. When Ofelia tells her that she has seen fairies and fauns, Mercedes is happy to play along, advising her to take care. Working as a housekeeper for Vidal while spying for the resistance places her firmly in a very difficult and conflicting reality, risking her life on a daily basis. Nevertheless, her political beliefs and sense of self-sacrifice hint at the idealism characteristic of certain anti-fascist resistance at the time of the Civil War, and the rapport she quickly strikes up with Ofelia suggests that both share common ground in terms of their principles and independent minds.

Conversely, Carmen, Ofelia's mother, offers a real point of contrast to the other main female characters. Pregnant, and trapped in Vidal's reality, she is under no illusions about the life that awaits her. Consequently, she has little time for Ofelia's stories and implores her to mature quickly. Ofelia's father, a tailor, is dead, and Carmen appears eager to move on with her life. She mentions that Captain Vidal has been very good to them, and even asks her daughter to now call him 'father': 'Quiero que le llames "padre", ¿me has oído? "Padre".' Carmen's reality is one of terrible suffering and tragic death during childbirth, but this turbulent period is also influenced by the fantasy world, with the mandrake provided by the faun alleviating her symptoms temporarily. Carmen's character does also show glimpses of childlike wonder and innocence lost. She is proud to dress Ofelia like a princess for the meal Vidal will host, and remarks that she would have loved such a dress when she was a child. At one point, she even briefly reminisces on 'better times', and perhaps the pain of such memories have forced her to move on quickly with her life.

See the sections in 'Characters' on Ofelia, Captain Vidal, Mercedes, Carmen for more information (pages 45–53).

Key quotation

Mi abuela decía que a los faunos les gusta engatusar a la gente.
(Mercedes)

Key quotation

Cuentos de hadas. Ya eres mayor para llenarte la cabeza con tantas zarandajas.
(Carmen)

Key quotation

Las cosas no son tan simples, te estás haciendo mayor, y pronto entenderás que la vida no es como en tus cuentos de hadas, el mundo es un lugar cruel.
(Carmen)

Build critical skills

1 Piensa en una historia que hayas leído o en otra película que hayas visto en la que aparezcan hadas, faunos u otras criaturas mitológicas. ¿Cómo son? ¿Se asemejan a las de *El laberinto del fauno*? ¿Por qué crees que el director Guillermo del Toro quiso usar criaturas mitológicas en esta película?

Subordinación y desobediencia

la **cobardía** cowardice

obedecer to obey

a pies juntillas
unquestioningly

falangista Falangist
(member of the fascist
movement Falange,
founded in Spain in
1933, of which Franco
eventually became
leader)

ciego/a blind

El tema de la subordinación y la obediencia a lo largo de *El laberinto del fauno* aparece reflejado como una consecuencia del miedo, la **cobardía** y la falta de voluntad propia. Desde un punto de vista general, vemos al capitán Vidal **obedeciendo a pies juntillas** a Franco, hasta el punto de mudarse a otra parte del país y de vivir en un molino antiguo para defender los ideales **falangistas**. A su vez, todos los hombres que están bajo el mando de Vidal le obedecen con una confianza **ciega**, no cuestionan nada de lo que hace o les pide, ni siquiera en los momentos más crueles cuando torturan al tartamudo o a Mercedes. De alguna manera, esta obediencia está ligada a la violencia y al régimen franquista.

comer a dos carrillos
to gorge, to stuff
oneself

Hay varios ejemplos: cuando matan violentamente a un padre y a un hijo que cazaban conejos; en la cena de Vidal, cuando el cura, dos señoras y el resto de oficiales se mofan de los campesinos y de su necesidad de las cartillas de racionamiento mientras **comen a dos carrillos**, así como en las diferentes escenas de torturas en la película. Es evidente que los que obedecen son los "malos" en este caso, y que aceptar reglas sin cuestionarlas no lleva por buen camino, como el propio doctor Ferreiro dice antes de ser asesinado: él no es el tipo de persona que obedece en silencio. Ofelia desobedece al fauno en varias ocasiones y al propio Vidal, e incluso **se atreve** a entrar en su habitación y a drogar su bebida para escapar después con su hermano en brazos.

atreverse to dare

Disobedience appears in this film as a virtue; a sign of independence and hope for the future. The director, Guillermo del Toro, has affirmed in several interviews that the characters who think for themselves, question and disobey are those who ultimately triumph. Right from the first scene Ofelia is portrayed as a rebel, as she wanders into the woods in defiance of her mother during a brief stop en route to the mill. She dirties her dress when crawling into the tree in pursuit of the key that will allow her to fulfil the first task, and she even disobeys the request from the faun to not touch the food on the table when entering the monster pale man's lair. Ofelia also defies her mother on numerous occasions, despite her deep love for her. She will not call Captain Vidal her father, nor acknowledge him as such, so strong are her convictions. Most strikingly, Ofelia's most defiant act — refusing to sacrifice the blood of her baby brother — gives her the ultimate reward and makes her the authentic heroine of the film.

As well as Ofelia, the other characters who most clearly display defiance, heroism and an independent mind are Mercedes, Doctor Ferreiro and the rebels they support in the mountains. Vidal is unable to comprehend the doctor's choice to assist the rebels, and when confronted with the truth, that he obeys only for obedience's sake, Vidal chooses to shoot the doctor in the back. Mercedes shows an iron will in spying with such success under the nose of Vidal and the troops, and then attacking him with a knife to prevent her own torture. The disobedience of the rebels appears unshakeable, morally superior, and has endured since the start of the Civil War. The viewer is likely aware that in reality their efforts were in vain, but in this film at least, their victory, however temporary, is assured.

The most striking battle between subordination and disobedience is fought between Captain Vidal and the captured rebel. Vidal is desperate to break the rebel's will through torture, and the rebel cannot put his colleagues in danger by divulging information. The viewer witnesses a battle between good (disobedience) and evil (subordination). The rebel would rather die rather than give Vidal more information. This is a powerful statement, and leaves us in no doubt which side is the force for good.

Naturaleza y alimentación

En esta película, vemos a Carmen como una madre que se preocupa por su hija, pero que no entiende su **malestar**. De manera egoísta se casa con el capitán Vidal y se muda a vivir con él, a pesar de la insistencia de la niña, que cuestiona a su madre y le recrimina que nunca estuvo sola. Ofelia adora a su madre, pero siempre queda cierta **desazón** en la niña al no aceptar las decisiones de Carmen. Por otro lado, Mercedes, que no es madre, se convierte en una figura materna para la niña. Es ella, y no su madre, la que entiende el malestar de Ofelia en el molino y su **animadversión** hacia Vidal. Es Mercedes también quien se empieza a preocupar por Ofelia más que su propia madre, hasta el punto de

Key quotation

El capitán no es mi padre.

(Ofelia)

Key quotation

Mi hermano se queda conmigo.

(Ofelia)

Key quotation

Es que, obedecer por obedecer, así, sin pensarlo, eso solo lo hacen gentes como usted, capitán.

(Doctor Ferreiro)

Build critical skills

2 Con tu compañero/a, haz un diagrama de Venn que divida a los personajes de la película en grupos según sean obedientes, desobedientes o ambas cosas. Habla sobre tus elecciones.

el malestar uneasiness

la desazón unease, anxiety

la animadversión antagonism, ill-will

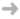

cantarle una nana para consolarla, cuidarla y compartir secretos. Desde el momento en que Carmen fallece, Ofelia no duda en pedirle a Mercedes que la lleve con ella. Mercedes no se niega y la acepta con amabilidad. Los valores y las formas de Mercedes contrastan con las **regañinas** de Carmen, que a pesar de querer a su hija, parece estar más concentrada en acomodarse en el molino y agradar a Vidal.

la regañina scolding, telling off

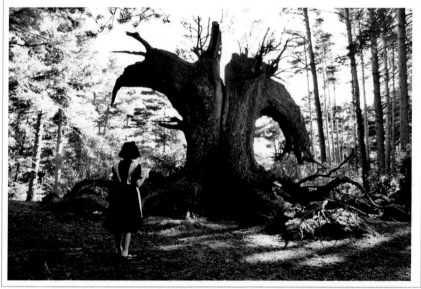

Key quotation

Yo soy la montaña, el bosque, la tierra. Yo soy... un fauno.
(Fauno)

Key quotation

Era la luna que te llevó.
(Fauno)

Key quotation

Esta es una mandrágora... Colocadla debajo de la cama de vuestra madre, en un cuenco con leche fresca.
(Fauno)

Nature has a prominent role in the film. The luscious green forest is the ideal setting for the labyrinth, and the tribal symbols that adorn it give a sense of timelessness and authenticity, as if it were the essence of the natural world. The faun is a product of the Earth, and asserts that it was the moon that bore Ofelia, or rather Princess Moanna. Ofelia herself notices the crescent moon shape on her shoulder, denoting her relationship with the underworld. The labyrinth is a place where Ofelia feels comfortable, and there is clear imagery of femininity within it, with the ageing tree evoking the female reproductive organs. The tree appears to offer sanctuary, but its decay foreshadows the struggles of Ofelia's pregnant mother, and even the plight of women in society. The image reappears disturbingly later in the film as Ofelia opens the book given to her by the faun. Blood spreads across the pages like branches from a tree. See also pages 58–59 in the 'Director's techniques' section, where colour and light and shade are discussed.

Milk, so synonymous with nurture in the animal world, is also a recurrent feminine symbol in the film. Mercedes milks the cows, and this milk is mixed with the mandrake provided by the faun to miraculously improve the health of Ofelia's mother. It is such a potent combination that by throwing it on the fire later in the film, Carmen unwittingly brings about her own death in childbirth. The Franco regime used milk and bread and other staples of a healthy diet as a way to control the population, by rationing supplies and distributing them

with propaganda messages that would on the one hand laud the success of the rationing programme and on the other, demand gratefulness and subservience from the masses. Here, nurture under dictatorship does not nourish the soul.

GRADE *BOOSTER*

> When writing about a particular theme in an essay, avoid all use of *bueno*, *malo* and other simplistic terms. Try to use specialised vocabulary that convinces the examiner you have an excellent knowledge of the work and a high level of Spanish. This is easier than it sounds: make and learn a list of ambitious key words.

TASK
Busca más información sobre la apariencia y el uso simbólico de la mandrágora en el folklore popular.

Guerra, codicia e inocencia perdida

Esta es una película **bélica** de alguna manera. Se puede observar continuamente como las armas, las tropas y los planes de un **bando** para atacar al otro forman parte importantísima de la película. La guerra civil ya ha terminado, pero 5 años después, en 1944, muchas guerrillas todavía se esconden en las montañas y el bando ganador, con Franco a la cabeza, está obsesionado con acabar con todos y cada uno de los rebeldes. Se pueden ver ciertas escenas que, sin estar basadas en hechos reales al **cien por cien**, sí que reflejan una realidad de los oficiales que recibieron órdenes de acabar con cientos de maquis que resistían en el monte, muchos de ellos con historias muy dramáticas en sus familias. Los maquis son, en general, hombres que han dejado a sus familias, mujeres e hijos, y se esconden en el monte mientras planean sus ataques, siempre con ayuda e información de algunos **aliados** en el mundo exterior.

bélico/a war, warlike
el bando side, faction

cien por cien completely, 100 percent

el aliado/a ally

The postwar period is a nightmare for those who oppose the nascent regime. War has torn families apart, exacerbated poverty and suffering, and established a future of reprisals and uncertainty. The greed of Captain Vidal and his associates in the military and Church is insatiable: they control supplies of food and tobacco and enjoy using this as a political lever over the population. The banquet Vidal hosts is relatively opulent, and completely at odds with the living standards of others. This bleak reality of evil and excess runs parallel to that witnessed by Ofelia in the fantasy world. The toad is gluttonous and putrid, and the pale man presides over a banquet of similar proportions to that witnessed earlier. The idea of sharing the wealth is anathema to the winners of this war, and sacrifice is only something contemplated by those on the side of good. The rebels in the mountains sacrifice their very existence in search of a better society, Mercedes and the Doctor risk their own safety in sharing military plans and provisions, and Ofelia must show courage and maturity way beyond her

Key quotation

¡Qué bueno está esto!: Es tabaco de hebra. − Difícil de conseguir.
(Capitán Vidal)

Key quotation

Fauno: ¿Sacrificaréis vuestro derecho sagrado—por este mocoso al que apenas conocéis?

Ofelia: Sí, lo sacrifico.

years, losing her innocence and, in the biggest act of sacrifice, ultimately her life, regaining both only at the end of the film, when she retakes her position of royal status in the underworld. Perhaps the only innocent character at the end of the film is Ofelia's baby brother, but he will now grow up without a mother, father or sister. No one in the Spain of the 1930s and 1940s is untouched by the ravages of war. See pages 9–10 on *La sociedad española del momento* in the 'Historical and social context' section to learn more about this time in history.

Many of the characters in the film momentarily display a yearning for their childhood. At one point, Mercedes and Carmen share a brief reminiscence, but neither has the will (it hurts them too much to dwell on the past), nor the time (they both share a difficult present) to let the memory linger on. Similarly, the dreams of the anti-fascists are fading. The dictatorship is consolidating its power, supplies are low, illness and fatigue are taking hold, and dear comrades have been lost. With such a relentlessly bleak outlook, and with the true story of the fascist victory looming large in many viewers' minds, perhaps the only potential escape is a different world.

GRADE BOOSTER

When writing about the themes of a particular work, you should choose one, clearly illustrate its significance with a few key examples, and then choose another. Repeat this process a number of times. This structure will help you avoid repeating yourself and will make for a more comprehensive answer.

Actividades

1 Busca un sinónimo en el texto para las siguientes palabras o expresiones.
 1 interés profundo
 2 cruel
 3 van unidos conjuntamente
 4 la autoridad
 5 se ríen de
 6 tiene malas consecuencias
 7 desazón
 8 confortarla
 9 de guerra
 10 totalmente

2 Ahora busca un antónimo en el texto para las siguientes palabras o expresiones.
 1 los ganadores
 2 la valentía
 3 no tiene nada que ver con
 4 pacíficamente
 5 rechazar
 6 se sometían

3 Traduce este texto al español.

 There is a range of themes in this film, and many are interrelated. It is true that the labyrinth in the forest is the entrance to an underworld of fairies, fauns and magic, but it is full of symbolism that increases our knowledge of the society of that time. Ofelia must face up to several different challenges, and it could be said that each one represents an aspect of postwar Spain. Despite its beauty, this film is undoubtedly a political statement and the director wants us to understand this.

4 ¿Hasta qué punto viven en el mundo real los siguientes personajes? Da ejemplos.
 ◥ Ofelia (menciona: sus libros, el laberinto, los dos finales).
 ◥ El capitán Vidal (menciona: la posguerra, el reloj de su padre).
 ◥ Mercedes (menciona: su infancia, su relación con Ofelia, su espionaje).
 ◥ Carmen (menciona: su embarazo, su futuro, su relación con Ofelia).

5 ¿Hasta qué punto son desobedientes los siguientes personajes? Da ejemplos.
 ◣ Ofelia (menciona: el comienzo de la película, su vestido, el banquete del hombre pálido, su hermano).
 ◣ El capitán Vidal (menciona: su ideología).
 ◣ Mercedes (menciona: su resistencia, su astucia y su reacción violenta).
 ◣ El doctor Ferreiro (menciona: sus ideas políticas, su filosofía, su muerte).

6 Comenta la relación entre Carmen y Ofelia. ¿Cómo difiere de la relación entre Mercedes y Ofelia?

7 ¿Cuáles son las características femeninas del laberinto?

8 ¿Qué características humanas representan el sapo y el hombre pálido?

9 ¿Qué sacrificios hacen los siguientes personajes a lo largo de la película?
 ◣ Mercedes
 ◣ el doctor Ferreiro
 ◣ Ofelia

Temas

Temas

Subordinación y desobediencia
- La desobediencia: aparece como una virtud, inteligencia
- La obediencia: se convierte en una forma de vida
- La España de la posguerra: líderes tiranos y violentos

Guerra, codicia e inocencia perdida
- La guerra: presente en toda la película
- Los monstruos: no triunfan, al contrario de lo que ocurre en la realidad
- El sacrificio: Ofelia se sacrifica por su hermano

Fantasía frente a realidad
- Dos finales: un final feliz y otro triste, cubierto de muerte
- El mundo de hadas de Ofelia: una realidad paralela
- La realidad de la guerra: dura y violenta
- Dos mundos: la fantasía de Ofelia y la dura realidad

Naturaleza y alimentación
- La naturaleza: un bosque frondoso, el laberinto, el río y la cueva de la guerrilla
- El fauno: se presenta como parte de la naturaleza
- La maternidad: Carmen, una madre enferma y conformista. Mercedes, una figura materna para Ofelia
- La leche: un símbolo de vida materna

Vocabulario

el/la aliado/a ally

la animadversión antagonism, ill-will

a pies juntillas unquestioningly

atreverse to dare

el bando side, faction

bélico/a war, warlike

ciego/a blind

cien por cien completely, 100 percent

la cobardía cowardice

comer a dos carrillos to gorge, to stuff oneself

conformista conformist

el cuento de hadas fairytale

la desazón unease, anxiety

despiadado/a wicked, cruel

la dualidad duality

echar de menos to miss, to long for

el embarazo pregnancy

engatusar to trick

falangista Falangist (member of the fascist movement Falange, founded in Spain in 1933, of which Franco eventually became leader)

frondoso/a dense, thick, overgrown

imponer to impose

ir de la mano to go hand in hand

el malestar uneasiness

obedecer to obey

el/la perdedor/a loser

premiado/a rewarded

recompensado/a rewarded

la regañina scolding, telling off

triunfar to triumph

el trono throne

las zarandajas silly little things

Ofelia

Ofelia es una niña de 13 años que está a punto de cambiar su vida por completo. Junto a su madre embarazada, se va a vivir con el capitán Vidal, quien será su nuevo padre. Ofelia no tiene ningún interés en su nueva casa y aparece como una niña un poco melancólica. La gran imaginación de Ofelia y una realidad desagradable le hacen **involucrarse en** un mundo de aventuras y pruebas fantásticas por medio de un fauno. A partir de ese momento, vemos a una Ofelia astuta y **con ganas de** ayudar y de cuidar de su madre enferma, a la vez que le hace la vida más difícil al capitán Vidal. Ofelia es una preadolescente llena de energía y vitalidad, deseosa de aceptar **retos** y aventuras.

involucrarse en to get involved in

con ganas de willing to, eager to

el reto challenge

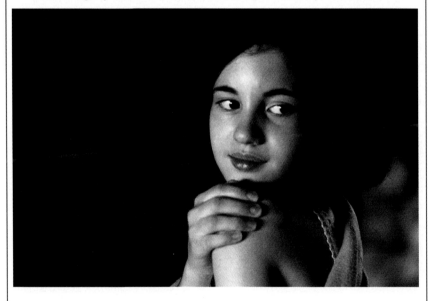

Por otra parte, en el mundo real de guerra y violencia, la niña es menos feliz. A pesar de vivir en una época horrible, la niña tiene un mundo interior enorme en el que ella misma se pierde en historias fantásticas de hadas y pruebas, hasta tal punto que el espectador dudará a veces entre lo real y lo imaginario.

Dulce y espontánea, Ofelia es también una niña muy madura para su edad. A pesar de querer a su madre por encima de todo, le desobedece y sigue sus instintos hacia las pruebas del fauno, porque cree que hay otro mundo mejor donde puede ser más feliz junto a sus seres queridos.

Key quotation

Era la luna que te llevó.
(El fauno)

In the opening scene of the film, Ofelia travels to a village in the north of Spain with her mother. She appears to be a well-mannered, temperate young girl, but she is clearly anxious about what sort of life awaits in her new environment in Francoist Spain. Ofelia starts to rebel against the imposed changes in her life, and is particularly scathing about her new stepfather, affirming 'El capitán no es mi padre'. Nevertheless, she retains a deep love for her pregnant mother, Carmen, worrying about her ailing health and talking affectionately to the baby in the womb. Ofelia seemingly possesses a unique bond with the natural world, and when a small stick insect-like creature leads her into a labyrinth, she meets a faun who believes her to be a princess of the underworld. The faun sets Ofelia three tasks, and, as challenging and fantastical as they may be, she finds shelter and solace from the real world in them, displaying great strength and resilience to overcome the supernatural horrors awaiting her. Refer back to the fantasy versus reality theme on pages 34–35 for more detail about Ofelia's character.

Ofelia undoubtedly has an independent streak, a strong set of beliefs, and a clear moral code, to such an extent that she even refuses the request of the faun at the end of the film to draw the blood of her brother, so sure is she of the impropriety of such an action. Ofelia personifies disobedience and anti-Franco sentiment, and the viewer is left thinking that, in some way, her successes in the trials she faces in the underworld may be linked to a rebel victory in the war-torn reality.

Key quotation

El capitán no es mi padre.
(Ofelia)

GRADE BOOSTER

Careful use of adjectives is very important for effective essay writing. When describing characters, vary the adjectives you use and avoid repeating any as much as possible. Try to learn at least ten ambitious adjectives for each of the main characters and, more importantly, provide evidence via examples and quotations that explain why you believe them to possess the particular characteristics you have mentioned.

Mercedes

callado/a quiet, reserved

esconder(se) to hide

Esta mujer de apariencia **callada** esconde un gran secreto: además de trabajar como ama de llaves en la casa del capitán, ella es republicana y su propio hermano, Pedro, está a la cabeza de la guerrilla republicana que **se esconde** en el monte. Mercedes no duda en ayudarles continuamente sin que Vidal lo sepa. Esta doble vida de la mujer le hace comportarse de manera distante y fría, pero con la llegada de Ofelia al molino, su carácter se vuelve más protector y cercano.

➜

46

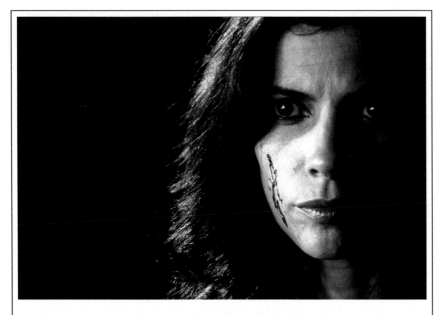

Ofelia pronto se convierte en su **cómplice** y Mercedes será una figura materna para la niña, sobre todo cuando su madre fallece al dar a luz al bebé en un parto complicado. Mercedes es **perspicaz**, muy trabajadora y leal a sus ideales, los cuales nunca abandona. A pesar de mantener un **perfil** bastante **bajo** a los ojos del capitán, a lo largo de la historia su personaje adquiere más protagonismo, y sorprende la fuerza que muestra al final para defenderse ella misma, a los suyos y a Ofelia. Mercedes es un personaje femenino fundamental en la película. Ella refleja la vida de una mujer trabajadora y luchadora, cuyo único deseo es ayudar a su hermano y a los rebeldes a terminar con Vidal, aunque eso signifique un sacrificio por su parte al tener que trabajar para el capitán.

el/la cómplice accomplice

perspicaz sharp, insightful

el perfil bajo low profile

Key quotation

Ofelia: Mercedes… ¿tú crees en las hadas?

Mercedes: Ya no… pero cuando era muy niña, sí.

Mercedes is a resolute and resourceful woman, with a strong moral code and sense of self-sacrifice. For much of the early scenes in the film, she is seen busying herself in the household, and appears to be meek and servile. Her caring nature and motherly instinct protect Ofelia in her new environment, and she strikes up a positive relationship with the young girl. We gradually realise that there is much more depth to Mercedes' character. She puts aside any personal danger to serve the Republican cause, sending food, provisions and strategic information to the guerrillas who are hiding in the forest. When Captain Vidal uncovers her duplicitousness, he arranges her torture. In a scene of great tension and brutality, Mercedes cunningly effects her escape, slashing Vidal across the face with a kitchen knife. Given Vidal's relentless misogyny, this victory is not only for Mercedes, but also for womankind. Her reserved nature belies her inner strength. Much like Ofelia, she attracts the sympathies of the viewer, and we will for her escape from Vidal's clutches. The fact that Mercedes ultimately

brings about her own emancipation is a significant feminist victory, and also a political one, so loyal is she to the rebel cause. Through Mercedes, the viewer is also better able to appreciate the cost of war. It is her brother who hides in the mountains as a member of the rebel faction, and she must constantly seek to provide support in whatever form to him and his comrades. As well as the breaking of family ties, the postwar period depicted in the film also illustrates the suppression of women's rights, with many of the freedoms granted to women in anarchist groups and workers' cooperatives now brutally crushed. On the surface, Mercedes appears no more than a woman in servitude, to be seen and not heard. In this environment, she is forced to fight for her own freedom.

TASK

Busca más información sobre las Mujeres Libres. ¿Qué papel tuvieron durante la guerra civil española?

El capitán Vidal

retorcido/a twisted

el poder power

la estirpe lineage

Este oficial franquista es especialmente **retorcido** y cruel. No tiene ningún

problema en torturar a los campesinos o en abusar de su **poder** por medio de la violencia. Parece no tener demasiado interés en Carmen, la madre de Ofelia; solo es su esposo para asegurarse una línea sucesoria y la continuidad de su **estirpe** a través de su hijo a punto de nacer. Su machismo es evidente en cómo trata a los personajes femeninos, incluso odiaría tener una hija con Carmen, y no un hijo.

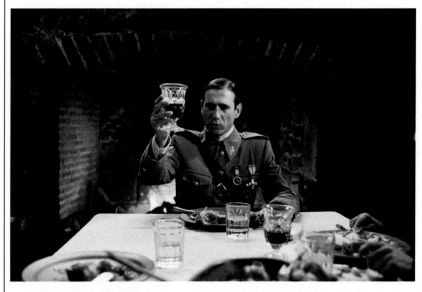

Vidal siente un especial odio por Ofelia, a quien desprecia e ignora continuamente. Para él, ni es su hija ni nadie importante. Además, es una niña y su carácter vivo y espontáneo le molesta, ya que él solo quiere concentrarse en sus planes de ataque a los rebeldes. El capitán es arrogante, **déspota** y está obsesionado con terminar con las guerrillas para asegurar que el franquismo **tenga vía libre** en España durante mucho tiempo.

déspota tyrannical

tener vía libre to have free rein

As he waits impatiently for the arrival of Carmen and Ofelia in the opening scene, Captain Vidal remarks '15 minutos tarde'. He is a man of precision and military prowess, with a political ideology that is avowedly fascist. He declares: 'Quiero que mi hijo nazca en una España limpia y nueva', and he is obsessive and remorseless in his quest to eliminate the threat offered by the Republican resistance, torturing and murdering irrespective of guilt. Allied to these characteristics is his denigration of women. His wife serves only to provide him a son, and he regards Ofelia as a weak and foolish little girl. He dismisses the idea that Mercedes could have the guile to pass on knowledge to the resistance, or even retaliate physically when about to be tortured, stating 'Es solo una mujer'. These beliefs ultimately bring about his downfall.

In many ways, Vidal is a solitary individual. He keeps a professional distance between himself and his fellow soldiers, is especially cold towards his wife, and reacts uncomfortably to sentiment. For example, when his father's bravery is commended during the banquet, he hastily quashes all mention of it. The viewer is left to speculate as to the reasons behind this behaviour. It may well be the case that Vidal is simply incapable of human empathy, but given that he glances meaningfully at his father's watch and carries it with him all of the time, it is more likely that the director is consciously granting the character more depth and ambiguity than is first apparent. By doing so, his cruel actions that take place throughout the film are even more disturbing, as they are the actions not of a psychopath, but of a man of duty, twisted by war and the burden of fulfilling his father's mythical status.

Refer to pages 58–59 on the use of colour and camera angles in the 'Director's techniques' section to see how the director conveys this impression of 'el capitán'.

El fauno

Este personaje mitad humano mitad animal es el responsable de que Ofelia **se adentre** en un mundo mágico de monstruos y **pruebas**. A pesar de su apariencia **tenebrosa**, Ofelia no duda en **abrazarlo** y tratarlo con familiaridad; es evidente que tienen una relación **entrañable**. No obstante, el fauno tiene un carácter fuerte, y cuando la niña no cumple sus órdenes y le **desobedece**, este no duda en regañarla duramente. Con una voz **contundente** y una presencia que asusta debido a su apariencia y altura, parece tener un gran corazón y querer ayudar a Ofelia a conseguir su acceso al reino, al que él asegura que la niña pertenece.

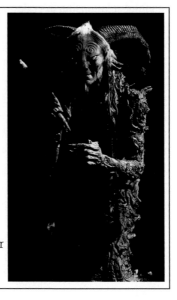

adentrarse to go deep into
la prueba test
tenebroso/a dark, sinister
abrazar to embrace, hug
entrañable close, dear
desobedecer to disobey
contundente forceful

sabio/a wise

la recompensa reward

> Siempre se dirige a Ofelia con mucho respeto, como si fuera una princesa, y la llama "alteza". El fauno da la impresión de ser una criatura **sabia**, que conoce muy bien el mundo de la naturaleza, la magia y otras criaturas fantásticas. Para Ofelia, el fauno es su acceso a un mundo lejos del conflicto, del dolor y la violencia. A pesar de que Ofelia se enfrenta a monstruos y pruebas difíciles de superar, parece que es un mundo más justo donde el esfuerzo tiene su **recompensa**, como bien le explica el fauno a la niña en varias ocasiones.

The faun is a mystical creature and Ofelia's spiritual guide. He claims that she is Princess Moanna of the Underworld, and on identifying the moon-shaped mark on her shoulder, he insists that she should complete three tasks before the arrival of the full moon to facilitate her return to the Underworld. Physically, the faun is a monstrous beast: half-man, half-goat, with many exaggerated features, such as his horns and fingers. He acts ambiguously towards Ofelia; alternately warm, then hostile; calm, then angry. Ofelia has an admirable strength in his presence, and it is clear that the faun offers her escape from the oppression of her new life at the mill. His comments are often cryptic, pertaining to matters of another world. Nevertheless, his impact can be felt within the human world. He advises Ofelia to use mandrake and milk to ease her mother's suffering in pregnancy, and when she does so, her mother's condition quickly improves. The faun is a major source of symbolism within the film.

The shadow of Vidal's father looms large in the film, and for Ofelia, whose own father died in the war, and who has comprehensively rejected Vidal as her stepfather, it is the faun who represents a father-like figure for her. This father–daughter relationship is evident on a number of levels. Ofelia hugs the faun warmly at certain points; is told off by him when she lets him down, and when her defiance of him reaches a new peak near the end of the film, it is symbolic of her growing up and taking her own path in life, much like that of a teenager finding her way in the world.

It is important to acknowledge that the faun in *El laberinto del fauno* possesses many of the traits of the faun as depicted in Greek mythology: bound closely to nature and typically dwelling in forests, guiding people in need, but also unpredictable in behaviour, and capable of leading people astray.

See page 59 on light and shade in the film to understand how the director chose to portray the faun.

TASK

¿Hasta qué punto comparte el fauno en la película características del fauno más tradicional y popular en la mitología?

Key quotation

Yo soy la montaña, el bosque, la tierra. Yo soy... un fauno.

(Fauno)

El doctor Ferreiro

El doctor es un personaje secundario **imprescindible** en la película. Es un hombre de pocas palabras, pero muy **reflexivo**, inteligente y con unos ideales importantes para él. Aunque trabaja para el capitán Vidal, al igual que Mercedes, su corazón está en la montaña, con el resto de los hombres que se esconden y luchan en contra del franquismo. No duda en ayudar en todo lo que puede: a Carmen en su **parto** complicado, a un guerrillero cuya pierna hay que amputar, y al prisionero tartamudo que le pide morir con dignidad.

imprescindible essential

reflexivo/a thoughtful

el parto birth, labour

Sus valores y su reacción ante Vidal le cuestan la vida, pero muere como un valiente. Ferreiro tiene claro que su fin es ayudar a los rebeldes cueste lo que cueste, aunque tenga que estar al servicio de Vidal. Su creciente frustración ante las atrocidades de Vidal es evidente, y en su escena final seguro que sorprende a todos los espectadores la gran **entereza** y valentía que muestra el médico.

la entereza integrity, strength

The figure of an educated, principled doctor with socialist beliefs is a recurring one in literature and cinema. Doctor Ferreiro is a key figure for the resistance: he can cure their ailments and pass on information as a man on the inside of the regime. He also collaborates effectively with Mercedes. Nevertheless, his duties are filled with compromise and difficult decisions; he is forced to provide treatment for Vidal's men, can only amputate when a member of the resistance has a leg injury, and must help a tortured man to die. The brutality of the regime, and the futility of the doctor's position becomes evident when he is shot in the back by Vidal, who discovers his duplicity. The doctor is a source of hope and hopelessness for the rebels: they depend on his wisdom and selflessness, but his exploitation by the Francoists and his untimely death leave them exposed to illness, ostracisation and attack.

Key quotation

Es que, obedecer por obedecer, así, sin pensarlo, eso solo lo hacen gentes como usted, capitán.
(Doctor Ferreiro)

51

Carmen

dispuesto/a ready for

Embarazada del hijo del capitán Vidal, la madre de Ofelia es una mujer que llega al molino **dispuesta a** empezar una nueva vida. Ofelia adora a su madre, pero se rebela constantemente contra ella y la cuestiona porque no entiende por qué prefiere vivir con Vidal. Carmen afirma que Ofelia ya no es una niña y que debería dejar de leer los libros de hadas que tanto le gustan. Su embarazo le cuesta la vida, lo que entristece mucho a Ofelia, pero parece dejar indiferente al capitán Vidal.

reñir to tell off

En varias ocasiones podemos ver a Carmen **reñir** a Ofelia por ser demasiado infantil y no aceptar su nueva vida, que según Carmen, es mejor que la anterior. En Carmen tenemos a una mujer de clase media de la época que quiere, ante todo, mantener su posición social. A pesar de tener buenas intenciones y de desear una vida cómoda para Ofelia y su hijo a punto de nacer, Carmen a veces aparece en la película como una

insensible insensitive

mujer algo **insensible** y egoísta con su propia hija, quien empieza a guardarse sus secretos y a compartirlos con otros, como Mercedes o el fauno.

Key quotation

Las cosas no son tan simples, te estás haciendo mayor, y pronto entenderás que la vida no es como en tus cuentos de hadas, el mundo es un lugar cruel.

(Carmen)

Carmen's character is a microcosm of female repression in the postwar years. She is socially excluded, with her comments at the banquet cruelly dismissed by her husband; she receives little affection or attention apart from the medical sort, and she is restricted only to pregnancy, dressmaking and frustration at the rebelliousness nature of her daughter. Nevertheless, apart from Ofelia, Carmen is the only character who is affected by the Underworld. The mandrake placed under her bed drastically improves her health during her pregnancy, and conversely, by throwing it on the fire, she brings about her own death. Carmen's past is vague; we only know that her husband was a tailor who died during the war, and that at some point, she developed a relationship with Captain Vidal. As a middle-class woman determined to make sacrifices in order to retain her social status, it is difficult to place her in terms of the moral hierarchy of the characters in the film, but it is clear that she now finds herself in the centre of fascist Spain with a rebellious daughter and a difficult pregnancy. The nature of her suffering is best exemplified by her journey to the mill in an expensive limousine in the opening scene of the film. Under Vidal's protection, Carmen is materially secure,

but as a consequence of being forced to make the arduous trip and then live a life under oppression at the mill, her physical and emotional state is extremely poor, and will deteriorate as the film progresses.

Actividades

Lee las descripciones de los personajes de la película. Luego contesta a las preguntas en español usando las entradas que van a continuación para estructurar tus respuestas.

1 ¿Cómo evoluciona el carácter de Ofelia en la película?
 ◤ Al principio, Ofelia parece…
 ◤ Sin embargo, en su nuevo entorno, Ofelia empieza a ser…
 ◤ Después de conocer al fauno, Ofelia se hace más…

2 ¿Cuál es la actitud de Ofelia hacia su madre y el capitán Vidal?
 ◤ Con respecto a su madre, Ofelia expresa sentimientos de…
 ◤ En cuanto al capitán, Ofelia…

3 ¿Cuál es el secreto que guarda Mercedes?
 ◤ Por una parte, Mercedes trabaja de…
 ◤ Por otra parte, tiene un papel clave en…

4 ¿Qué actos de valentía realiza Mercedes?
 ◤ Es evidente que Mercedes sigue apoyando…
 ◤ Cuando está a punto de ser torturada,…

5 ¿Cuáles son las creencias políticas del capitán Vidal?
 ◤ Es innegable que el capitán pertenece a…
 ◤ Afirma que quiere una España…

6 ¿Cómo se manifiesta su odio hacia las mujeres?
 ◤ La actitud del capitán hacia su esposa es…
 ◤ Con respecto a Ofelia, el capitán tiene una actitud…

7 ¿Cómo es el fauno físicamente?
 ◤ Es evidente que esta criatura mítica es una combinación de…
 ◤ Tiene un aspecto a la vez… , pero también es…

8 ¿Por qué se podría describir la relación entre el fauno y Ofelia como ambigua?
 ◤ En presencia de Ofelia, el fauno se comporta de manera…
 ◤ No obstante se nota que la relación entre los dos es…

9 ¿Cuáles son las creencias políticas del doctor Ferreiro?
 ◤ Al parecer, el doctor apoya…

10 ¿Qué conflicto hay entre Carmen y Ofelia?
 ◤ A pesar de su amor profundo,…

Los personajes

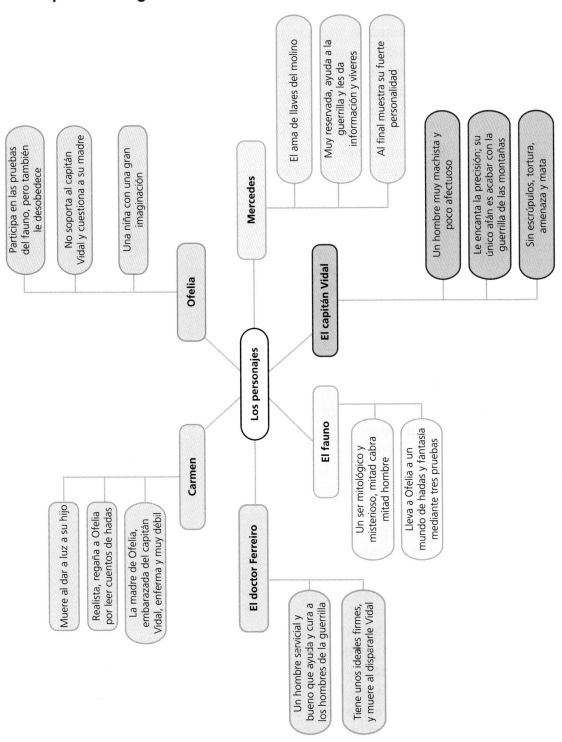

Los personajes

Ofelia
- Participa en las pruebas del fauno, pero también le desobedece
- No soporta al capitán Vidal y cuestiona a su madre
- Una niña con una gran imaginación

Mercedes
- El ama de llaves del molino
- Muy reservada, ayuda a la guerrilla y les da información y víveres
- Al final muestra su fuerte personalidad

El capitán Vidal
- Un hombre muy machista y poco afectuoso
- Le encanta la precisión; su único afán es acabar con la guerrilla de las montañas
- Sin escrúpulos, tortura, amenaza y mata

Carmen
- Muere al dar a luz a su hijo
- Realista, regaña a Ofelia por leer cuentos de hadas
- La madre de Ofelia, embarazada del capitán Vidal, enferma y muy débil

El fauno
- Un ser mitológico y misterioso, mitad cabra mitad hombre
- Lleva a Ofelia a un mundo de hadas y fantasía mediante tres pruebas

El doctor Ferreiro
- Un hombre servicial y bueno que ayuda y cura a los hombres de la guerrilla
- Tiene unos ideales firmes, y muere al dispararle Vidal

Vocabulario

abrazar to embrace, to hug

adentrarse to go deep into

el afán desire

la cabra goat

callado/a quiet, reserved

el/la cómplice accomplice

con ganas de willing to, eager to

contundente forceful

culto/a educated

débil weak

desobedecer to disobey

déspota tyrannical

dispuesto/a ready for

la entereza integrity, strength

entrañable close, dear

esconder(se) to hide

estar a punto de to be about to

la estirpe lineage

imprescindible essential

insensible insensitive

involucrarse en to get involved in

luchador/a brave, feisty

el parto birth, labour

el perfil bajo low profile

perspicaz sharp, insightful

el poder power

protector/a paternal

la prueba test

la recompensa reward

reflexivo/a thoughtful

reñir to tell off

resuelto/a determined, resolute

el reto challenge

retorcido/a twisted

sabio/a wise

tenebroso/a dark, sinister

tener vía libre to have free rein

tirano/a tyrannical, despotic

Allegory

Of all the techniques used in *El laberinto del fauno*, perhaps the most striking is the use of **allegory**. Guillermo del Toro stated that he did not originally intend the film to juxtapose a child's journey into a fantasy world with the aftermath of the Spanish Civil War, but in doing so, there is undoubtedly much greater depth to the story. As the only character with involvement in both worlds, Ofelia is the conduit for this allegory. She represents the Spanish resistance, and Captain Vidal, the **Francoists** (and perhaps even Franco himself). As a young girl trapped in a ruthless society, obliged to seek refuge in myth and fantasy, there is an element of tragedy to Ofelia's predicament. She tells a vivid fairy tale to her unborn brother that evokes the agony and frustration of the rebels who continue to resist the expansion of the Franco regime. Ofelia is also bound by fate, finding herself opposite an ancient stone monolith at the start of the film. As she places the stone at her feet into the empty eye socket, her journey begins. The symbolism of the eye is significant; only Ofelia is capable of 'seeing' the underworld and unlocking the mysteries within. Lacking in humanity and obsessed with ruthlessly consolidating their power, the Francoists have no contact with this other world. Furthermore, whereas Captain Vidal is repulsed by Ofelia, Mercedes, a rebel sympathiser, builds a close relationship with the young girl and values her imagination. Although the rebels' hopes of victory are increasingly desperate, they retain their idealism and dreams of a better society.

Look back at pages 9–10, *La sociedad española del momento*, in the 'Historical and social context' section for more information about this period in history.

allegory (*a story with hidden meaning, frequently political or historical*) la alegoría

Francoist (*supporter of Franco*) franquista

Key quotation

Entre los hombres, solo se hablaba del miedo a la muerte y al dolor, pero nunca de la promesa de la inmortalidad. Y todas las tardes, la rosa se marchitaba sin poder otorgar sus dones a persona alguna. Olvidada y perdida en la cima de aquella montaña de piedra fría, sola hasta el fin de los tiempos...

(Ofelia)

To reinforce the point that these real and unreal worlds are very much intertwined, many images reoccur in both. Ofelia obtains the key from the toad to fulfil the first task, and Mercedes possesses the key that provides vital access to the provisions that support the rebels. Ofelia acquires a dagger from the pale man's lair, and Mercedes uses a kitchen knife to wound Vidal and make her escape.

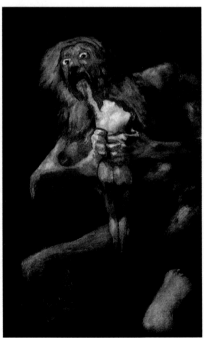

▲ Goya's painting *Saturno devorando a su hijo*

crosscutting/
parallel editing
(*alternating one scene
with another*) la
contraposición de
escenas/el montaje
paralelo

antagonist (*the
opponent of the hero
of the story*) el/la
antagonista

TASK
Busca información
sobre la pintura
de Goya *Saturno
devorando a su hijo*
y su colección de
pinturas negras.

Though himself not of such a disposition to believe in Ofelia's mythical world,
Captain Vidal's monstrosity is undoubtedly present there. The banquet laid out
in front of the pale man is **crosscut** by the similarly indulgent meal hosted by
Vidal. Such **parallel editing** makes a striking comparison between a monstrous
fairy tale and a monstrous present, with two frightening **antagonists**. Similarly,
the bloated toad deep inside the entrails of the tree represents the selfishness
and greed of the Nationalists, who hoard the limited resources available. Time
also overlaps both worlds: the egg timer brings a sense of terror to proceedings
as Ofelia makes her escape from the pale man's lair, and Vidal carries his
father's broken watch with him at all times. Even in the background of his
quarters a waterwheel turns relentlessly. Guillermo del Toro has referred to
Goya's painting *Saturno devorando a su hijo* as a thematic inspiration, and the
image of Saturn (or in Greek myth, Titus Cronus) eating his children to prevent
them usurping him as he did to his own father is a brutal representation of time
as the devourer of all things, as well as an allegory of the situation in Spain,
with the Civil War consuming its own people. It is undeniable that the images on
the wall of the pale man's lair evoke Goya's painting, and the pale man devours
the fairies with similar frenzy.

Use of colour and camera angles

El laberinto del fauno won the Oscar for best cinematography in 2007, and the
techniques used certainly have a significant impact on the viewer's perception
of the characters. For the most part, the rebels, with their makeshift uniforms
and equipment, **blend into** the wild landscape; a rich palette of greens and
browns. We see little of their movements as **wide-angled shots** dominate.
The Nationalist troops are based at a mill in a clearing in the forest, the blue of
their uniforms contrasting sharply with the nature around them. The Nationalist
uniform is worn impeccably by captain Vidal, and his fastidiously well-groomed
appearance and square jaw seems to be a stereotype of a fascist leader, such as
Mussolini.

blend into mezclarse
con, perderse entre
wide-angled shot el
plano general

low-angle el ángulo
bajo
close range a corta
distancia

medium shot el plano
medio

Camera shots of the captain are often **low-angle** and **close range**, magnifying
his presence and, with his harsh, angular features (and his intimidating scar
later in the film), they bring a sense of awe, even dread, exemplified when
the tortured rebel cowers as Vidal towers over him with his implements of
torture. This technique contrasts with that used for the female characters,
who are often filmed from higher angles or in **medium shot**, with the aim of
showing their subservience (they are often cooking, serving, and cleaning) and
their powerlessness (they are dominated by the misogynistic Captain Vidal, as
women were in general within Spanish society under Franco, where they were
very clearly second-class citizens). Vivid colours are largely absent in the film,
reserved for royalty at the start and the end, as Ofelia joins her mother and
father as rulers of the underworld. Her shoes are bright red, and gleaming golds
stand out amidst a rich palette. Postwar Spain does not offer this vibrancy and
splendour.

Light and shade

Light, or the absence of it, is also a tool by which characterisation is developed. There is a Gothic air to the film. The labyrinth, so tied to nature, is under almost constant **darkness**, and this gives the faun a moral **ambiguity** that seizes the attention of the viewer. It is within this fantasy world that Ofelia must succeed, and for her, dark and menacing locations such as the inside of the tree, or the pale man's lair, do not appear to make her fearful. In fact, the director appears to challenge the assumption that evil is associated with darkness and good with light. Though the poorly lit mill at night gives the viewer a sense of **foreboding**, many of the film's most gruesome scenes take place in daylight; such as the torture of the prisoner.

darkness la oscuridad
ambiguity la ambigüedad

foreboding el presentimiento

Sound

The use of sound also sets the tone of a number of scenes in the film. As Ofelia wanders off in the woods in the first scene, a loud **crack** is heard as she stands on a piece of sculpted stone. This represents her first dealings with the underworld. At night, Ofelia and her mother hear the **creaks** and **groans** of the old house and Ofelia becomes unsettled. The latent threat of violence is also heightened through sound, as the leather of Captain Vidal's military gloves squeaks loudly and the sharp noise of knives is heard, whether the '**ping**' of the dagger in the pale man's lair, the scrape of the razor whilst Vidal shaves, or the violent **slash** of the kitchen knife across his face by Mercedes as she makes her escape. It is also apparent that in this society, where women's roles are subordinated, voices are not heard clearly. Mercedes and the servants work quietly around the mill, **whispering** to each other, and Carmen's opinions, on the rare occasions she offers them, are quickly dismissed by her husband.

crack el chasquido

creak el chirrido
groan el gruñido

ping el sonido metálico
slash la cuchillada

to whisper susurrar

Key quotation

Aquí las casas son viejas. Gruñen, se quejan... ¿A que parece que hablan?
(Carmen)

Build critical skills

Cuando veas la película, presta atención al uso de la música en diferentes escenas. ¿Qué papel tiene y cómo influye en las emociones de los espectadores?

Special effects

special effects los efectos especiales

make-up el maquillaje

costume el vestuario

Special effects are used in a number of scenes, and seek to immerse the viewer in the plot. The toad is imbued with a vulgarity that only extensive use of special effects could provide. The **make-up** and **costume** required to create the pale man has made the character an icon of modern cinema. Although the underworld necessarily demands more use of special effects, they are also used in the real world to intensify emotion. As Vidal attempts to sew his torn face back together, the viewer is filled with revulsion. Similarly, the mandrake, a plant that supposedly resembles the human form and was traditionally used in herbal medicine, is brought to life in the film, giving it supernatural qualities. It squirms and shrieks when thrown onto the fire.

TASK
Si es posible, busca y mira algún video del proceso creativo para hacer el vestuario y maquillaje del hombre pálido o monstruo con los ojos en las manos que devora bebés.

Actividades

1 Empareja estos términos cinematográficos con sus definiciones.

1 primer plano
2 plano general
3 fuera de campo
4 contraposición de escenas
5 banda sonora
6 escenografía
7 efectos especiales
8 alegoría

A técnicas específicas en el cine que crean una ilusión audiovisual que no se puede obtener por medios normales
B música de acompañamiento grabada y sincronizada con las imágenes de una película
C acción o diálogo que oímos, pero no vemos
D vista amplia que informa al espectador del lugar y de las condiciones en que se desarrolla la acción
E conjunto de objetos, efectos de iluminación, artilugios mecánicos y decorado que representan el lugar de la acción
F representación simbólica de ideas abstractas por medio de una obra artística
G encuadre de una figura humana cuando el rostro del actor suele llenar la pantalla
H comparación de una escena con otra

2 Completa las siguientes frases sobre la cinematografía de la película con la forma correcta del verbo en paréntesis.

1 El cuento de hadas que le (contar) Ofelia a su hermano (evocar) la agonía de los rebeldes.
2 Después de (atacar) a Vidal, Mercedes (huir) del molino.
3 Durante la posguerra, los franquistas (usar) las cartillas de racionamiento para (controlar) a la población.
4 Goya (pintar) el cuadro *Saturno devorando a su hijo* entre 1820 y 1823.
5 Es posible que las imágenes en las paredes del salón del banquete del hombre pálido (imitar) las pinturas negras de Goya.
6 En 2007, *El laberinto del fauno* (ganar) tres premios Óscar.

3a Busca la palabra "alegoría" en un diccionario. ¿Conoces algún cuento que sirva de alegoría? Explícaselo a un/a compañero/a de clase.

3b Lee con atención el fragmento del cuento (en la página 57) que le cuenta Ofelia a su hermano. Explica por qué podría ser una alegoría. ¿Qué representan las siguientes imágenes?

- la montaña de piedra fría
- la rosa que florecía todas las noches con sus espinas envenenadas

4 Hay varias imágenes que reaparecen durante la película. Explica el significado de:

- las llaves
- los cuchillos
- los banquetes
- los uniformes

5 Analiza el cuadro de Goya *Saturno devorando a su hijo*. Describe lo que ves y los sentimientos que provoca en ti. Luego intenta explicar por qué evoca al hombre pálido en la película.

6 ¿Cómo usa el director la luz para dar forma a la película?

7 Menciona dos maneras en las que el director usa los sonidos para transmitir un tono de suspense.

Las técnicas del director

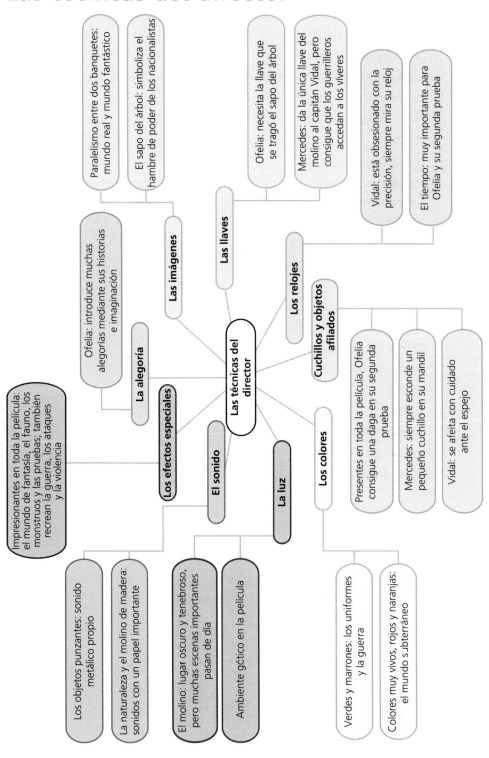

Vocabulario

allegory (*a story with hidden meaning, frequently political or historical*) la alegoría

ambiguity la ambigüedad

antagonist (*the opponent of the hero of the story*) el/la antagonista

to blend into mezclarse con, perderse entre

close range a corta distancia

costume el vestuario

crack el chasquido

creak el chirrido

crosscutting/parallel editing (*alternating one scene with another*) la contraposición de escenas/el montaje paralelo

darkness la oscuridad

foreboding el presentimiento

Francoist (*supporter of Franco*) franquista

groan el gruñido

low-angle el ángulo bajo

make-up el maquillaje

medium shot el plano medio

ping el sonido metálico

slash la cuchillada

special effects los efectos especiales

to whisper susurrar

wide-angled shot el plano general

7 Exam advice

Planifica tu redacción

Planning is an important part of your examination time. As a rough guide you should spend about 10 minutes planning your essay, 50 minutes writing it and 5 minutes checking it.

A well-planned essay makes points clearly and logically so that the examiner can follow your argument. It is important to take time to devise a plan before you start writing. This avoids a rambling account or retelling the story of the work you are writing about. The following points may help you to plan your essay well:

- Read the essay question carefully. Make sure you have understood what you are being asked to do rather than focusing on the general topic.
- From the outset it is sensible to plan your essay in the target language. This will prevent you writing ideas that you are not able to express in the target language.
- Focus on the key words. For example, you may be asked to analyse, evaluate, explore, explain. Look for important key words such as *de qué manera, por qué, cómo.*
- Select the main point you want to make in your essay and then break this down into subsections. Choose relevant information only. Avoid writing an all-inclusive account that occasionally touches on the essay title.
- Decide on the order of the main ideas that become separate paragraphs. Note down linking words or phrases you can use between paragraphs to make your essay flow as a coherent and logical argument.
- Select one or two relevant and concise quotations that you can use to illustrate some of the points you make.
- Think about the word count for the essay. The examination boards stipulate the following word counts:

	AS	A-level
AQA	Approximately 250 words	Approximately 300 words
Edexcel	275–300 words	300–350 words
WJEC	Approximately 300 words	Approximately 400 words
Eduqas	Approximately 250 words	Approximately 300 words

- Consider how many words to allocate to each section of your essay. Make sure that you give more words to main points rather than wasting valuable words on minor details.
- Finally, consider how to introduce and conclude your essay, ensuring that you have answered the question set.

A well-planned essay will have an overall broad structure as follows:

- **Introduction**: you should identify the topic without rewriting the essay title. You should state your position on the issue.
- **Body of the essay**: in several paragraphs you should give evidence to support a number of main points.
- **Conclusion**: here you should summarise your ideas and make a final evaluative judgement without introducing new ideas.

Escribe tu redacción

Enfoque

Now you have to put flesh on the bones of the plan that you have drafted by writing a structured response to the essay question.

- Remember that you are writing for a person who is reading your essay: the content should interest your reader and you should communicate your meaning with clarity and coherence.
- It is important to be rigorous in sticking to your plan and not to get side-tracked into developing an argument or making a point that is not relevant to the specific essay question. Relevance is always a key criterion in the examination mark schemes for essays, so make sure that you keep your focus throughout on the exact terms of the question. Don't be tempted to write all that you know about the work; a 'scattergun' approach is unproductive and gives the impression that you do not understand the title and are hoping that some of your answer 'sticks'.
- It is important to think on your feet when writing an examination essay. If you produce a pre-learnt essay in an examination, in the hope that that will fit the title, you will earn little credit, since such essays tend not to match what is required by the title, and give the impression that you do not understand the question.
- If you are completing an AS examination, the question might require you, for example, to examine a character or explain the theme of the work. You will also have a list of bullet points to help you focus on the question. Ensure that you engage with these guidance points, but be aware that they do not in themselves give you a structure for the essay. At A-level you will normally have a statement requiring you to analyse or evaluate an aspect of the work.
- Since examination essays always have suggested a word limit, it is important to answer as concisely as you can. It should be always possible to write a meaningful essay within the allocated number of words.

Estructura

1 Introducción

The introduction gives you the opportunity to show your understanding of the work. It should be a single paragraph that responds concisely to the essay question. In a few sentences you should explain to your reader what you understand the question to mean, identify issues it raises and say how you are going to tackle them. Avoid statements in the target language that equate to 'I am now going to demonstrate…' or 'This essay is about…'.

2 Desarrollo

- This part will be divided into a number of interconnected paragraphs, each of which picks up and develops the points raised in your introduction.
- Each paragraph should be introduced with a sentence stating what the paragraph is about.
- Make sure you follow a clear pathway through your paragraphs, leading to your conclusion. This requires skills of organisation, in order to ensure the smooth development of your argument. You should move from one facet of your argument to the next, linking them conceptually by, for example, contrast or comparison.
- Each paragraph will have an internal logic, whereby you examine a separate point, making your argument and supporting it with examples and quotations. For example, your essay title might lead you to examine the pros and cons of a statement, with the argument finely balanced. In this case you can dedicate one paragraph to discussing the pros in detail, another to the cons and a third to giving your decision on which view is the more persuasive and why.

3 Conclusión

Read through what you have written again and then write your conclusion. This should summarise your argument succinctly, referring back to the points you raised in your introduction. If you have planned your essay well, there should be no need to do anything other than show that you have achieved what you set out to do. Do not introduce new ideas or information.

Lenguaje

Linkage of the paragraphs is both conceptual, i.e. through the development of connected ideas in the body of the essay, and linguistic, i.e. through expressions which link paragraphs, sentences and clauses. These expressions are called connectives and they work in various ways, for example, through:

- contrast (*sin embargo, por otro lado, por el contrario*)
- explanation (*es decir, en otras palabras, hay que destacar*)
- cause/result (*como consecuencia, por lo tanto, debido a esto, por esta razón*)

- additional information (*además, también, asimismo*)
- ordering points (*primero, luego, a continuación*)

When writing your essay, a degree of formality is necessary in your style. Be attentive to the register you use, especially the differences between written and spoken language. Avoid colloquial language and abbreviations.

It is important to learn key quotations from the work and to introduce them in order to support aspects of your argument. When quoting, however, be careful not to make the quotation a substitute for your argument. Quotations should illustrate your point aptly and not be too long. Resist the temptation to include quotations that you have learned if they are not relevant to the essay question.

In a foreign language examination, accurate language is always an assessment factor. Review your finished essay carefully for errors of grammar, punctuation and spelling. Check especially verb endings, tenses and moods, and adjective agreements. You should employ a good range of vocabulary and include terminology related to film or literature (e.g. *argumento* (or *trama*), *personaje, escena, tema*).

For a list of useful connectives and essay-related vocabulary, see pages 71–73.

Actividades

1 ¿Qué aprendemos del carácter de Ofelia en la primera escena?

2 Describe la sociedad española de aquel entonces.

3 Comenta y evalúa el uso de los efectos especiales en la película.

4 ¿Hasta qué punto es el fauno un personaje ambiguo?

5 ¿Por qué se puede considerar a Mercedes feminista?

6 ¿Cómo vence sus miedos Ofelia en la primera prueba del fauno?

7 ¿Qué tienen en común Mercedes y Carmen?

8 ¿Qué actos de Vidal muestran que no siente ningún aprecio por Ofelia?

9 ¿Qué sabemos de los hombres que se esconden en el monte? ¿Cómo era su vida antes de estar escondidos?

10 ¿Es Ofelia un personaje de ficción, al igual que el fauno?

11 Compara las dos introducciones a la película siguientes y decide cuál te gusta más y por qué.

A *El laberinto del fauno* es una película de ciencia ficción que adquiere un tono más realista al hablar de la España de la posguerra. Una adolescente llamada Ofelia y su madre embarazada se mudan a vivir con el capitán Vidal, un hombre despiadado al mando de las tropas franquistas. Ofelia, tal como ya lo hiciera *Alicia en el país de las maravillas*, se adentra en un mundo de fantasía oscuro y terrorífico, en el que la niña superará pruebas para volver al reino en el que es una princesa.

B *El laberinto del fauno* es una película de guerra que narra un momento crítico de la historia de España. Los maquis se esconden en el monte mientras Vidal, un capitán sin escrúpulos, y su tropa quieren encontrarlos. Entretanto, su nueva esposa y la hija de esta, Ofelia, llegan a la casa de Vidal. La niña, una enamorada de los cuentos de hadas, viajará por mundos maravillosos debido a su gran imaginación, mientras que la violencia del mundo real adquiere protagonismo.

12 Describe a los personajes principales de la película con dos adjetivos para cada uno. Justifica tu respuesta y debátela con tu compañero/a. Puedes usar los adjetivos del recuadro como ayuda.

- ◣ el fauno
- ◣ el capitán Vidal
- ◣ Ofelia
- ◣ Mercedes
- ◣ Carmen
- ◣ el doctor Ferreiro

hábil	vulnerable
respetuoso/a	caprichoso/a
violento/a	preocupado/a
aventurero/a	valiente
cariñoso/a	desvalido/a
espeluznante	arrogante
capaz	sabio

Essay-writing vocabulary

La acción transcurre en (el pasado/presente/futuro) The action takes place in (the past/present/future)

a causa de because of

Además,... Furthermore/Moreover,...

Además de... In addition to...

Ahora sigamos/continuemos con... Let us now continue with...

Al contrario de/que,... Contrary to/Unlike,...

al mismo tiempo at the same time

Al principio,... At the beginning,...

el ambiente (de la ciudad, del barrio) the atmosphere (of the town, district)

A medida que avanza el relato/la historia,... As the story progresses,...

analizar to analyse

asimismo likewise

Básicamente,... Basically,...

Cabe destacar que... It should be stressed that...

como consecuencia (de) as a result (of)

como punto de partida as a starting point

Como señala el director/la directora,... As the director points out/shows,...

con referencia a with reference to

con respecto a in relation to, regarding

de manera semejante in the same way

el desarrollo de la trama the development of the plot

el desarrollo lineal linear development

el desenlace denouement, outcome

destaca el personaje (x) the character (x) stands out

En cambio,... On the other hand/Instead,...

en ciertos aspectos in some/certain respects

En/Como consecuencia,... As a result,...

En cualquier caso, hay que decir que... In any case, you have to say that...

en estos tiempos these days

en general in general

En mi opinión, (no) se puede creer que... In my opinion, one can(not) believe that...

en pocas palabras,... briefly

En primer/segundo lugar,... In the first/second place,...

En realidad,... In fact, in reality,...

En resumen,... To sum up, In a nutshell,...

En su conjunto,... On the whole,...

una escena emocionante an exciting/emotional scene

es decir that is (to say)

Es un telón de fondo perfecto. It is a perfect backcloth/backdrop.

la evolución del personaje the development of the character

hay que tomar/tener en cuenta you have to take into account

hoy en día nowadays

una imagen efectiva an effective image

Incluso se puede decir que... You/One can even say that...

interpretar to interpret

el/la lector/a reader

Lo cierto es que... The fact/truth is that...

luego then, next

mientras tanto,... meanwhile

No se puede negar que... It cannot be denied that/There's no denying...

La novela refleja (la realidad de la época, etc.) The novel reflects (the reality of the period etc.)

Otro ejemplo es... Another example is...

Para comenzar/terminar,... To begin/finish,...

Para concluir,... In conclusion,...

Parece que... It seems that...

pongamos por caso for instance

Por el contrario,... On the contrary,...

Por lo general,... In general,...

Por lo tanto,... Therefore,...

Por último,... Finally/In the end,...

Por una parte,... Por otra,... On the one hand,... On the other,...

Primero, consideremos... First let's consider...

el propósito principal the main purpose

la razón por la que the reason why

recrear el periodo/lugar to recreate the period/place

Resulta difícil creer que... It is hard to believe that...

un resumen del argumento plot summary

un retrato del/de la protagonista a portrait of the protagonist

Sea lo que sea, hay que decir que... Be that as it may, you have to say that...

Se diferencian mucho en su carácter They are very different in character/temperament

según hemos visto/se ha visto as has been seen

el sentido de lugar sense of place

Se podría incluso decir que... You could even say...

Se suele afirmar que... It is often said/claimed that...

sin duda without doubt

sobre todo especially

También debemos considerar que... We must also consider that...

el telón de fondo backcloth, background

el tema principal the main theme

Tengo la impresión de que... I have the impression that...

Tiene un carácter duro/amable/alegre He/She has a hard/kind/cheerful character

la vida interior de los personajes the characters' inner life

Viendo la película, uno se da cuenta de que... Watching the film, you realise that...

AS essays

Although a mark is awarded in the examination for use of language (AO3), all the example essays here are grammatically accurate and the examiner comments focus on the students' ability to critically and analytically respond to the question (AO4).

Question 1

Describe al personaje de Ofelia y su relación con los otros personajes de la película. Puedes mencionar a:
- los personajes femeninos (Carmen y Mercedes)
- los personajes masculinos (el fauno y el capitán Vidal)

Student A

Al comienzo, la niña está triste porque no quiere vivir en el molino con el capitán Vidal. Se queja a su madre continuamente. Gracias a sus libros, Ofelia se olvida de la dura realidad que la rodea. Ofelia es también muy desobediente y muchas veces no escucha a su madre o al fauno y sigue sus propios instintos. En la segunda prueba come dos uvas y el monstruo se despierta.

Ofelia tiene una buena relación con el fauno. Para ella, estar con el fauno y hacer las pruebas es una salvación en contraste con la vida tan difícil que tiene. El fauno confía en Ofelia y quiere ayudarla, pero cuando la niña no sigue las normas, se enfada con ella.

El capitán Vidal es una persona antipática y machista que solo se preocupa por organizar su plan en contra de la guerrilla de la montaña. No muestra afecto por Carmen y espera tener un hijo, y no una hija.

Mercedes y Carmen son mujeres muy diferentes. Para Ofelia, su madre es muy importante, pero no entiende su decisión de vivir con Vidal y muestra su descontento con frecuencia. Carmen no entiende los cuentos de hadas de Ofelia, mientras

GRADE *BOOSTER*

Write the essay question you have chosen at the top of your answer booklet before you start. It will help you refer to it more closely in your answer.

que Mercedes siempre la escucha y tiene tiempo para ella.
Ofelia y Mercedes se entienden muy bien. Mercedes es una
mujer trabajadora, sacrificada y con unos ideales muy firmes.
Ella solo quiere ayudar a su hermano que pertenece en la
guerrilla y evitar que Vidal los encuentre.

(245 words)

Examiner comments

The absence of an introduction affects the structure of this essay, and makes it more likely that the student will not answer all aspects of the question. There is lots of impressive vocabulary in the first paragraph, but the points lack clarity. Also, the final sentence simply tells the story, without linking it to a particular point.

The second paragraph is much more successfully executed, with accurate knowledge and supporting evidence.

There is a good description of Vidal in the third paragraph, but it contains no mention of Ofelia.

There is evidence of good knowledge in the fourth paragraph, and the language is impressive, but it would be much more effective to answer the question in the order it sets out and also leave room for a brief conclusion. Leaving the description of Ofelia's relationship with the female characters until the end makes for a confused essay. It would have been better if the female characters had been analysed first, and then the male, as in the question.

Student A would be likely to receive a mark in the middle band for AO4 for this essay.

Student B

En la película "El laberinto del fauno", del director mexicano
Guillermo del Toro, el personaje de Ofelia es central en toda la
trama, y de una manera u otra, tiene relación con el resto de
los personajes. A continuación, voy a describir estas relaciones
y la evolución del personaje.

Desde el principio, Ofelia es una niña inteligente, educada y
muy atenta con su madre. Ofelia la describe como una mujer
muy guapa y está orgullosa de ella. A pesar de esto, Ofelia es
también crítica con su madre ya que no entiende por qué ha
tenido que casarse con el capitán Vidal y mudarse a vivir con
él. Además, la niña está encantada con sus libros de cuentos
de hadas y fantasía, lo que su madre critica varias veces.

En este aspecto, hay una gran diferencia con la relación de Ofelia y Mercedes. Al contrario que Carmen, Mercedes nunca critica a Ofelia. La escucha y participa de sus historias cuando Ofelia le dice que ha visto un fauno. Ofelia pronto descubre el secreto de Mercedes: que pasa información a la guerrilla y que está en contra de Vidal. Será también Mercedes la que adopta el papel de protectora cuando Carmen muere, y no duda en llevarse a la niña con ella cuando escapa del molino por la noche.

En la relación de Ofelia con los dos grandes personajes masculinos de la película, también hay un gran contraste. Vidal no muestra ningún tipo de afecto por Ofelia, y la niña nunca interacciona con él. Ofelia le rechaza desde el primer momento: "El capitán no es mi padre." Sin embargo, su relación con el fauno es diferente. A pesar de ser una criatura oscura y no demasiado cercana para una niña, ella se siente segura a su lado y le abraza.

Desde el comienzo de la película, vemos a Ofelia como una niña con un carácter fuerte, que no duda en desobedecer para conseguir lo que quiere. La pequeña vence sus miedos y se enfrenta a monstruos horribles. Su cuento de hadas tiene un final feliz, aunque en la historia real el final sea más dramático.

(354 words)

Examiner comments

This brief introduction is an effective way of starting the essay as it sets clear, relevant parameters for discussion, using the language in the question, along with some ambitious A-level vocabulary.

In the second paragraph, the points about the relationship between Ofelia and her mother are made efficiently. Although there is no limit to how much can be written, with an advised word count of approximately 250 for an AS essay, aim to be succinct.

Note that the structure of the essay logically follows the structure of the question, with paragraphs separating the analysis of Ofelia's relationship with each character.

The description of Ofelia's relationship with the male characters is shorter than that for the females in the film, but it is an accurate analysis and benefits from a suitable quote to justify opinion. There is also an effective conclusion.

Student B would be likely to receive a mark in the top band for AO4 for this essay.

Question 2

¿Crees que cambia el carácter de Ofelia a lo largo de la película? Puedes considerar los siguientes aspectos:
- su carácter al comienzo
- las tres pruebas
- su relación con otros personajes

Student A

En la película "El laberinto del fauno", Ofelia se relaciona con todos los personajes principales, pero su relación con el fauno es la que tiene más importancia.

La niña conoce al fauno al principio de la película, y aunque es un ser mitológico que puede dar miedo, creo que la pequeña es valiente y acepta lo que le pide. El fauno está contento de encontrar a la niña porque él sabe que es una princesa. Ofelia acepta las pruebas del fauno para volver a su reino y escapar de su horrible realidad.

Ofelia empieza su relación con el fauno muy bien, termina la primera prueba sin problemas y el fauno está contento. El problema está en la segunda prueba, cuando la niña no acepta todas las reglas y come unas uvas de la mesa. Esto tiene unas consecuencias malas que el fauno no aceptará, y aunque para la niña el fauno representa una salida de su realidad, él decide abandonarla.

No se puede afirmar que el fauno y la niña son amigos, pero su relación es buena hasta que Ofelia le desobedece. El fauno vuelve más tarde y no abandona a la chica por completo y le ofrece una tercera prueba, que Ofelia acepta. El fauno representa todo lo que a Ofelia le encanta: el misterio, las hadas, un mundo donde ella es una princesa, y aunque el animal mitológico tiene una apariencia desagradable, la niña lo ve con otros ojos.

(241 words)

Examiner comments

There is an attempt to answer the question, but there is clearly too much emphasis on one character here: the faun, and this severely limits the depth of the response.

The level of narration is of a high quality. It would benefit from more explicit reference to the question. For example, 'Ofelia no cumple con las reglas en la segunda prueba, lo cual demuestra su carácter desobediente'.

The essay would also benefit from more detail: the candidate has not discussed Ofelia's relationship with a range of key characters.

Student A would be likely to receive a mark in the middle band for AO4 for this essay.

Student B

En la película "El laberinto del fauno" se puede observar una evolución en casi todos sus personajes. Así pues, voy a ilustrar cómo Ofelia, el personaje central, se desarrolla de manera progresiva, aprende, se equivoca y evoluciona hasta el final.

Al principio, Ofelia es una niña vital, pero está muy angustiada con su nueva situación porque no acepta a su nuevo padrastro. Ahora tiene que vivir con el capitán Vidal, y el molino no es un lugar adecuado para una madre embarazada y su hija adolescente. Así pues, Ofelia se refugia en sus libros de hadas, en los cuentos y en su enorme imaginación.

La niña entra en otro mundo paralelo donde todo es diferente a la España de la posguerra. Allí, el fauno está al mando de la situación y quiere que la niña pase tres pruebas para poder volver a su reino. Al principio, Ofelia está un poco asustada del fauno, pero es valiente y acepta el reto de la primera prueba. Con valor e inteligencia, pasa la prueba.

Ofelia vuelve a aceptar otra prueba y su relación con el fauno se hace más fuerte porque hay confianza entre ellos. En esta prueba la niña, por primera vez, no obedece las reglas, lo que enfada mucho al fauno. Cuando su relación parece estar rota, el fauno vuelve para ayudar a Ofelia. Cuando Carmen muere, Ofelia solo puede apoyarse y confiar en Mercedes y en el fauno. La relación de Mercedes con la niña también crece y evoluciona, y llega a ser una auténtica relación de madre e hija.

Ofelia acepta la última prueba, pero cuando el fauno le pide unas gotas de sangre de su hermanito, ella se niega totalmente y le desobedece por segunda vez diciendo: "Mi hermano se queda conmigo." Al final, este gesto tiene una recompensa. Según el director, la desobediencia es una virtud importante, y en mi opinión, que esta característica es la esencia de Ofelia.

(322 words)

Examiner comments

There is a mature introduction, confidently setting out the line of discussion. The candidate uses the bullet points offered at AS to help structure the essay. As a result, there is a comprehensive list of points made. There is a successful attempt to tackle the tricky task of not only describing Ofelia's character, but also explaining how it changes over the course of the film.

The last paragraph contains a succinct but relevant quote, sophisticated vocabulary and a clear, intelligent opinion directly relating to the question, all of which combine to make a highly effective conclusion.

Student B would be likely to receive a mark in the top band for AO4 for this essay.

A-level essays
Question 1

Analiza la relación entre el mundo real y el mundo fantástico en *El laberinto del fauno*.

Student A

El mundo de cuento y el mundo de la guerra civil en la película "El laberinto del fauno" viven al mismo tiempo, pero son muy diferentes.

Ofelia es la única que tiene acceso al mundo de magia y fantasía, y gracias a esto, puede olvidar un poco la terrible realidad en la que vive. Por una parte, España acaba de terminar una guerra civil con muchas muertes y Franco, el general fascista, está en el poder. Las personas que perdieron la guerra deciden esconderse en el monte y el ejército y los militares como Vidal, dirigen ofensivas para encontrarlos y

matarlos. A mi modo de ver, no es una realidad agradable para una niña, pero la visita del fauno cambia toda la acción en la película.

Ofelia tiene que pasar tres pruebas muy diferentes para volver al reino mágico. El fauno le cuenta cómo hacer las pruebas y la chica es valiente y las acepta.

Mientras que en un mundo hay aventuras, monstruos y pruebas, en el otro hay guerra, violencia y muerte. Solo vi la muerte en el mundo mágico, cuando el monstruo con los ojos en las manos se comió a dos hadas.

En el mundo real no hay magia, ni recompensas ni alegría. Hay odio y sangre. Carmen, la madre de Ofelia, se muere y Ofelia está muy triste. Mercedes habla con ella y es una buena ayuda, pero cuando el fauno vuelve con una nueva prueba, la niña vuelve a ser valiente y la acepta para coger a su hermano de la habitación donde está Vidal y escapar con él.

El doble final de la película muestra cómo en el mundo de hadas Ofelia tiene su recompensa final, con su familia al completo, mientras que en la realidad muere, pero también muere Vidal y hay esperanza también.

(301 words)

GRADE *BOOSTER*

There is no upper word limit, so if you have points to make, do so, but be careful to avoid repetition and simply 'telling the story'. Also the more you write, the more your accuracy and quality of language may suffer.

Examiner comments

There is an attempt at an introduction, but it is more like a conclusion. More use of the words in the question may have helped the candidate to structure his or her essay better.

The second paragraph includes a well-written summary of the two worlds and sets up further analysis of the relationship between them.

In the third paragraph, retelling of part of the story is not backed up by appropriate depth of analysis, so the material becomes irrelevant.

There is some attempt to link the two worlds, but it is quite superficial, and the tendency to just retell the story reappears. Also, the absence of reference to cinematic techniques means the answer lacks depth.

Student A would be likely to receive a mark in the middle band for AO4 for this essay.

Student B

El director de la película, Guillermo del Toro, mantiene dos mundos muy diferentes, y voy a decidir si estas dos realidades muchas veces se cruzan y los eventos de una parte afectan a los de la otra.

"El laberinto del fauno" está ambientada en la España después de la guerra civil, en el año 1944. En ese momento, Franco está en el poder y después de haber ganado la guerra, no perdona a los del bando opuesto, a los que quiere eliminar. El capitán Vidal y sus hombres tienen órdenes de buscar y acabar con las guerrillas que se esconden en las montañas. No cabe duda de que es una dura realidad.

Entre toda la violencia de la guerra, empieza otra historia de monstruos, fantasía, pruebas y magia. Ofelia siempre lee sus libros de cuentos y hadas, y pronto recibe la visita de un fauno que la reconoce como una princesa que tiene que volver a su reino. A primera vista, parece que este mundo de fantasía contrasta mucho con el mundo real, pero es evidente que el director usa la contraposición de escenas y el montaje paralelo para hacer una analogía entre los dos mundos. Así, se puede comparar la cena del capitán Vidal con el banquete del monstruo, y la gula del sapo con la del bando ganador de la guerra civil.

En el mundo real, hay dolor y mucho sufrimiento. Es un mundo muy sangriento y violento: Vidal no duda en disparar a unos campesinos que cazaban conejos, torturar para obtener información o usar su pistola para disparar a los guerrilleros. En el mundo de fantasía hay muchos retos también, pero a medida que transcurre la acción, se puede ver que el mundo fantástico, donde la valentía tiene una recompensa, tiene un final feliz. Mientras que en el final real, en el que el sufrimiento es omnipresente, hay muerte y tragedia. En esta película, la realidad y la fantasía van de la mano, y es posible que el mundo fantástico en esta película sea una alegoría de la España de la posguerra.

(345 words)

Examiner comments

A-level essays are worth more marks than those at AS, so they are naturally longer. Nevertheless, the principles of clarity and concision remain.

The second paragraph contains the description of postwar Spain that the question demands, with impressive vocabulary and essay expressions.

Cinematic terminology is used accurately and to justify points of view.

After clearly describing the real world and the fantasy world, there is a successful attempt here to bring the two together and reach a meaningful conclusion.

Student B would be likely to receive a mark in the top band for AO4 for this essay.

Question 2

¿Hasta qué punto se puede decir que *El laberinto del fauno* es una película histórica? Explica tu respuesta.

Student A

En esta película hay eventos históricos mezclados con hechos irreales.

Esta obra no se basa en hechos reales, pero se inspira en la guerra civil española y en las guerrillas de la resistencia que se escondieron en las montañas. En la película se ve cómo el capitán Vidal planea atacar a los maquis allí. El capitán es un hombre muy preciso y tiene muchos planes para terminar con ellos. Esto fue muy común en los años cuarenta y cincuenta en España. Vidal es un hombre despiadado y agresivo que solo quiere venganza y acabar con todos los campesinos. Es cruel con muchas personas y no me gusta nada porque es muy malo.

Muchas partes de la película, aunque con nombres y personas diferentes, sí son fieles a la historia, pero la mayoría de la película tiene que ver con las hadas, el misterio y el mundo de fantasía de Ofelia, y esto no es histórico. Gracias a la imaginación de la niña, el espectador entra en un mundo más justo, donde Ofelia tiene varias aventuras, y lo mejor de todo, un final feliz.

La película empieza y termina como un cuento, y creo que esta es la esencia de la película al completo. No es muy histórica y simplemente usa algunos hechos reales como ambientación para contar un cuento de hadas.

(221 words)

Examiner comments

This essay starts reasonably well, with good historical context, but it lapses into general character description and basic opinion. By the third paragraph, the essay is starting to become quite unbalanced, with the weight of analysis focused on dismissing its historical value. Such an approach makes it harder to obtain marks for content, owing to the limitations set by the candidate's own opinion.

There is a fair conclusion, but it would have benefited from greater sophistication, such as the allegorical role of the underworld.

Student A would be likely to receive a mark in the middle band for AO4 for this essay.

Student B

"El laberinto del fauno" está dirigida por Guillermo del Toro y cuenta la historia de una niña que tiene que mudarse con su madre a vivir en un molino antiguo con su padrastro, el capitán Vidal. Él está a cargo de un ejército dirigido por Franco en contra de las guerrillas que aún apoyan el régimen republicano.

En la película se muestra de manera fiel cómo las tropas franquistas aún continuaban en pie de guerra para acabar con los maquis escondidos en la montaña. Estoy seguro de que existieron muchos militares similares a Vidal, con hambre de venganza. "Esta gente parte de una idea equivocada, que somos todos iguales. Pero hay una gran diferencia: que la guerra terminó y ganamos nosotros."

En la película no se ofrecen muchos datos, pero la historia de los maquis que se esconden en las montañas y que reciben ayuda de otras personas es real. Hay escenas muy auténticas en relación con la España de la posguerra, como cuando los militares reparten las cartillas de racionamiento y el pan gritando: "Este es el pan de cada día en la España de Franco." Además, es incuestionable que mucha gente del campo y los sirvientes ocultaban sus ideales opuestos al régimen.

En mi opinión, el mundo fantástico de Ofelia, el fauno y las pruebas son un contraste enorme con la España de la posguerra, y hacen de esta película una obra única. En general, no me atrevería a decir que es una película histórica al cien por cien, pero sí que está basada en hechos reales. Me parece una obra maestra y creo que Guillermo del Toro es un genio al combinar los dos mundos en uno porque, a veces, parece que todo ocurre al mismo tiempo.

Examiner comments

In the opening paragraphs the candidate successfully depicts the historical context of the film and links it explicitly to the characters and plot.

The references to the Maquis and the ration books show a fine understanding of the film and the debate of historical authenticity.

Student B would be likely to receive a mark in the top band for AO4 for this essay.

GRADE **BOOSTER**

Always try to add some relevant quotations and cinematic expressions in your film essay. They make a good impression and are a succinct way of gaining content points.

In order to be able to recall essential aspects of the film, it is advisable for you to focus on quotations. You do not necessarily need to learn them by heart, but it is important to recall and even paraphrase them when you write about the film.

Cuentan que hace mucho, mucho tiempo en el reino subterráneo, donde no existe la mentira, ni el dolor, vivía una princesa que soñaba con el mundo de los humanos, soñaba con el cielo azul, la brisa suave y el brillante sol. Un día, burlando toda vigilancia, la princesa escapó. Una vez en el exterior, la luz del sol la cegó y borró de su memoria cualquier indicio del pasado. La princesa olvidó quién era, de dónde venía. Su cuerpo sufrió frío, enfermedad y dolor.

1

▿ Esta cita aparece al comienzo de la película, cuando el narrador cuenta el principio de la historia fantástica en la que se basa la película. Parece que esta cita no da ninguna pista sobre el contexto sociopolítico de la película, solo de la historia fantástica. Será después de varios minutos, cuando Ofelia entra en contacto con el mundo fantástico del fauno, su laberinto y las tres pruebas que tiene que afrontar para ser finalmente coronada como la princesa que el fauno cree que es. Es entonces cuando los espectadores pueden recordar el comienzo de la película e identificar a Ofelia como la princesa. Así, empiezan a, y empezar a dar forma al cuento dentro de la película, al mundo de fantasía dentro de la historia en la España de la posguerra e intentan entender la alegoría.

Capitán Vidal: No lo entiendo, ¿por qué no me obedeció?
Doctor Ferreiro: Es que, obedecer por obedecer, así, sin pensarlo, solo lo hacen gentes como usted, capitán.

2

▿ Esta escena es el preludio de un momento importante de la película, cuando el doctor Ferreiro, harto de trabajar para el capitán, se subleva y expresa sus auténticas ideas políticas. Desde que conocemos a Ferreiro en la película, lo vemos como a un hombre noble y trabajador, que ayuda a los guerrilleros republicanos que se esconden en el monte. No tiene otra opción más que trabajar para Vidal y curar y ayudar al ejército franquista, aunque siempre que puede, ayuda a Mercedes.

En el momento de esta cita, Ferreiro pone su voz a otros muchos que, como él, no aceptan el régimen franquista, la represión, la dictadura y el miedo. En cambio, el doctor expresa que solo la gente como el capitán obedece órdenes sin cuestionarlas, haciendo referencia a cómo Vidal acepta órdenes de Franco sin oposición alguna. Ese "gentes como usted" no solo hace referencia a Vidal, sino también a tantas otras personas, segmentos sociales como las clases altas, la Iglesia, el ejército, y todos aquellos que sin preguntarse si está bien o está mal, aceptan todo.

3

Ofelia: ¿Qué es ese ruido?
Carmen: No es nada hija. Es el viento. Las noches aquí son muy distintas a las de la ciudad. Ahí se oyen los coches, los tranvías. Aquí las casas son viejas. Gruñen, se quejan… ¿A que parece que hablan?

> Tras una simple pregunta de Ofelia al comienzo de la película, Carmen, su madre, responde de una manera un tanto misteriosa que nos deja ver que muchas aventuras y vicisitudes están por venir. *"Las casas gruñen"* es un ejemplo de falacia patética, y la niña se sorprende del crujir de la casa y del propio sonido del viento, algo que desconocía por vivir en la ciudad. Pronto estos sonidos formarán parte de su rutina diaria y vivirá rodeado de ellos.

4

Capitán Vidal: Decidle a mi hijo, decidle a qué hora murió su padre. Decidle que yo…
Mercedes: No. Ni siquiera sabrá tu nombre.

> Al final de la película, esta cita llama la atención por la rotundidad de Mercedes. Apenas unos segundos antes de morir, Vidal le pide que su hijo sepa a qué hora murió, seguramente dando a entender que también querría que su hijo le recordara por su nombre y por sus hazañas, lo cual Mercedes corta inmediatamente de manera tajante al contestarle que el niño no sabrá nada sobre él. Después de cómo Vidal ha tratado a Ofelia desde el primer minuto y sin olvidar Mercedes que el bebé es hermano de Ofelia e hijo de su madre también, ella se siente fuerte para afirmar lo que dice. Sin duda, un momento con un cierto sabor a venganza bien merecido.

5

Oficial: ¿Le he dicho ya que conocí a su padre, capitán?
Vidal: No, no tenía ni idea.
Oficial: En Marruecos, lo conocí brevemente, pero causó en mí una vivísima impresión.
Vidal: Un gran militar.
Oficial: Los hombres de la tropa decían, que cuando el general Vidal murió en el campo de batalla, estalló su reloj contra el suelo para que mostrara la hora exacta de su muerte… para que su hijo supiera cómo muere un valiente.
Vidal: Habladurías… nunca tuvo un reloj.

> Esta conversación tiene lugar durante la suculenta cena de presentación que el capitán Vidal ofrece para su mujer y otros miembros locales destacados. La conversación muestra el carácter frío y distante del capitán. Parece que se siente incómodo hablando de asuntos personales. Un oficial cuenta una historia que explica la razón por la que Vidal quiere que su hijo lo recuerde como un valiente quedado en el campo de batalla. Mercedes le negará su deseo.

No comáis ni bebáis nada durante vuestra estancia.

6

> ◁ Al comienzo de la segunda prueba, una de las escenas más memorables de la película, Ofelia tiene dudas y no sabe muy bien cómo comenzar. Mientras lee las instrucciones en el libro, esta cita parece tener mucha más importancia de la que parece a primera vista. Algo tan inocente como comer una uva ocasionará grandes problemas para la niña y consecuencias en su relación con el fauno al no pasar la prueba correctamente. Además, la decisión que toma la niña muestra su desobediencia innata.

Ofelia: Hermano, hermano: Hace muchos, muchos años, en un país muy lejano y triste, existía una enorme montaña de piedra negra y áspera. Al caer la tarde, en la cima de esa montaña, florecía todas las noches una rosa que otorgaba la inmortalidad. Sin embargo, nadie se atrevía a acercarse a ella porque sus numerosas espinas estaban envenenadas....

7

> ◁ Nuevamente, la gran imaginación de Ofelia y su amor por los cuentos de hadas y la fantasía hacen que la niña le cuente un cuento a su hermano que aún no ha nacido. Este pequeño relato habla de una rosa con espinas y de la idea de la inmortalidad, un tema muy usado en la literatura y en los cuentos populares. Este mismo cuento hace que el espectador se adentre en el mundo imaginario de la niña. Esta cita aparece en el minuto 13 de la película, cuando todavía no se conoce al fauno ni a todo el mundo de aventuras que está por venir, pero sirve de pista para advertir al espectador de la gran imaginación de Ofelia. Además, a lo largo de la película el espectador se dará cuenta de que el cuento es, hasta cierto punto, una metáfora que refleja la realidad de la posguerra.

Mercedes: Mi abuela decía que con los faunos hay que andarse con cuidado.

8

> ◁ Justo el día después de haber conocido al fauno y a sus hadas, Ofelia, con su vestido nuevo, baja a las cocinas, donde Mercedes la lleva fuera para darle un poco de leche con miel, tras decirle que está muy guapa. Mientras Mercedes ordeña la vaca, la niña le cuenta que la noche anterior vio a unas hadas y conoció a un fauno que huele a tierra, que es muy alto y muy viejo. Mercedes responde con esta cita, y da la idea de su complicidad con Ofelia, ya que en ningún momento le dice que eso sea un cuento o que los faunos no existen, sino que forma parte de la imaginación de la niña, dando veracidad a su comentario y empezando así una relación cercana con ella. La vida es dura para la niña, y Mercedes no quiere que pierda su infancia ni su inocencia.

EL LABERINTO DEL FAUNO

9

Capitán Vidal: Al principio no voy a poder confiar en ti, pero cuando termine de usar esto, me vas a decir alguna que otra verdad… Cuando pasemos a estas, ya vamos a tener una relación… como diría yo… más estrecha… como de hermanos. Y cuando lleguemos a esta, te voy a creer todo lo que me digas.

⬎ Después de rastrear la zona e insistir mucho con una gran ofensiva en todo el bosque, el capitán Vidal acaba capturando a uno de los guerrilleros que no murió en el bosque durante el ataque, y lo lleva al granero del molino donde vive para poder obtener información sobre la ubicación del grupo. Vidal pronuncia estas palabras mientras le enseña al guerrillero, que es tartamudo y no se expresa muy bien, algunos utensilios como un martillo y otros más afilados con los que le torturará si él se niega a hablar. Los métodos de tortura fueron usados en el franquismo para obtener información de los detenidos, a pesar de lo cruel e inhumano de esas acciones. Parece que Vidal disfruta el proceso con perversidad.

10

Habéis derramado vuestra sangre antes que la de un inocente. Esa era la última prueba, la más importante.

⬎ Con estas palabras se dirige el padre de Ofelia a la niña al final de la película. Ese sastre humilde del que apenas se habla, aparece durante unos segundos al final, como el rey de un mundo imaginario en el que Carmen es la reina y Ofelia, la princesa. Esta reunión familiar pone fin a la parte fantástica de la película, no a la parte real, que tiene un final oscuro y terrible. El padre de Ofelia acepta así que la niña ha pasado la última prueba al proteger a su hermano, y ahora se merece una vida feliz con su auténtica familia.

WITHDRAWN
Luton Sixth Form College
Learning Resources Centre